Uncanny Creatures

Social History, Popular Culture, and Politics in Germany
Kathleen Canning, Series Editor

Recent Titles
Uncanny Creatures: Doll Thinking in Modern German Culture
 Christophe Koné
Women in German Expressionism: Gender, Sexuality, Activism
 Anke Finger and Julie Shoults, Editors
Queer Livability: German Sexual Sciences and Life Writing
 Ina Linge
Moderate Modernity: The Newspaper Tempo *and the Transformation of Weimar Democracy*
 Jochen Hung
African Students in East Germany, 1949–1975
 Sara Pugach
The Arts of Democratization: Styling Political Sensibilities in Postwar West Germany
 Jennifer M. Kapczynski and Caroline A. Kita, Editors
Decolonizing German and European History at the Museum
 Katrin Sieg
Spaces of Honor: Making German Civil Society, 1700–1914
 Heikki Lempa
Bankruptcy and Debt Collection in Liberal Capitalism: Switzerland, 1800–1900
 Mischa Suter
Marking Modern Movement: Dance and Gender in the Visual Imagery of the Weimar Republic
 Susan Funkenstein
Anti-Heimat Cinema: The Jewish Invention of the German Landscape
 Ofer Ashkenazi
Dispossession: Plundering German Jewry, 1933–1953
 Christoph Kreutzmüller and Jonathan R. Zatlin, Editors
Sex between Body and Mind: Psychoanalysis and Sexology in the German-speaking World, 1890s–1930s
 Katie Sutton
Imperial Fictions: German Literature Before and Beyond the Nation-State
 Todd Kontje
White Rebels in Black: German Appropriation of Black Popular Culture
 Priscilla Layne
Not Straight from Germany: Sexual Publics and Sexual Citizenship since Magnus Hirschfeld
 Michael Thomas Taylor, Annette F. Timm, and Rainer Herrn, Editors
Passing Illusions: Jewish Visibility in Weimar Germany
 Kerry Wallach

For a complete list of titles, please see www.press.umich.edu

Uncanny Creatures

Doll Thinking in Modern German Culture

CHRISTOPHE KONÉ

UNIVERSITY OF MICHIGAN PRESS
Ann Arbor

Copyright © 2024 by Christophe Koné
All rights reserved

For questions or permissions, please contact um.press.perms@umich.edu

Published in the United States of America by the University of Michigan Press
Manufactured in the United States of America
Printed on acid-free paper
First published July 2024

A CIP catalog record for this book is available from the British Library.

Library of Congress Cataloging-in-Publication data has been applied for.

ISBN 978-0-472-13329-1 (hardcover: alk. paper)
ISBN 978-0-472-03973-9 (paper: alk. paper)
ISBN 978-0-472-22083-0 (e-book)

This book will be made open access within three years of publication thanks to Path to Open, a program developed in partnership between JSTOR, the American Council of Learned Societies (ACLS), University of Michigan Press, and The University of North Carolina Press to bring about equitable access and impact for the entire scholarly community, including authors, researchers, libraries, and university presses around the world. Learn more at https://about.jstor.org/path-to-open/

For Ousmane Koné, my father, in loving memory.
To all the doll thinkers, makers, players, and lovers out there ...

Contents

List of Illustrations — viii

Acknowledgments — xi

Prologue — 1

Chapter 1.
 Doll Thinking: A Hermeneutic Method. The Wooden Doll Olimpia in E.T.A. Hoffman's "The Sandman" (1816) — 14

Chapter 2.
 Doll Thinking: An Aesthetic Investigation. Oskar Kokoschka's Fluffy Alma Doll by Hermine Moos — 37

Chapter 3.
 Doll Thinking: A Kinetic Approach. Lotte Pritzel's Wax Dolls — 65

Chapter 4.
 Doll Thinking: An Epistemological Method. Hans Bellmer's Papier Mâché Dolls — 105

Epilogue — 152

Bibliography — 157

Index — 163

Digital materials related to this title can be found on the Fulcrum platform via the following citable URL: https://doi.org/10.3998/mpub.12265924

List of Illustrations

Figure 1. Helmut Newton, *Upstairs at Maxim's*, 1978 — 2
Figure 2. Photographer unknown, *Photograph of Hermine Moos with the Skeleton of Oskar Kokoschka's Alma Doll* — 41
Figure 3. Oskar Kokoschka, *Standing Female Nude, Alma Mahler*, 1918 — 46
Figure 4. Photographer unknown, *The Dollmaker Hermine Moos in front of the Doll in her Parents' Apartment*, Munich 1919 — 50
Figure 5. Photographer unknown, *The Doll*, Munich 1919 — 51
Figure 6. Photographer unknown, *The Doll Seated Next to a Head Study by Oskar Kokoschka*, Munich 1919 — 53
Figure 7. Photographer unknown, *The Doll Reclining*, Munich 1919 — 53
Figure 8. Oskar Kokoschka, *Study for Woman in Blue*, 1919 — 57
Figure 9. Oskar Kokoschka, *Woman in Blue*, 1919 — 58
Figure 10. Oskar Kokoschka, *Painter with Doll*, 1922 — 59
Figure 11. Atelier Madame d'Ora, *The Dollmaker Lotte Pritzel*, 1924 — 69
Figure 12. Still from the Universum Film AG Documentary, *Die Pritzelpuppe (The Pritzel-Doll)*, 1923 — 70
Figure 13. Lotte Pritzel, *Dolls for the Vitrine*, 1910 — 73
Figure 14. Lotte Pritzel, *Dolls for the Vitrine*, 1910 — 74
Figure 15. Lotte Pritzel, *Dolls for the Vitrine*, 1910 — 75
Figure 16. Lotte Pritzel, *Dolls for the Vitrine*, 1912 — 76
Figure 17. Lotte Pritzel, *Dolls for the Vitrine*, 1912 — 79
Figure 18. Lotte Pritzel, *Vitrine-Dolls*, 1913 — 81
Figure 19. Lotte Pritzel, *Vitrine-Dolls*, 1914 — 84
Figure 20. Germaine Krull, Kara Druck, 1924 — 87
Figure 21. Lotte Pritzel, *Female Dancer/Bayadere*, c. 1923 — 93
Figure 22. Lotte Pritzel, *Exotic Female Dancer*, c. 1920 — 96

List of Illustrations ix

Figure 23. Lotte Pritzel, *Harlequin*, c. 1917 98
Figure 24. Nini & Carry Hess, *Niddy Impekoven as Lotte Pritzel Doll*, 1918–1919 100
Figure 25. Atelier Madame d'Ora, *Anita Berber as Pritzel Doll*, 1919 101
Figure 26. Lotte Pritzel, *Anita Berber Doll*, c. 1920 102
Figure 27. Hans Bellmer, *Die Puppe (The Doll)*, 1934 111
Figure 28. Hans Bellmer, *Die Puppe (The Doll)*, 1934 112
Figure 29. Hans Bellmer, *Die Puppe (The Doll)*, 1934 114
Figure 30. Hans Bellmer, *La poupée (The Doll)*, 1936 115
Figure 31. Hans Bellmer, *La poupée*, 1936 116
Figure 32. Hans Bellmer, *The Doll*, 1934–1935 118
Figure 33. Hans Bellmer, *La poupée (The Doll)*, 1933–1936 119
Figure 34. Hans Bellmer, *Die Puppe (The Doll)*, 1934 120
Figure 35. Hans Bellmer, *Die Puppe (The Doll)*, 1934 121
Figure 36. Hans Bellmer, *La poupée (The Doll)*, 1936 123
Figure 37. Hans Bellmer, *Die Puppe (The Doll)*, 1934 124
Figure 38. Hans Bellmer, *Poupée: Variations sur le montage d'une mineure articulée* 125
Figure 39. Hans Bellmer, *The Doll*, 1935 126
Figure 40. Hans Bellmer, *Les Jeux de la Poupée (The Games of the Doll)*, between 1938 and 1949 130
Figure 41. Hans Bellmer, *Les Jeux de la Poupée (The Games of the Doll)*, between 1938 and 1949 131
Figure 42. Hans Bellmer, *Les Jeux de la Poupée (The Games of the Doll)*, between 1938 and 1949 132
Figure 43. Hans Bellmer, *Les Jeux de la Poupée (The Games of the Doll)*, between 1938 and 1949 133
Figure 44. Hans Bellmer, *La Poupée (The Doll)*, 1949 134
Figure 45. Hans Bellmer, *La Poupée (The Doll)*, c. 1936 136
Figure 46. Hans Bellmer, *La Poupée (The Doll)*, c. 1935–1936 137
Figure 47. Hans Bellmer, *Les Jeux de la Poupée (The Games of the Doll)*, between 1938 and 1949 138
Figure 48. Hans Bellmer, *Les Jeux de la Poupée (The Games of the Doll)*, between 1938 and 1949 139
Figure 49. Hans Bellmer, *Les Jeux de la Poupée (The Games of the Doll)*, between 1938 and 1949 140
Figure 50. Hans Bellmer, *Les Jeux de la Poupée (The Games of the Doll)*, between 1938 and 1949 141

x List of Illustrations

Figure 51. Matthias Grünewald, *Isenheim Altarpiece*, 1506–1515 142
Figure 52. Hans Bellmer, *La mitrailleuse en état de grâce
 (The Machine-Gunneress in a State of Grace)*, 1937 144
Figure 53. Hans Bellmer, *La mitrailleuse en état de grâce
 (The Machine-Gunneress in a State of Grace)*, 1937 145
Figure 54. Hans Bellmer, *Les Jeux de la Poupée* (*The Games
 of the Doll*), between 1938 and 1949 146
Figure 55. Hans Bellmer, *La demi-poupée (The Half Doll)*, 1971 150
Figure 56. Helmut Newton, *Store Dummies II*, 1976 153

Acknowledgments

Writing my first academic book has been a challenging, years-long process, one I could not have managed without the help of many individuals and institutions.

The project started a decade ago at Rutgers, the State University of New Jersey, where I attended two graduate seminars in German Studies: one on Romanticism, taught by Martha Helfer, and one on the Avant-garde, taught by Peter Demetz. Both professors' excitement about the course materials was intoxicating. While I credit them for sparking my interest in German Romanticism and the avant-garde, I was most intrigued by the recurrence of anthropomorphic artifacts called "Puppen" in their discussion materials. I am deeply indebted to Michael Levine for his enthusiasm and his unconditional faith in the project, first as a dissertation and then as a book. His outstanding advising and mentorship, along with Martha Helfer's, have deeply informed and shaped my thinking about doll artifacts.

I also have many people to thank at Williams College, where I have taught since 2013. I am grateful to my colleagues from the department of German and Russian, Julie Cassiday, Helga Druxes, Gail Newman, and Janneke van de Stadt, for their support and feedback on my chapter drafts. I would like to thank Guy Hedreen, Liz McGowan, and Christi Kelsey for their precious help with the book proposal, as well as Katarzyna Pieprzak. I am grateful to Gage McWeeny and Krista Andrews for providing me with the perfect space to write: a storage room at the Oakley Center overlooking a garden visited by birds, rabbits, groundhogs, and deer turned out to be a summer paradise and a safe haven.

I would like to express my deep gratitude to Jill Casid for her support and her faith in the book manuscript. She challenged my ideas about doll artifacts and pushed me to think more theoretically and beyond the binary. I am also

grateful to Jennifer Bajorek and Kirsten Scheid for their excellent feedback and input.

Amy Holzapfel, Catriona MacLeod, and Marquard Smith gave detailed comments and asked challenging questions, which pushed me to further foreground the originality of my reading of doll artifacts in modern German culture, and to take a clear stand about the existing scholarship on dolls.

I was able to conduct research in France, Germany, and Austria with the generous support of the Hellman Fellowship and the Williams College Class of 1945 World Fellowship. During these trips I met very supportive art historians and curators at museums in Vienna, Paris, Darmstadt, and Munich, all of whom I would like to recognize and thank. I am indebted to Bernadette Reinhold at the Oskar Kokoschka Center, whom I had the good luck of meeting in Vienna when I was still dissertating, for her expertise on Kokoschka's Alma doll and her vast knowledge of Viennese Modernism. Camille Morando and Véronique Bourgeaud at the Kandinsky Library at the Pompidou Centre in Paris gave precious insight into Hans Bellmer's ball-jointed doll and Surrealism. Lastly, I am tremendously grateful to Wolfgang Glüber and Sabine Princ, whom I had the privilege of meeting during my visits to the Hessisches Landesmuseum Darmstadt and the Stadtmuseum Munich, respectively, for their availability, generosity, and expertise on Lotte Pritzel and her wax dolls.

I would like to express my gratitude to Sam Douglas, Jonathan Odden, and Mason Cummings, as well as Christopher Dreyer, Katie LaPlant, Anna Pohlod, and Delilah McCrea at the University of Michigan Press for their editing work on my book manuscript. I am also grateful to the anonymous readers for their serious and meticulous responses. Their comments and suggestions have strengthened the main argument and enhanced the overall quality of the monograph.

Carol Anne Costabile-Heming and Rachel Halverson organized a remote writing group and invited me to participate in it during the summer of 2020. I greatly benefited from the group's support and appreciated the camaraderie, candor, and humor of its participants during the Covid-19 pandemic.

Last, but not least, I want to wholeheartedly thank my friends and family, Stefan Börnchen, Julien Jimenez, Marie-Thérèse Koné, Fabiane Lima, Keith Lloyd, Laure de Margerie, Elidor Mëhilli, Olivier Meslay, Marie-France Morel, Sébastien Raphaëlian, Stéphanie Tobbal, and Cristel Volpi for their unrelenting support. I simply could not have completed this book manuscript without their love, steady push, and faith in me.

Prologue

> Sie ist ein Model und sie sieht gut aus
> Ich nähm' sie heut gerne mit zu mir nach Haus
> Sie wirkt so kühl, an sie kommt niemand ran
> Doch vor der Kamera da zeigt sie, was sie kann
> —Kraftwerk, *Das Model*, 1978

The black and white photograph [Fig. 1] appeared in a fashion spread for the March, 1978 issue of French *Vogue*.

"Upstairs at Maxim's," shot by Helmut Newton in the famous Parisian restaurant, depicts a scene of hand-kissing that takes place in a richly-furnished interior – Belle Époque-style mirror, chair, and lighting fixture. An elegant gentleman, wearing a pinstriped suit over a white shirt, bends forward to kiss the extended hand of a stylish woman in a Chanel suit and hat. She casts her gaze down on the man, who places an ardent kiss on her wrist. The image is structured by symmetries: the chair in the background echoes the oval-shaped mirror on the wall; the man and woman's hands align symmetrically; her upright body intersects with his stooping form, her extended arm with his bent elbow; the dark of her hat is counterpart to his sleek hair; her lowered gaze pairs with his closed eyes.

With a nod to film-noir aesthetics (contrast lighting, models dressed in black) Newton's photograph establishes an atmosphere of mystery and secrecy, into which the onlooker has intruded. Positioned as voyeur, we witness a courting scene of a particular kind: a first glance suggests a courtly tableau of male adoration, the man submissive before the woman, object of his desire. But a close reading reveals something else entirely: a scene of male fetishism. Indeed, as we look closer, we see that the ardent lover is worshiping the severed hand of a store dummy. "Upstairs at Maxim's" captures the complexity and peculiarity of the relationship between a man and a human-like artifact. The scene of

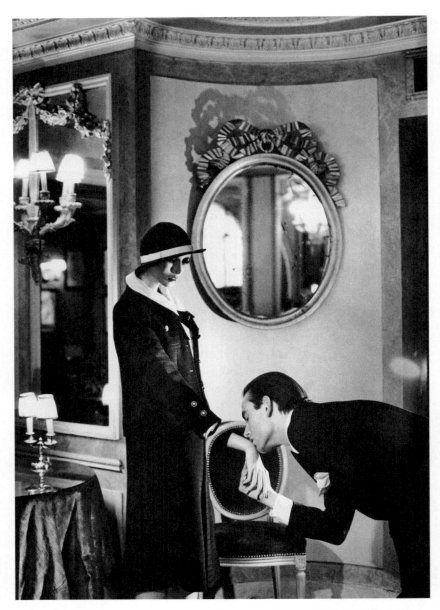

Fig. 1. Helmut Newton, *Upstairs at Maxim's*, 1978. © 2022 HELMUT NEWTON FOUNDATION. All rights reserved.

a man and a female mannequin is as much about violence, fetishism, and kink as it is about desire, love, and worship. Did he ask for her hand ... and she literally gave it to him? Did he get carried away and take it by force? Did she give him a hand with which to satisfy his autoerotic desires, and then, as a token of gratitude, he kisses it before returning it to her?

Remembering this fashion shoot for French *Vogue*, Newton, whose fascination with store dummies had started a decade earlier, writes in his autobiography: "it's fascinating to play with these mannequins. [...] Part of the fun for me is to make them look as real as possible."[1] Indeed, he manages to trick the viewer into mistaking the mannequin for a real woman, and thus lures us into a romantic, hetero-normative viewpoint.

But Newton's mischief does not end there: he places a trompe l'oeil at the center of the image. Looking more carefully, we see that the hand the man is kissing seems to have pierced the back of the chair. (In reality, he holds and kisses the dummy's severed hand, which aligns with the arm on the other side of the chairback.) This piercing hand is what Roland Barthes calls "the punctum," a detail that punctures the photograph's general visual field, known as "the stadium."[2] Channeling Surrealist photography, Newton's dummy and its piercing hand disturb the viewer, disrupting our visual perception while highlighting the act of representation: what we see in the photograph is both real (a man kissing the piercing hand of a woman at Maxim's) and not real (the woman is not human and her hand is not doing what we thought at first glance it was).

Newton's image captures an encounter with the uncanny – an experience of something strangely familiar and completely foreign at the same time. The reflection of the lights in the mirror, the shadows surrounding and enlarging the mirror and chair, create an environment both oneiric and eerie. The reason for this private meeting is mysterious, and the action is strange: the hand-kissing gesture seems anachronistic, while the piercing hand is unsettling. The woman is upright, rigid, and distant, while the man is ardent and intense. The man is having his own uncanny experience, while we, as viewers, are having ours. Eyes shut, lips pressed to the dummy's wrist, nose close to the skin of her forearm, hand locked into hers, fingers caressing her palm, the suitor surrenders to a mysterious ecstasy, provoked by the synesthetic experience of a detached hand. The viewer is immersed in a different strangeness: we follow her dainty hand through the back of the chair, and realize the mistake of our initial perception. Thus, we fully engage in the encounter with an "uncanny creature."

1. Helmut Newton, *Autobiography* (London: Duckworth, 2003), 246.
2. See Roland Barthes, *Camera Lucida: Reflections on Photography*, trans. Richard Howard (New York: Hill & Wang, 1981)

In his 1905 article "On the Psychology of the Uncanny" ("Zur Psychologie des Unheimlichen") German psychiatrist Ernst Jentsch made one of the first attempts to define the term. Jentsch describes a feeling of disorientation and uncertainty, arising from the "doubt as to whether an apparently living being really is animate, and conversely, doubt as to whether a lifeless object may not in fact be animate." He singles out wax figures and life-size automatons as uncanny-inducing figures. "In storytelling," he observes, "one of the most reliable devices for producing uncanny effects easily is to leave the reader in uncertainty as to whether he has a human person or rather an automaton before him in the case of a particular character."[3] We can see Jentsch's definition illustrated in "Upstairs at Maxim's" and we do feel uncertainty, disorientation, and confusion as to which model is animate or inanimate: paradoxically, the dummy's face seems more expressive than the man's. Imagination and fantasy both play a role: the scene between mannequin and man is highly eroticized and, within it, we see that the man has closed his eyes to further indulge his imagination. Newton is telling one uncanny story within another: What uncanny experience is the man having, and what uncanny scene have we, the viewer, stumbled into?

A decade later, in 1919, Austrian neurologist Sigmund Freud rejected Jentsch's theory of intellectual uncertainty as the source of feeling in his essay "The Uncanny" ("Das Unheimliche").[4] Freud disregards wax figures and automatons as the site of uncanniness, arguing instead that the uncanny is a subconscious manifestation of something repressed that has returned. He attributes the phenomenon to the castration complex. Freud's psychoanalytic interpretation may do more to elucidate the man's behavior in "Upstairs at Maxim's." Read as a symbol of castration, his veneration of the mannequin's severed hand is the enactment of phallic worship and fetishistic adoration. The man's desiring lips are pressed to the dummy's phallic hand, and he has bowed obsequiously before this erectly standing woman with her arm jutting out from her body. This is an uncanny image in the Freudian sense: the severed female hand becomes the repressed fear of castration, one tempered with male desire. The viewer is invited to see the hand as alternately penetrating or severed, thus enacting the same theory of denial Freud develops in his 1927 essay on Fetishism.[5]

3. Ernst Jentsch, "On the Psychology of the Uncanny" (1906), trans. Roy Sellars, *Angelaki* 2, no. 1 (1995): 7–16.

4. Sigmund Freud, "The Uncanny" (1919), in James Strachey, ed., *The Standard Edition of the Complete Psychological Works of Sigmund Freud*, vol. XVII (1917–1919): *An Infantile Neurosis and Other Works*, 217–256.

5. Sigmund Freud, "Fetishism," in *Miscellaneous Papers, 1888–1938*, vol. 5 of *Collected Papers* (London: Hogarth and Institute of Psycho-Analysis, 1924–1950), 198-204.

While Freud's and Jentsch's definitions can both be applied to Newton's uncanny scene, I believe that each falls short of explaining the experience the photographer evokes. Jentsch and Freud explore the uncanny entirely through fear and anxiety, drawing on their reading of E.T.A. Hoffmann's horror stories. But perhaps these are not the only emotions to arise when we encounter a three-dimensional, human-like and life-sized object of desire. A quick glance at the bliss and ecstasy on the male model's face (not to mention the viewer's titillation) suggests another dimension to the uncanny, one characterized by desire, eroticism, playfulness, and irony.

Closing his eyes as he takes the dummy's hand, the man in the image submits himself to "doll thinking": he has surrendered completely to his imagination and indulged in the aesthetic experience of the uncanny, i.e. in an experience of indeterminacy and undecidability. I coined the term doll thinking to describe this "in-between" experience provoked by the encounter with a doll-like object of desire. "Upstairs at Maxim's" shows us doll thinking from several angles: photographer, model, and viewer are all caught in the act of doll thinking. All three share the perception that the doll-like artifact possesses some life on its own. The passionate man kneels before the dummy, caresses it, and seeks its affection; Newton, life-long doll and dummy fanatic, stages the mannequin like a real woman; and the viewer descends into an indeterminate relationship with the female figure, and therefore with the scene itself.[6]

Doll thinking invites playfulness, and everyone involved in this scene plays along. Doll thinking describes a visual and mental process, activated by an encounter with a doll-like object that arouses desire and provides a sensorial experience of the in-between. Doll thinking as a concept relies on a paradox: it pairs "thinking," an abstract, mental human activity with "doll," a non-human, man-made object. Doll thinking triggers the viewer to think poetically and as a result inspires the latter to write, design, and perform creatively. Doll thinking does not involve thinking like a doll, or as a doll, but rather *with* the doll, and thus dissolving divisions between subject and object. Because doll thinking is not rational, and therefore cannot be grasped in binary oppositions, it undoes boundary and hierarchy, and unknows categories of thought. "Upstairs at Maxim's," which stages the photographer's own doll-thinking fantasies, invites the viewer to doll think along, to fantasize, and abandon boundaries

6. Newton confesses in his autobiography that his fascination with store dummies and dolls dates back to 1968, when English *Vogue* published his first series of photos with dummies. See Helmut Newton, *Autobiography*, 222.

between human/doll, animate/inanimate, active/passive, male/female, and real/unreal/not real. As a phenomenological concept drawing on a familiarity with the uncanny, doll thinking creates a new type of relationship to human-like objects of desire, one shaped by ambivalence and undecidability. As a new methodological concept, doll thinking is positioned to question the canon and challenge norms, by uncovering the uncanniness of the human attraction to doll-like artifacts and by queering the very nature of human desire.

Despite their interest in the uncanny, Freud and Jentsch demonstrate a complete inability to doll think. As heirs to positivism, both are unable (and unwilling) to articulate any theory that does not answer to scientific rationality. Reading their respective theories on the uncanny – one drawing on intellectual uncertainty, the other on the return of the repressed – one cannot help but sense a lingering anxiety: the object of their study seems to resist their scientific explanations. Jentsch and Freud could not allow their respective imagination to guide them; they could not submit to uncertainty either in order to grasp the uncanny. Instead, Jentsch's concept of "intellectual uncertainty" conveys the limits of positivist thinking, and his own debilitating attachment to the binaries. Freud's theory shows his own struggles to reconcile rational thinking (dolls are inanimate objects) with animistic thinking (dolls have a soul). He recognized, however, that animistic and magical thinking had been suppressed since the Enlightenment, and that the human imagination had suffered as a result.[7] It would take the artists of the nineteenth- and twentieth-century avant-garde (Romanticism, Symbolism, Expressionism, and Surrealism), to reclaim and rehabilitate that fertile indeterminacy and undecidability in which the doll lies, and draw inspiration from it.

We can trace Jentsch's and Freud's misunderstanding of doll-like artifacts and the uncanny to the theoretical discourse on eighteenth-century automatons, which began in admiration and evolved (by way of the Industrial Revolution) into suspicion and fear. Eighteenth-century-Europe was fascinated by automatons, many of them built by mechanics, cabinetmakers, and clockmakers for experiments or to fulfill courtly commissions.[8] French inventor Jacques de Vaucanson (1709–1782) presented three automata to the Académie des

7. See Spyros Papapetros, "Movements of the Soul: Traversing Animism, Fetishism, and the Uncanny," *Discourse* 34, no. 2–3 (Spring/Fall 2012): 185–208.

8. For an in-depth analysis of eighteenth-century musical automatons, see Adelheid Voskuhl, *Androids in the Enlightenment: Mechanics, Artisans, and Cultures of the Self* (Chicago: University of Chicago Press, 2013), and Kara Reilly, *Automata and Mimesis on the Stage of Theatre History* (New York: Palgrave Macmillan, 2011).

Sciences in Paris in 1738: a flute player, a galoubet (tabor pipe) player, and a duck, all three displaying a high level of craftsmanship, virtuosity, and sophistication. Vaucanson's mechanical duck, which could ingest food, digest it, and defecate, became one of the most famous and popular automatons of its time. In 1774, Swiss watchmaker Pierre Jacquet-Droz (1721–1790) and his son Henri Louis Jacquet-Droz (1752–1791) introduced a child-like "Writer" and "Draughtsman," and the young female "Musician," the latter of which played the harpsichord by moving its arms and pressing the keys with its fingers.[9] A decade later, German cabinetmaker David Roentgen (1743–1807), in collaboration with German clockmaker Peter Kinzing (1745–1816), presented French queen Marie-Antoinette with a delicate, smaller-scale musical automaton, "The Dulcimer Player" which graciously moved its arms, eyes and head.[10] These were by far the most acclaimed, admired, and discussed artifacts of the eighteenth century, but they had serious competition. German mechanic Friedrich von Knaus (1724–1789) constructed the "All-writing Miraculous Machine," a small-scale automaton holding a quilt and composing letters, which he presented to the Austrian empress Maria Theresa in Vienna in 1760.[11] Hungarian inventor Wolfgang von Kempelen (1734–1804), the inventor of four speaking machines, became famous in 1770 for building a chess-playing hoax, known as the "Mechanical Turk," which inspired E.T.A. Hoffmann's short story *Automata* (1814) and Edgar Allan Poe's essay "Maelzel's Chess Player" (1836). In 1810, German musical instrument maker Johann Gottfried Kaufmann (1751–1818) and his son Johann Friedrich Kaufmann (1785–1865) built "The Trumpeter," an android musical automaton with an artificial larynx and a tongue, which could play tunes.[12]

9. The three Jacquet-Droz automatons are still in excellent working condition and can be seen at the *Musée d'Art et d'Histoire* in Neuchâtel, Switzerland: https://collections.mahn.ch/fr/search-notice/detail/aa-2-automate-l-ae932; https://collections.mahn.ch/fr/search-notice/detail/aa-3-automate-l-5065b; https://collections.mahn.ch/fr/search-notice/detail/aa-1-automate-l-bcbd2.

10. The dulcimer player is on display at the Musée des arts et métiers in Paris, France: https://www.arts-et-metiers.net/musee/automate-joueuse-de-tympanon.

11. The "All-writing Miraculous Writing Machine" is on view at the Technisches Museum in Vienna, Austria: https://www.technischesmuseum.at/object/all-writing-miraculous-machine.

12. The trumpeter by Friedrich Kaufmann, which is no longer functional, is kept under inventory at the Deutsches Museum in Munich, Germany: http://www.deutsches-museum.de/sammlungen/meisterwerke/meisterwerke-ii/trompeter/?sword_list[]=kaufmann&no_cache=1.

Whether these unique, labor-intensive pieces of craftsmanship fulfilled an epistemic or cultural function is still up for debate among scholars. Jessica Riskin argues that Vaucanson's "Duck" and "Flute Player" imitated animal and human anatomy in order to provide knowledge about physiology. Adelheid Voskuhl posits that Roentgen's "Dulcimer Player" and Jacquet-Droz's "Musician" merely replicated cultural and gendered body practices.[13] Most of these eighteenth-century automatons were animated by clockwork hidden inside their bodies, which, in a sense, enabled them to act of their own volition. This idea underlies the mechanistic philosophy of René Descartes (1596–1650) and his successor Julien Offroy de la Mettrie (1709–1751). Descartes, rejecting Aristotelian finalism and purposiveness, asserted that man is a machine and can only be understood as such. The French philosopher had already put forward the hypothesis of a "beast-machine," in the *Discourse on the Method* (1637), arguing that beasts were machines, and that all of their faculties could be explained mechanically.[14] The difference between animals and men, he said, is that humans have a soul and the capacity for reasoned thought. His posthumous *Treatise on Man* (around 1630) formally compares a human being with a humanoid automaton, and concludes that human bodies are essentially machines, albeit of divine origin.[15] In *Man a Machine* (1747), French atheist thinker Julien Offroy de La Mettrie broadened Descartes' beast-machine premise to include human beings, thus presenting an entirely materialist and mechanistic view of humanity.[16] Until the rise of the Industrial Revolution, eighteenth-century culture held a mechanistic view of nature according to which God is the greatest clockmaker of a clockwork universe. Thus, nature and machine were not construed as rivals but as imitations of one another; the androids displayed in the public gardens represented the harmonious interplay between nature and machine. The industrialization process occurring in Europe brought a swift end to this harmony. By the early nineteenth century, nature and machines were viewed as opposite and antagonistic. With that change, android automatons appeared in a new light: no longer symbols of human knowledge

13. See Adelheid Voskuhl, *Androids in the Enlightenment* (2013) and Jessica Riskin, "The Defecating Duck or The Ambiguous Origins of Artificial Life," *Critical Inquiry* 29, no. 4 (2003): 559–633.

14. René Descartes, *Discourse on the Method and Meditations on First Philosophy*, edited by David Weissman (New Haven: Yale University Press, 1996).

15. See David Bates, "Cartesian Robotics," *Representations* 124, no. 1 (Fall 2013): 43–68.

16. Julien Offroy de La Mettrie, *Machine Man and Other Writings*, edited by Ann Thompson (New York: Cambridge University Press, 1996).

and ingenuity or mediators of the human–machine boundary, they were now seen as forerunners of mechanized industrialization, objects of fear and mistrust. This brings us to Jentsch and Freud, addressing uncanniness solely from a position of fear and anxiety.

Doll thinking breaks with Jentsch and Freud, engaging with the uncanny from a position of desire. As an aptitude that does not rely on reason and understanding, but rather on imagination and fantasy, it also breaks with eighteenth-century mechanistic philosophy – and with the idea of man as machine in particular. In that regard, E.T.A. Hoffmann's *The Sandman* represents a turning point: the tale subverts the motif of the musical automaton from the Enlightenment discourse. Hoffman's automated doll, Olimpia, takes its driving force not from the clockwork mechanism hidden inside but from the power of her suitor's imagination. The doll-maker's glass- and clock-making skills may animate Olimpia, but Nathanael's doll thinking brings the wooden automaton to life to the extent that the reader ultimately wonders whether it is not alive after all. Because *The Sandman* articulates and redefines the nexus between doll making and thinking – because Nathanael's fantasy gives Olimpia life, doll thinking thereby becomes doll making – I regard E.T.A. Hoffmann's tale as an Urtext, for it sets an early example of the demiurgic power of doll thinking. Besides, the story of Nathanael and Olimpia inspired Hans Bellmer, the most famous German-speaking doll-maker of the twentieth century, who was also influenced by Oskar Kokoschka's and Lotte Pritzel's dolls. For this reason, I chose *The Sandman* over Pygmalion's myth in Ovid's *Metamorphoses* (8 AD) as my point of departure. Even though, at the beginning of Ovid's story, the narrator describes Pygmalion's doll thinking, the divine intervention of Venus puts an end to his fantasy, by bringing his beguiled ivory statue to life, and fulfilling his wish for a pure and virtuous wife.[17] Although Ovid's poem does not further engage with the doll-thinker/maker Pygmalion's experience of indeterminacy and undecidability with a non-human artifact he desires, it nevertheless brings materiality into the equation. By drawing our attention to the ivory, Ovid links materiality to doll thinking/making: it is because the statue is made of ivory that Pygmalion is able to doll think every time he sees and touches its smooth and creamy texture, reminiscent of human skin. For materiality serves

17. "Pygmalion/ Marvels and loves the body he has fashioned./ He would often move his hands to test and touch it/ Could this be flesh, or was it ivory only?/ No, it could not be ivory. His kisses/ He fancies, she returns; he speaks to her/ Holds her, believes his fingers almost leave/ An imprint on her limbs, and fears to bruise her." Ovid, *Metamorphoses*, trans. Rolfe Humphries (Bloomington: Indiana University Press, 1961), 241–43.

as a conduit for doll thinking. The doll-making materials chosen by the artists in this book (wood for Hoffmann, plush for Kokoschka, wax for Pritzel, papier mâché for Bellmer, plastic for Newton) reveal their intentions and aspirations as doll thinkers. They also enforce a certain type of engagement and "scripted behavior" on the part of the maker and the viewer. The material composition of a doll scripts behavior, that is issues a set of prompts, argues Robin Bernstein in her book *Racial Innocence*. Bernstein regards a doll as "a scriptive thing, an item of material culture that prompts meaningful bodily behaviors."[18] In the works I will discuss, the material composition not only informs but also scripts the doll-thinking process, and this duality operates on the viewer as much as the maker. In "Upstairs at Maxim's," for instance, the mannequin's plasticity makes the whole sensorial and aesthetic experience of doll thinking possible. The dummy's stiffness and rigidity, the smoothness of its face and the soft feel of its hand, its graceful woman-like appearance—all these elements conspire to initiate the choreography of the male model. He in turn happily executes his suitor role, which in turn elicits confusion, titillation, and discomfort in the viewer.

Uncannily enough, elements of Newton's photograph trace back to the texts, images, and artifacts I investigate in "Uncanny Creatures: Doll Thinking in Modern German Culture." The hand-kissing motif conjures Hoffmann's *The Sandman*, in which a similar scene of courtship occurs between the protagonist and a wooden doll; the worshiping of a woman-like artifact recalls Kokoschka's fetishistic fantasy during the making of his Alma doll; and the scene of elegant courtship between a female mannequin and a stiff-looking male evokes the postures and choreography of Lotte Pritzel's early wax dolls. The dummy's hand piercing the chair brings to mind the concept of amalgamation derived from the essay "Notes on the Ball Joint," which Hans Bellmer wrote to accompany his ball-jointed doll. As a Berlin-born Jew who came of age during the Weimar Republic and worked for the renowned female photographer Yva (Else Ernestine Neuländer-Simon), Newton, whose photographs were largely indebted to the aesthetics of Weimar culture, was likely familiar with all of the artists mentioned above and their respective work.[19]

All four stories of doll thinking and doll making contain a historical and a political dimension. A closer look at the date of creation reveals that Hoffmann,

18. Robin Bernstein, *Racial Innocence: Performing American Childhood from Slavery to Civil Rights* (New York: New York University Press, 2011), 71.

19. On the topic of the influence of Weimar culture on Helmut Newton's photography, see Gero von Boehm (dir.), *Helmut Newton: The Bad and the Beautiful*, Kino Lorber, 2020.

Kokoschka, Pritzel, and Bellmer would all have been jarred and influenced by war. The impulse to doll think in the presence of uncanny artifacts comes to each of them at a time of major political crisis, societal upheaval, and economic collapse. Hoffmann published his tale, *Der Sandmann* (1817), two years after the Congress of Vienna put an end to the Napoleonic Wars and restored monarchy in Europe. In 1918, shortly after the end of World War I, Oskar Kokoschka requested a life-size doll replica of his former lover Alma Mahler. Lotte Pritzel, who had started making dolls before the interwar period, really came into her own during the Weimar Republic (1918–1933), a time marked by political and economic instability. And Hans Bellmer started constructing his disjointed dolls after Hitler seized power in Germany, in 1933, as a protest against National Socialist ideology.

While acknowledging that war and political instability inevitably shaped each of these creators, I will not be examining their work primarily through the lens of trauma studies or Marx's materialist theory. Instead, "Uncanny Creatures" pursues a "doll-thinking" approach, seeking out the unstable nexus between doll thinkers and makers. The constant flux of gendered roles (the doll thinker traditionally being male, and the maker female) and positions (male artist versus female craftsman) illustrates this experience of indeterminacy and undecidability, which is the sine qua non of doll thinking. But the lens of doll thinking proves useful for more than one purpose: by highlighting the instability in the doll thinker–maker dyad, this method of analysis will certainly seek to expose the fragility of binary categories. In addition, it will also explore the uncanniness of hetero-normative desire and fantasies, in which most doll projects are rooted. At last, a doll-thinking approach uncovers the unsettledness and versatility of the uncanny itself: the various doll artifacts by Hoffmann, Kokoschka, Moos, Pritzel, Bellmer, and Newton informs us that their uncanny power never resides where one would expect it. As it turns out, doll thinking fulfills an epistemic function as there is clearly something to be learned from doll thinking.

My first chapter, which focuses on the wooden doll Olimpia in E.T.A. Hoffman's *The Sandman*, uses doll thinking as a hermeneutic method. In considering Hoffmann's 1815 short story about a young student falling madly in love with a wooden automaton, my reading diverges significantly from prevailing interpretations: moving Nathanael's doll thinking to the foreground, I shift the focus from the Sandman to Olimpia, while distancing myself from Freud's version of the uncanny. The lens of doll thinking fulfills a twofold interpretive function: it queers Nathanael's hetero-normative desire for a wooden doll, and reveals that the identity of doll-makers and thinkers in the story is in constant flux.

My second chapter, which looks into *Oskar Kokoschka and the Fluffy Alma Doll*, uses doll thinking as an aesthetic approach. Singling out the primacy of touch in my close reading of Kokoschka's letters, I examine the creation of a life-size doll replica of Alma Mahler, which Kokoschka commissioned in 1918 from Hermine Moos, as well as the two doll paintings he made in its aftermath. I withdraw the usual pathologizing discourse from Kokoschka's doll-fetish episode, then proceed in two steps: first to show how the painter's eager doll thinking is disrupted by Moos' feminist intervention (she chooses a fluffy material for the doll's texture, thus annihilating the painter's fetishistic fantasies); and, second, to demonstrate how Kokoschka's position shifts from doll thinker to maker, reclaiming the doll-thing and re-appropriating it as his own object in *Woman in Blue* (1919) and *Artist with Doll* (1922).

In *Lotte Pritzel's Wax Dolls*, I examine the famous female doll-maker's "Dolls for the Vitrine," which were showcased in the *Deutsche Kunst und Dekoration* periodical between 1910 and 1922, and I consider their enthusiastic reception in avant-garde circles. An underappreciated missing link between Kokoschka and Bellmer's doll projects, Pritzel crafted doll sculptures whose androgynous look, languid eroticism, and lively posture prompted doll thinking in her viewers. Looking at her miniature wax dolls under the lens of doll thinking explores the seductive force and uncanny power these sculptures had, ultimately inspiring many journal reviews, an essay by the Symbolist poet Rainer Maria Rilke, and solo pieces by Expressionist dancers Niddy Impekoven and Anita Berber, in which each performer became a doll.

In my last chapter, the lens of doll thinking reveals Hans Bellmer's papier mâché dolls as epistemological artworks. Focusing on the black and white doll photographs by the German Surrealist, along with related essays and sculptures, I examine the evolution of his doll thinking/making, while charting the transformations of his ball-jointed doll. I argue that, by painstakingly probing the doll's anatomy, disassembling and reconfiguring its body parts like the letters of an anagram, Bellmer's doll thinking pushed the limits of the human body, ultimately uncovering what he called the "physical unconscious."

The doll artifacts I examine in this book are uncanny creatures – often unsettling the boundaries between the human and technological and challenging various kinds of binary thinking – which certainly qualify as posthuman figures, even though, for the record, they were originally not designed or intended to be techno-human beings. And yet my book does not investigate dolls under a posthuman lens. My focus instead lies in the anthropocentric paradigm of knowledge from which these doll thinkers and makers in modern

German culture were working and, more specifically, the human-centric, Freudian discourse within which their dolls are deeply rooted.

Even though "Puppe," the German word for doll, is gendered feminine, I do not use the feminine pronouns (she/her) in this book when referring to the dolls I examine. I resist anthropomorphizing or assigning binary gender to the doll-like artifacts, opting instead for the neuter personal pronoun and possessive adjective (it, its). The dolls I consider here are androgynous and hermaphrodite creatures. Indeed, the term "Puppe" refers etymologically to the insect pupa, an insect in a state of transformation. The neuter seems more appropriate to capture this liminality. While my insistence on the neuter amounts to a distancing strategy, it is also meant to address a feminist critique of male doll fetishism, and underscore the fundamental difference between doll and woman: a doll-like artifact, even when modeled on an image of a woman, is ultimately a copy without an original.[20] I hope here to question the nature of representation and call attention to the complex relationship between image and reality, one deepened further by doll-makers' use of photography and championed by the Surrealists. The neuter also befits the concept of doll thinking, which undoes binaries by embracing ambiguity and resisting stabilization. "*It*" is also a reminder that a doll-like artifact is a polymorphous organism, one that cannot be assimilated: it oscillates between thing and object, breaks down the boundaries between human and non-human, and deconstructs categories of gender and sex.[21]

20. See Eunjung Kim "Why Do Dolls Die? The Power of Passivity and the Embodied Interplay Between Disability and Sex Dolls," *Review of Education, Pedagogy, and Cultural Studies* 34, nos 3–4 (July 2012): 94–106.

21. See Gerburg Treusch-Dieter, "Das Rätsel der Puppe," in Christine Lammer, ed., *Die Puppe, Eine Anatomie des Blicks* (Vienna: Verlag Turia + Kant, 1999), 9–10.

CHAPTER 1

Doll Thinking: A Hermeneutic Method

The Wooden Doll Olimpia in E.T.A. Hoffman's "The Sandman" (1816)

> I go mental every time you leave for work
> You never seem to know when to stop
> I never know when you'll return
> I'm in love with a robot
> —Röyksopp, *The Girl and the Robot*, 2009

Ernst Theodor Amadeus Hoffmann's short story "The Sandman" (*Der Sandmann*), written in 1815 and published in 1816 in the first of the two volumes of *Night pieces* (*Nachtstücke*), is both the point of departure of my exploration of "Doll thinkers in Modern German Culture" and the primary source of inspiration for German-speaking visual artists such as Oskar Kokoschka, Lotte Pritzel, and Hans Bellmer. Although the ominous figure of the Sandman drives the plot from the beginning to the end and his mysterious identity may well be an origin of uncanniness in the text, I nevertheless decided to shift the focus from this character to the story of a young student falling madly in love with a wooden doll. For this romance gives one of the most disturbing accounts of "doll thinking," which I define as follows: it is a concept I coined in order to describe a visual and mental process, activated by an encounter with a doll-like object that arouses desire, ignites fantasy, and provides a sensorial experience of the in-between. For it is only through the lens of doll thinking that one can uncover Hoffman's scheme and expose the main protagonist as a queer doll lover, the reader as a doll thinker, and the narrator as a doll-maker.

The Sandman: Story and Reception

A complex tale narrated in the form of two imbricated stories, it begins with a complicated exchange between Nathanael, Lothair, and Clara. Each of these characters in their own way seeks to come to terms with the Sandman, a folktale creature notorious for stealing children's eyes. The university student Nathanael had feared the Sandman greatly as a child, and confused him in his young mind with the fearsome advocate Coppelius, who occasionally conducted alchemical experiments with his father, and whom Nathanael years later still held responsible for an explosion that cost his father his life. The second story deals with the beautiful Olimpia, a wooden automaton, that the physics professor Spalanzani presented as his daughter unbeknown to the university town residents. Nathanael, after spying on Olimpia with a pocket spyglass he had purchased from Coppola, an Italian glass peddler who resembled Coppelius, fell madly in love with her, turning away from his fiancée Clara. Once he found out that Olimpia was a mere mechanical doll constructed by Spalanzani and Coppola, he suffered a severe breakdown. Reunited with his former betrothed Clara, Nathanael was seized by a bout of madness: after a failed attempt to harm and kill Clara, he killed himself by jumping from a tower parapet. With the reappearance of the advocate Coppelius at the very end, who functions as the unifying character, both narratives come together.

Despite the critical acclaim Hoffmann earned with the first two volumes of his *Fantasy Pieces in Callot's Manner* (*Fantasiestücke in Callots Manier*) (1814), which made him a celebrity during his lifetime in the German-speaking literary world, the critical reception of his writings after his death in 1822 shifted dramatically: his literary work was discredited as the expression of a lunatic, or an alcoholic's deranged mind. In his 1827 review of Hoffmann's tales, the Scottish novelist Walter Scott dismissed them on the medical grounds that "they are not the visions of a poetical mind; [...] they are the feverish dreams of a light-headed patient."[1] Soon Johann Wolfgang von Goethe himself, Germany's greatest man of letters, weighed in with a criticism of Hoffmann's writings, which he described as "the pathological

1. See Walter Scott, "On the Supernatural in Fictitious Composition, and in Particularly in the Works of E.T.A. Hoffmann," *Foreign Quarterly Review* 1 (1827): 60–98.

works of [an] ailing man."[2] Unlike their German counterparts, the French Romantics had a real appreciation for Hoffmann's tales, and a great fondness for the erratic style, misleading narrative, and the manifestations of the fantastic in his stories. Not only did French writers and critics recognize his literary talent, but they also admired his multifaceted genius as a writer, composer, and illustrator. The translation of Hoffmann's tales into French in 1830 marked the beginning of a Hoffmann vogue in France, which reached its peak with the staging of "The Sandman," first as a ballet, *Coppelia or The Girl with Enamel Eyes* (*Coppélia ou la fille aux yeux d'émail*) (1870) by choreographer Arthur Saint-Léon and composer Léo Delibes, and then as part of a fantastic opera, *Tales of Hoffmann* (*Les contes d'Hoffmann*) (1881), by composer Jacques Offenbach.[3] In their respective adaptations, Delibes and Offenbach focused exclusively on the love story between a young man and a doll and, in so doing, moved the animated doll center stage.

Ernst Jentsch, Sigmund Freud, and the Uncanny

If Offenbach's acclaimed opera *Tales of Hoffmann* served as proof of the enthusiastic reception of E.T.A. Hoffmann and of his popularity in late-nineteenth-century France, thus counterbalancing the harsh criticism of his writings in Germany and England at the time, it was the reading of "The Sandman" by Sigmund Freud in the early twentieth century that propelled Hoffmann's story to lasting fame. Not only did Freud's reading cast a new light on the text, but it also rehabilitated its author's reputation in the German-speaking world and beyond. Thus, a century later, it is nearly impossible to speak about "The Sandman" without addressing Freud's seminal essay "The Uncanny" ("Das Unheimliche") (1919).[4] While Freud has often been taken to task for over-simplifying and stabilizing Hoffmann's complex narrative in

2. For a detailed analysis of the history of E.T.A. Hoffmann's reception in Germany, see Claudia Lieb, "Krank geschrieben: Wie Ärzte und Poeten Hoffmanns Bild vom pathologischen Künstler prägten," *Staatbibliothek Berlin*: https://etahoffmann.staatsbibliothek-berlin.de/erforschen/rezeption/rezeption-laender/deutschland/.

3. See Stéphane Lelièvre, "Présence d'E.T.A. Hoffmann sur les scènes lyriques francaises," in Agnès Terrier and Alexandre Dratwicki, eds., *Le surnaturel sur la scène lyrique: du merveilleux baroque au fantastique romantique* (Lyon: Synergie, 2012), 49–63.

4. Sigmund Freud, "The Uncanny," in James Strachey, ed., *The Standard Edition of the Complete Psychological Works of Sigmund Freud*, vol. XVII (1917–1919), (London: Hogarth Press, 1952), 217–256.

the interest of illustrating his own theory of neurosis, his misreading of the text has proven very valuable for my analysis of doll thinking and making in E.T.A. Hoffmann's story. From the start, Freud dismisses the work of his predecessor, the German psychiatrist Ernst Jentsch who, in his 1906 article "On the Psychology of the Uncanny" ("Zur Psychologie des Unheimlichen"), attempts to grasp the uncanny.[5] Freud has other issues with Jentsch: not only does he reject his theory of intellectual uncertainty as the source of uncanny feelings but he also takes issue with the view that the automaton is the sole site of uncanniness. Offering an alternative reading, Freud attributes the uncanny primarily to the castration complex linked to the figure of the Sandman. In his attempt to explain the uncanniness of Hoffmann's tale, he favors Coppelius/the Sandman over the doll Olimpia, opting for an analytic interpretation over concerns about intellectual uncertainty.[6] Ignoring the automaton Olimpia as the origin of uncanniness while relegating the doll to a lengthy footnote in his essay, Freud clearly refuses to engage in doll thinking. However, the feeling of uncertainty described by Jentsch is that which the reader of "The Sandman" and the viewer of *Coppélia* and *Tales of Hoffmann* definitely experience. Reading about Olimpia, watching her dance, or listening to her sing on stage equates to sharing Nathanael's vision and partaking in his doll thinking.[7]

E.T.A. Hoffmann's Interest in Doll Making

Doll making was from the start present in Hoffmann's mind and clearly had a significant impact on the genesis of "The Sandman." "Hoffmann recorded in his diary under the date of October 2, 1802," notes his biographer Harvey Hewett-Thayer, "that he spent the whole evening foolishly enough in reading Wiegleb [a German chemist] and determined sometime to try his hand at the construction of an automaton." From that entry he infers that it seems plausible "that Hoffmann examined automatons whenever opportunity offered."[8]

5. Ernst Jentsch, "On the Psychology of the Uncanny," Roy Sellars, trans., *Angelaki* 2, no. 1 (1955): 7–16.

6. See Hélène Cixous, "Fiction and Its Phantoms: A Reading of Freud's *Das Unheimliche* (The 'Uncanny')," *New Literary History* 7, no. 3 (Spring, 1976): 525–548.

7. The two most recent examples of stage adaptations are: Bob Wilson's opera *Der Sandmann*, which premiered in Düsseldorf, Germany, in 2017 and Andreas Heise's ballet *Der Sandmann*, which premiered in Graz, Austria, in 2019.

8. Harvey Hewett-Thayer, *Hoffmann: Author of the Tales* (Princeton: Princeton University Press, 1984), 167.

The purely mechanical aspect of their construction, the artful deceptiveness of their accomplishments fascinated him."[9] Based on his diary and letters, Scholar Claudia Lieb has discovered that Hoffmann attended a performance of musical automatons in Gdansk, Poland in 1801.[10] Hoffmann was very familiar with Wolfgang von Kempelen's *Chess-playing Turk* (1769), around which his short story *The Automata* (*Die Automate*) (1814) revolves, as well as with Johann Gottfried Kaufmann's *Trumpeter* (1810) and Henri-Louis and Pierre Jaquet-Droz's *Musician* (1768–1774), both musical automatons inspiring the character of Olimpia in "The Sandman."[11]

Climbing Step by Step up the Ladder of Doll Thinking

Far from being solely a tale about madness rooted in childhood trauma, "The Sandman" is actually a story about doll thinking that takes possession of various characters from the moment they come into contact with the doll Olimpia. One of them, the physics student Nathanael, turns out to be a perfect example of doll thinking.

In his second letter to his foster brother Lothair, which puts an end to his correspondence with him and his sister Clara before the narrator's voice takes over, Nathanael depicted his university professor, Professor Spalanzani, a physicist of Italian origin, and an encounter with his daughter Olimpia.[12] To Lothair he wrote that lately on his way to Spalanzani's evening lecture he had spied through a curtained door and caught sight of a "female, tall, very slender, but of perfect proportions, and splendidly dressed, sitting at a table."

9. Hewett-Thayer, *Hoffmann*, 178.

10. Claudia Lieb, "Der Sandmann," in Detlef Kremer, ed., *E.T.A. Hoffmann: Leben-Werk-Wirkung* (Berlin: De Gruyter, 2010), 181.

11. See Adelheid Voskuhl, *Androids in the Enlightenment: Mechanics, Artisans, and Cultures of the Self* (Chicago: University of Chicago Press, 2013). Although the chess-playing Turk was destroyed in a fire at the Philadelphia Museum of Arts in 1854, a replica was rebuilt in 1989 by manufacturer of magic, John Gaughan. Henri-Louis and Pierre Jaquet-Droz's automata, *The Musician, The Draughtsman,* and *The Writer,* are still on display at the Musée d'Art et d'Histoire de Neuchâtel, Switzerland.

12. E.T.A. Hoffmann, "The Sandman," in E.F. Bleiler, ed., *The Best Tales of Hoffmann* (New York: Dover Publications, 1967), 194; Nathanael writes to Lothair, "You cannot get a better picture of him than by turning over one of the Berlin pocket almanacs and looking at Cagliostro's portrait by Chodowiecki: Spalanzani looks just like him." Hoffmann, "The Sandman," 194.

A Hermeneutic Method 19

He described "her angelically beautiful face," noticing "a strangely fixed look about her eyes [...] as if they had no power of vision."[13] He later found out about the identity of the mysterious female, "whom [Spalanzani] keeps locked up in a most wicked and unaccountable way."[14] This short description not only underscores the imbalance of vision between the two protagonists, but indicates that Olimpia's beauty and blindness have piqued Nathanael's curiosity and interest. Why would he mention his encounter with her in his letter to his friend and confidant Lothair, if not to express the fact that his thoughts already turn around her?[15] Interestingly, the brief and serendipitous visual encounter with Olimpia is not only repeated but also heightened in the last part of the narrative, which fittingly revolves around Nathanael's passionate love for Olimpia.

Carrying on his story, the narrator relates that a fire, which had laid waste to the house in the town G. where Nathanael was renting a room, forced him to relocate. Because his new house was situated right across from Professor Spalanzani's, Nathanael could look out of his window and "see straight into the room where Olimpia often sat alone. Her figure he [could] plainly distinguish, although her features [were] uncertain and confused."[16] Because Olimpia's distant image had hitherto remained opaque and blurry to his eyes, the arrival of the glass peddler Coppola could not be timelier as he sold him a "small, very beautifully cut pocket perspective," which dramatically enhanced and sharpened his sight of Olimpia.[17] If Nathanael's vision of Spalanzani's daughter had hitherto been blurred and his visual desire frustrated, with the help of the pocket perspective purchased from Coppola he could now get an eyeful of Olimpia. He was immediately entranced by "the regular and exquisite beauty of her features" and transfixed by the tableau vivant of Olimpia sitting at a little table with her hands folded, as the narrator observes: "Nathanael remained standing at the window as if glued to the spot by a wizard's spell, his gaze riveted unchangeably upon the divinely beautiful Olimpia."[18] After repeatedly spying on her with his pocket perspective, Nathanael was under the impression that Olimpia's eyes started to lose their "singular look of fixity and lifelessness" and that "their power of vision was now being enkindled;

13. E.T.A. Hoffmann, "The Sandman," 194.
14. E.T.A. Hoffmann, "The Sandman," 194.
15. In the last paragraph of his letter to Lothair, Nathanael asks himself, "But why am I telling you all this? I could tell you it all better and in more detail when I see you." E.T.A. Hoffmann, "The Sandman," 194.
16. E.T.A. Hoffmann, "The Sandman," 202.
17. E.T.A. Hoffmann, "The Sandman," 203.
18. E.T.A. Hoffmann, "The Sandman," 203.

their glances shone with ever-increasing vivacity."[19] Interestingly, the more he watched her with the spyglass, the more he thought about her, to the point where her image followed him everywhere, as the narrator describes not without irony: "Olimpia's image hovered about his path in the air and stepped forth out of the bushes, and peeped up at him with large and lustrous eyes from the bright surface of the brook."[20] This obsessive image also caused thoughts of his fiancée Clara to "completely fade from his mind; he had no thoughts except for Olimpia."[21] Until Coppola's irruption, Clara continued to be "mistress of his heart" and for that reason "he remained perfectly unaffected by Olimpia's stiffness and apathy," observes the narrator. He was actually in the midst of writing to her when the glass peddler burst into his room, putting an end to his letter. Throughout his interaction with Coppola, whom Nathanael initially (mis)took for the terrifying advocate Coppelius of his childhood, the thought of his betrothed had a soothing effect on him.[22] However, after the purchase of the pocket perspective from Coppola, which Nathanael used increasingly to spy on his beautiful neighbor, Clara was immediately relegated to the background. "Urged by an irresistible impulse," describes the narrator, "he jumped up and seized Coppola's perspective; nor could he tear himself away from the fascinating Olimpia until his friend Siegmund called for him to go to Professor Spalanzani's lecture."[23]

It is no coincidence that Nathanael's fascination with Olimpia reaches its climax in the concert scene at Professor Spalanzani's. The physics professor decided to throw a party to introduce his daughter to high society and to have her perform music in front of them. The party merely serves as the stage for a threefold performance: Olimpia played the piano, sang, and danced with the sole purpose of this entertainment being to demonstrate virtuosity and performance of humanness. Olimpia's concert is indeed a pivotal scene in the story. Whereas Nathanael's perception of his beautiful neighbor had hitherto been restricted to the visual – a visuality mediated by Coppola's spyglass – it became at once directly acoustic, haptic, and interpersonal. From the last row he watched her closely with the help of his pocket perspective, listening to her play the piano and sing an aria di bravura. He then danced with her during the ball and even exchanged a few words with her afterwards. This synesthetic

19. E.T.A. Hoffmann, "The Sandman," 203.
20. E.T.A. Hoffmann, "The Sandman," 204.
21. E.T.A. Hoffmann, "The Sandman," 204.
22. E.T.A. Hoffmann, "The Sandman," 203.
23. E.T.A. Hoffmann, "The Sandman," 204.

A Hermeneutic Method 21

experience of Olimpia ignited Nathanael's passion and emboldened him to declare his love to her, as the narrator describes: "he sat beside Olimpia, her hand in his own and declared his love enthusiastically and passionately in words which neither of them understood, neither he nor Olimpia."[24] And yet, Nathanael's unintelligible thoughts and feelings seemed to resonate with Olimpia since she sighed and uttered: "Ah! Ah! And then, Good night, dear."[25] Although the narrator is obviously poking fun at Nathanael for his foolish act, I nevertheless take the main character's incomprehensible words seriously because I read them as an expression of doll thinking.

By the way, I shall briefly recall that it is not the first time that Nathanael had experienced something strange beyond his grasp: consider, for example, the death of his father in an explosion, the fire destroying his student lodging, the intrusion of an Italian glass peddler who resembled the villain Coppelius. In addition, let us also consider the dark poem he composed about Coppelius thwarting his love and happiness with Clara. After "he read it aloud to himself," as the narrator describes, "he was seized with horror and awful dread, and screamed: 'Whose hideous voice is this?'"[26] Nathanael's angst-ridden reaction indicates that he did not recognize his own lyrical voice, which suddenly seemed to be foreign and incomprehensible to him, before coming to his senses shortly after and quickly casting his doubts and fears aside. I, however, read this short scene of anxiety, incomprehensibility, uncertainty, and alienation as another occurrence of doll thinking. Nathanael's experience of not understanding his own words while declaring his love to Olimpia, coupled with his previous experience of not recognizing his own voice while writing a love poem for Clara, indicates that he is engaging in a different type of cognitive process, one in which the doll is no longer the object of thought and vision but a new and different way of thinking, i.e. doll thinking. This doll thinking is what grants him access to another reality. Such thinking about an alternative reality was already germinating in Hoffmann's mind until he fleshed out the idea of a bridge between lower and higher realities two years later in *The Serapion Brethren* (*Die Serapionsbrüder*) (1818), a compilation of stories framed around readings and conversations among friends. Here, speaking on behalf of the author (with whom he shares the same name, which is also the Greek version of Nathanael), the narrator Theodor elaborates the notion of a

24. E.T.A. Hoffmann, "The Sandman," 206.
25. E.T.A. Hoffmann, "The Sandman," 209.
26. E.T.A. Hoffmann, "The Sandman," 199.

passageway between these two worlds. Introducing the metaphor of a ladder to heaven, which the Romantic artist is eager to climb up into higher regions, he reflects:[27]

> What I think, and mean, is that the foot of the heavenly ladder, which we have got to mount in order to reach the higher regions, has to be fixed firmly in every-day life, so that everybody may be able to climb up it along with us. When people then find that they have climbed up higher and higher into a marvelous magical world, they will feel that that realm, too, belongs to their ordinary, every-day life, and is, merely, the wonderful and most glorious part thereof.[28]

This metaphor of a ladder to heaven may be read back onto "The Sandman," enabling us to see Nathanael as what he is, namely an artist who through doll thinking gains access to a higher reality. That is why, instead of interpreting Nathanael's falling for a wooden doll as the conduct of a lunatic – a pathological discourse endorsed at times by an ironical narrator, seconded by the vox populi of the town, and supported by a large body of post-Freudian scholarship – I take Nathanael's enamored vision of Olimpia seriously and offer an alternative reading.

Nathanael as doll thinker obtains access to supra-rational phenomena: he gains access to a different perspective on reality, one that the use of Coppola's spyglass both facilitates and symbolizes. With the help of this spyglass, he acquires the ability to close distances and get a bigger picture of the world. In this way, he is put in a position similar to that of the author/narrator of "The Sandman," a resemblance reinforced by the similarity of their names: Nathanael being the Hebraic version of Theodor, derived from the Greek Theódoros, "God's gift." Like the narrator of the tale, Nathanael tells himself a story and animates things with the power of his imagination. What he sees is that which others failed to see, namely that Olimpia comes to life right in front of his eyes. The first time he becomes aware of her liveliness was with the help of Coppola's spyglass with which he observed her face and witnessed how her eyes came alive. "But as he continued to look closer and more carefully through

27. See Hilda Meldrum-Brown, "The Serapiontic Principle: The Wider Critique," in *E.T.A Hoffmann and the Serapiontic Principle* (Rochester: Camden House, 2006), 185–196.

28. E.T.A. Hoffmann, *The Serapion Brethren* II, Alex Ewing, trans. (G. Bell & Sons: London, 1892), 94.

the glass," writes the narrator, "he fancied a light like humid moonbeams came into them. It seemed as if their power of vision was now being enkindled; their glances shone with ever-increasing vivacity"[29] The second time he saw her occurs at Spalanzani's ball, and this time his vision was not mediated by any optical device: Nathanael asked Olimpia for a dance and "by fixing his eyes upon her face, he saw that her glance was beaming upon him with love and longing, and at the same moment he thought that the pulse began to beat in her cold hand, and the warm life-blood to course through her veins."[30] Upon kissing her, he even felt that "the kiss appeared to warm her lips into vitality."[31] Both examples show the major role materiality plays as a conduit to doll thinking. Since Olimpia is a mechanical doll made of wood, one of whose properties includes thermal conductivity, its body parts store heat and warm up naturally to Nathanael's touch. Far from deceiving him, his senses are actually activating his doll thinking. Because of his talent as a doll thinker, he is able to access a superior reality, and to see through people and things, coming to realize in the process that, contrary to appearances, the wooden doll Olimpia is alive while his former love Clara is actually "a damned lifeless automaton" as he called the latter during a previous lovers' quarrel.[32] As a result of his newly acquired vision, Nathanael looks down on people unable and/or unwilling to engage in doll thinking whom he refers to as "prosaic." The term "prosaic" in the sense of lacking poetic beauty is of interest since prose is generally understood as the contrary of poesy (etymologically to make or create). Nathanael is a poet, albeit not a talented one since he bores his bride-to-be to tears with his verses. Although he did not construct Olimpia, his doll thinking made her come to life. Here again, the metaphor of the ladder to heaven from *The Serapion Brethren* proves helpful in so far as it provides a better understanding of the difference between poetic minds, gifted with doll-thinking skills, and prosaic spirits deprived thereof. One of the friends, Ottmar, nuancing Theodor's depiction of the ladder as being widely accessible, recalls that not everyone is capable of climbing up the ladder to heaven, let alone of seeing it:

> Don't forget, though, Theodore, my friend, [...] that there are quantities of people who don't go up the ladder at all, because it isn't proper or becoming. And many turn giddy by the time they get to the third rung of it.

29. E.T.A. Hoffmann, "The Sandman," 203.
30. E.T.A. Hoffmann, "The Sandman," 206.
31. E.T.A. Hoffmann, "The Sandman," 207.
32. E.T.A. Hoffmann, "The Sandman," 200.

Many never see the ladder at all, though it is facing them in the broad, daily path of their lives, and they pass by it every day.[33]

This quote explains why Nathanael and his "cold prosaic friend Siegmund" did not see eye to eye when it came to Spalanzani's daughter.[34] In a desperate effort to open his friend's eyes to the fact that Olimpia is a musical automaton, Siegmund asked him "how [he], a clever fellow, came to lose [his] head over Miss Wax-Face – that wooden doll across there?"[35] From Nathanael, visibly upset by the comment, he received the rebuke: "You cold prosaic fellows may very well be afraid of her. It is only to its like that the poetically organized spirit unfolds itself."[36]

Queering the Doll Thinker Nathanael

Nathanael's uncertainty about Olimpia arises during the ball scene, immediately after coming into physical contact with her. After grasping her hand, which "was cold as ice," the narrator remarks, "he shook with an awful, frosty shiver."[37] Similarly, after kissing Olimpia's hand, "he bent down to her mouth, but ice-cold lips met his burning ones. As he touched her cold hand, he felt his heart thrill with awe."[38] Even her quasi-muteness is on his mind as the narrator recalls: "And when Nathanael himself in his clear and sober moments, as for instance, directly after waking in a morning, thought about her utter passivity and taciturnity, he only said, 'what are words – but words? The glance of her heavenly eyes says more than any tongue.'"[39] The coldness of Olimpia's body gave him the shudders and her limited linguistic abilities filled him with doubts; and yet, one look into her hypnotic eyes suffices to dissipate any suspicion. This discrepancy between his senses of touch and hearing, on the one hand, and his sense of sight, on the other, underlines the significance of vision and imagination in doll thinking. The underlying uncertainty Nathanael felt at times about Olimpia combined with his ambivalence towards her, oscillating

33. E.T.A. Hoffmann, *The Serapion Brethren* II, 95.
34. E.T.A. Hoffmann, "The Sandman," 208.
35. E.T.A. Hoffmann, "The Sandman," 207.
36. E.T.A. Hoffmann, "The Sandman," 208.
37. E.T.A. Hoffmann, "The Sandman," 206.
38. E.T.A. Hoffmann, "The Sandman," 207.
39. E.T.A. Hoffmann, "The Sandman," 209.

between fear and desire, not only suggests that he is experiencing uncanniness in her presence but also that he is doll thinking about her.

The tension between certainty and uncertainty and the ambivalence between fear and desire, both of which Nathanael clearly has experienced in Olimpia's presence, have been accurately analyzed by Sigmund Freud, not in his study of *The Uncanny* though, but later in his 1927 essay on "Fetishism."[40] There, Freud explains that the fetish is a substitute for the lack of the maternal phallus and that "it remains a token of triumph over the threat of castration and a protection against it."[41] Because the fetishist cannot bear the idea of woman as a castrated man, he disavows this mental image. As a result, his belief/disbelief in the woman's lack of a penis gets resolved in the creation of a substitutive compromise formation, i.e. a fetish. Drawing from Freud's theory of fetishism, Nathanael definitely qualifies as a fetishist. To begin with, he is in complete denial about the true nature of Olimpia and refuses to acknowledge the empirical evidence of his senses. Obviously, Nathanael fell madly in love with a doll fetish, which functions as a substitute for his former bride-to-be Clara. His complex relationship with women is illustrated by his oscillation between two female characters, presented as polar opposites: Clara's shrewd mind is a turnoff to him, while Olimpia's alluring body turns him on. Torn between a human, whom the narrator depicts as "cold, unimaginative, and devoid of feelings," and a humanoid, whom Nathanael compared with a "ray from the promised paradise of love," he ultimately favored the mechanical woman over the flesh and blood one.[42] Or, to put it differently, he preferred the phallic and mute Olimpia, hard as wood, whom he compared to "a beautiful statue" to the castrating Clara, who rationally deconstructed his visions.[43] Upon closer look, though, one starts noticing a striking similarity between Clara and Olimpia, namely that they are both phallic female protagonists. It is because of his fiancée's castrating character that Nathanael feels drawn to another type of phallic woman, i.e. the wooden doll Olimpia. By contrast, Clara's sharp mind

40. See Kaja Silverman, *The Acoustic Mirror: The Female Voice in Psychoanalysis and Cinema* (Bloomington: Indiana University Press, 1988), 17. Silverman observes that Freud makes a passing reference to uncanniness in his 1927 essay on "Fetishism," revealing that both texts are in fact linked in his understanding.

41. Sigmund Freud, "Fetishism," in James Strachey, ed., *Miscellaneous Papers, 1888–1938*, vol. 5 (London: Hogarth Press, 1953), 198–204.

42. E.T.A. Hoffmann, "The Sandman," 197; E.T.A. Hoffmann, "The Sandman," 206.

43. E.T.A. Hoffmann, "The Sandman," in *Tales of Hoffmann* (New York: Penguin Books, 1986), 109. I quote here the translation by Hollingdale because of its greater fidelity to the German original for this sentence in particular.

and rational personality, which, according to the gender norms of 19th century conservative Biedermeier society, read masculine, shed light on Nathanael's demeanor perceived as feminine due to its overactive imagination and excessive emotionality. In fact, it is because Clara's phallic characteristics drove Nathanael outside of the realm of the masculine into the feminine that he ultimately turned to another phallic woman, i.e. the wooden doll Olimpia.

As tempting as it might be to understand "The Sandman" solely in terms of Freud's theory of fetishism, there is much that remains unaccounted for. This remainder leads me to take a further step in my analysis of Nathanael as a doll thinker. What I retain from Freud's insights into fetishism is actually his dialectical thinking, his dynamic way of weaving together belief and disbelief, knowledge and denial, and making a place for ambivalence, vacillation, and irresolution. Such features link doll thinking not only to Freud's writings on the uncanny and fetishism but also to the kind of queer reading French theorist Hélène Cixous practices in her reflection on Freud's *The Uncanny*. As Nicholas Royle succinctly states in his own discussion of Cixous, "the uncanny is queer and the queer is the uncanny."[44] This is not to claim a conceptual identity so much as to suggest that the experience of queerness like that of uncanniness triggers confusion, uncertainty, and anxiety. Even though Nathanael as a young man besotted with a female gendered automaton is the illustration of the performance of a hetero-normative desire, I would nevertheless like to offer a reading against the grain of this character, who reads queer in the etymological and modern sense of the term. At first sight, his infatuation with a wooden doll seems peculiar and his predilection for a wooden doll fetish over a real woman is non-normative.[45] Because Nathanael chose a wooden mechanical doll as his object of desire, I offer to queer his heterosexual romance with Olimpia. If Nathanael could hitherto steal a glance at Spalanzani's daughter only while peering through a curtained door, once in possession of Coppola's spyglass, his scopophilia reached its climax.[46] With a phallic extension of his eye in his hand, he got off on looking at "the regular and exquisite beauty of her features."[47] Even though Nathanael's object of desire reads as and passes for a

44. Nicholas Royle, *The Uncanny* (New York: Routledge, 2003), 43.

45. See Hélène Cixous's reading of Freud's *The Uncanny* in "Fiction and Its Phantoms: A reading of Freud's *Das Unheimliche* ('The Uncanny'), *New Literary History* 7, no. 3 (Spring, 1976): 538.

46. See Dirk Kretzschmar, "Geschlecht/Sexualität/Liebe," in Christine Lubkoll and Harald Neumeyer, eds., *E.T.A. Hoffmann Handbuch: Leben-Werk-Wirkung* (Stuttgart: Verlag J.B. Metzler, 2015), 261–266.

47. E.T.A. Hoffmann, "The Sandman," 203.

woman and his attraction to a doll fetish expresses his male heterosexual fantasies, he nevertheless departs from the "norm" defined as heterosexual genital intercourse. Indeed, opting for a wooden mechanical doll as object choice and voyeurism as object aim, he comes closer to the realm of sexual perversions discussed by Freud in *Three Essays on the Theory of Sexuality* (1905)[48]. In doing so, the figure of Nathanael may be read as an early literary example of a man entering into a queer relationship with a wooden doll. Moreover, he illustrates what it means both to be sexually attracted to an inanimate non-human body and infatuated with a gender-non-conforming being. Although Olimpia passes as a woman, she is actually neither human nor biologically speaking female. Her assigned gender and gender identity are completely at odds with her assigned sex and this mismatch underscores the way in which this hybrid character fails to fit into any category.

A Story of Brotherly Love?

In the course of the narrative Nathanael developed real feelings for Olimpia. Thus, as the narrator notes, "his heart trembled with rapture when he reflected upon the wondrous harmony which daily revealed itself between his own and his Olimpia's character."[49] However, his passion for her turns out to be entirely narcissistic since her dollness/dullness is the perfect foil for the young poet's egotism.[50] As if her quasi-muteness were fostering his lyricism and logorrhea, Nathanael read to his beloved during his visits "all the things that he had ever written – poems, fancy sketches, visions, romances, tales, and the heap was increased daily with all kinds of aimless sonnets, stanzas, canzonets."[51] While praising with tongue-in-cheek humor Olimpia's outstanding listening skills and unwavering focus (which stand out in sharp contrast to Nathanael's former beloved Clara), the narrator is quick to acknowledge, "but then he had never had such a good listener."[52] Nathanael's narcissism was already present during

48. Sigmund Freud, *Three Essays on the Theory of Sexuality. The 1905 Edition*. Edited and introduced by Philippe van Haute and Herman Westerink (London: Verso 2016).
49. E.T.A. Hoffmann, "The Sandman," 209.
50. For a psychoanalytical reading of Nathanael's narcissism, see Gail Newman, "Narrating the Asymbolic in E.T.A. Hoffmann's *Der Sandmann*," in *Seminar* 33, no. 2 (1997): 119–133.
51. E.T.A. Hoffmann, "The Sandman," 209.
52. E.T.A. Hoffmann, "The Sandman," 209.

his first verbal exchange with Olimpia after the ball. Thus, in response to her sighs, he exclaimed, "Oh! What a profound soul you have! My whole being is mirrored in it!"[53] His narcissism is further inflated in the course of his repeated visits and during his self-centered interactions with the wooden mechanical doll. As the narrator observes: "for he fancied that she had expressed in respect to his works and his poetic genius the identical sentiments which he himself cherished deep down in his own heart, and even as if it was his own heart's voice speaking to him."[54] Without disregarding the travesty of a clichéd love scene or the stinging satire of Romantic poets, I would like to emphasize the function Olimpia fulfills as an echo chamber and mirroring surface, both of which provide insight into Nathanael's character. The immediate attraction and intimate connection he felt for Spalanzani's daughter, his recognition of her as his soul mate, which is a doll-thinking revelation: "Only you – you alone understand me," might be after all far more than a mere expression of his unbridled narcissism.[55] Nathanael realizes that Olimpia is not a surface of projection but rather of self-revelation: he recognizes himself in her because she has the same look he does.

After losing his fight and his musical automaton to Coppelius, the wounded Professor Spalanzani revealed to Nathanael that Olimpia actually had his eyes: "your eyes – stolen your eyes."[56] If one were to believe Spalanzani's contradictory account, the theft of Nathanael's eyes most likely happened during his childhood, in the traumatic scene he recounted to his foster brother Lothair in the letter sent to Clara by mistake. Therein, he describes how the advocate Coppelius, refraining from stealing his eyes upon his father's request, probed the mechanism of his joints instead and manhandled him, "twisting [his] hands and [his] feet, pulling them now this way, and now that."[57] Based on his childhood memory and judging from his mechanical behavior towards Coppola's spying glass, the question arises whether Nathanael himself might not be an automaton after all. And if that were the case, then he and Olimpia would be closely related as half-siblings since they would share the advocate Coppelius as father/maker. Moreover, the disclosure of their family ties highlights the incestuous and taboo nature of Nathanael's love and desire for Olimpia. The questions of whether Olimpia has his eyes or not, whether Nathanael is an

53. E.T.A. Hoffmann, "The Sandman," 206.
54. E.T.A. Hoffmann, "The Sandman," 209.
55. E.T.A. Hoffmann, "The Sandman," 209.
56. E.T.A. Hoffmann, "The Sandman," 211.
57. E.T.A. Hoffmann, "The Sandman," 188.

automaton or not, whether they are closely related, cannot be answered with certainty as the reader is left in the dark throughout the story. One thing is sure though: Nathanael's predilection for a mechanical woman and his affinity to a wooden doll help us understand why it is that he is such a powerful doll thinker.

When the Public Starts Doll Thinking

Even though Nathanael is in the story the sole figure who adopts doll thinking as his *Weltanschauung* (world view), he is nevertheless far from being the only character who doll thinks after coming into contact with Olimpia. Whether one reads him as a doll maniac, who confuses reality and fantasy and hence mistakes a doll for a woman, or as a doll thinker, who accesses a superior reality in which a doll comes to life, it is to be expected in both cases that he equates woman with doll. The same is not true for the minor characters in the story, whose various doll-thinking reactions come as a surprise to say the least.

Unlike their friend, Nathanael, who is blinded by his vision of Olimpia, the young students who attended Spalanzani's ball were not fooled by her performance. "It was evident," the narrator observes, "that Olimpia was the object of the smothered laughter suppressed only with difficulty, which was heard in various corners among the young people; and they followed her with curious looks."[58] While the physics professor's ball was the talk of the town afterwards, the fun poked at his daughter rapidly turned into rejection for her doltishness. Thus, the narrator reports, "they [certain gay spirits] were especially keen in pulling Olimpia to pieces for her taciturnity and rigid stiffness; in spite of her beautiful form, they alleged that she was hopelessly stupid, and in this fact they discerned the reason why Spalanzani had so long kept her concealed from publicity."[59] Siegmund, Nathanael's student friend, also dismissed Olimpia, based less on her stupidity than on her mechanical, cadenced body movement, which he perceives as non-human. He concedes that "she is strangely measured in her movements, they all seem as if they were dependent upon some wound-up clockwork. Her playing and singing have the disagreeably perfect, but insensitive timing of a singing machine and her dancing is the same."[60] But foremost he rejects the beautiful Olimpia out of fear, and conveys the feeling

58. E.T.A. Hoffmann, "The Sandman," 206.
59. E.T.A. Hoffmann, "The Sandman," 207.
60. E.T.A. Hoffmann, "The Sandman," 208.

30 Uncanny Creatures

of uncanniness he and his comrades experienced in her presence: "We felt quite afraid of this Olimpia, and did not like to have anything to do with her; she seemed to us to be only acting like a living creature, and as if there was some secret at the bottom of it all."[61] Unlike his friend Nathanael, the fearful Siegmund refused to doll think. His prosaic mind has access only to a reality in which he perceives Olimpia as a mechanical doll and not as a "glorious heavenly lady" coming to life in front of his eyes, like his friend.[62]

Against all odds, all the prosaic and philistine Olimpia-critics Nathanael scorns, were forced against their will to doll think after the scandal involving the makers of Spalanzani's daughter, pitting the physics professor against his glass peddler friend. The disclosure of Olimpia's true identity as a mechanical wooden doll not only caused Nathanael's breakdown, but also plunged the entire university town into a state of paranoia and an epistemological crisis. The inhabitants were outraged at having been deceived by an automaton, passing as the daughter of the physics professor. Even though they never warmed up to dull Olimpia, they nevertheless admitted her into their social circles and in retrospect considered "that it was an imposture altogether unpardonable to have smuggled a wooden puppet instead of a living person into intelligent teacircles – for Olimpia had been present at several with success."[63] In depicting how an automaton perfectly fulfilled the demands of bourgeois society, the narrator illustrates with stinging irony how soulless, mechanical, and stiff bourgeois society in general and the behavior of well-bred young girls in particular have become.[64] The narrator clearly heaps scorn upon the mores of the German society of the restoration period. But beyond the outrage, the inhabitants were now left with doubt and paranoid uncertainty when it came to distinguishing humans from humanoids. The narrator notes how "the history of this automaton had sunk deeply into their souls, and an absurd mistrust of human figures began to prevail."[65] Clearly, the episode with Olimpia left its marks on the university town that henceforth could not get a wooden doll out of its mind. To put it differently, in the aftermath of the scandal the whole community is doll thinking against its will. Male suitors in town, as the sarcastic narrator

61. E.T.A. Hoffmann, "The Sandman," 208.
62. E.T.A. Hoffmann, "The Sandman," 206.
63. E.T.A. Hoffmann, "The Sandman," 211.
64. See Rudolf Drux's postface "Die lebendige Puppe, Ein Motiv romantischer Erzählliteratur," in *Die Lebendige Puppe, Erzählungen aus der Romantik* (Frankfurt am Main: Fischer Taschenbuch Verlag, 1986), 254.
65. E.T.A. Hoffmann, "The Sandman," 211

puts it, were particularly affected by Spalanzani's scam: with the fear of courting a wooden doll instead of a real woman lurking in the back of their minds, they now took extra precautions and "required that their mistress should sing and dance a little out of time, should embroider or knit or play with her little pug, &c, when being read to."[66] These male demands have a particular resonance with regard to Nathanael and Clara's relationship. They remind us not only of the protagonist's inability to keep pace with Olimpia's all too faultless singing and dancing, but also of Clara's limited listening skills and short attention span, which had so infuriated Nathanael in the first place. More generally, they have the paradoxical effect of enforcing another type of gendered performance. Wishing to set themselves off against the stiff and mechanical behavior of an automaton, the townies wound up reproducing the very behavior they rejected in their predictably faulty, all too human reactions, underscoring the unwitting resemblance between humans and dolls. Even the requirement that "she [the mistress] should frequently speak in such a way as to really show that her words presupposed as a condition some thinking and feeling" is not really a distinctive feature when one recalls that Olimpia's repeated interjection "Ah" conveyed thinking and feeling such as pain, regret, surprise.[67] The comical overreaction of the townies shows that the line between humans and humanoids has become increasingly blurry and that this confusion started prior to Spalanzani attempt at "having fraudulently imposed an automaton upon human society."[68] In other words, behind the funny social satire lurks the nagging uncertainty and lingering anxiety about the ways in which humans and humanoids have become increasingly similar to the point of no longer being undistinguishable.[69] Consider in this regard the very ending of the story where the similarity between Clara and Olimpia is so striking that Nathanael, apparently restored to health, looked through his spyglass only to mistake his fiancée for an automaton, which he tried to hurl from the city hall tower. The story closes with a pastoral depiction of Clara "sitting hand in hand with a pleasant

66. E.T.A. Hoffmann, "The Sandman," 212.

67. See the entry for "Ach" in the German dictionary *Duden*: https://www.duden.de/rechtschreibung/ach.

68. E.T.A. Hoffmann, "The Sandman," 212.

69. In this regard, one should also question the narrator's motives underlying his social critique. By reducing the epistemological crisis affecting the town to a satire, he diverts the reader's attention from the townies' doll thinking and underplays its impact on his own narrative. From the moment paranoia, disorientation, and intellectual uncertainty, i.e. a manifestation of the Jentschian Uncanny, started taking hold within the text, the whole narrative of "The Sandman" threatens to break down.

gentleman," which so closely resembles Nathanael's courtship of Olimpia, that one might wonder whether Clara was actually not an automaton all along.[70]

Doll Thinking is Doll making

If Hoffmann's story features various doll thinkers, it also includes different doll-makers. The most important one of these is the advocate Coppelius/glass peddler Coppola, who effectively drives the plot. "The Sandman" introduces two pairs of doll-makers: Nathanael's father and the advocate Coppelius on the one hand; Professor Spalanzani and the glass peddler Coppola on the other. The link between these two male couples is the double figure Coppelius/Coppola, who may be the same character involved in two successive doll-making projects – as Nathanael himself seems to believe. Judging from the proliferation of doll thinkers and doll-makers in town, both activities exclusively involve men.

Nathanael's detailed account in his first letter to Lothair of the childhood trauma he suffered at the hands of the advocate Coppelius, an account supported by Clara's astute analysis of it, implies that his father was conducting alchemistic experiments with the help of the lawyer. This is, at least, the rational conclusion Clara draws from Nathanael's letter, a message sent to her by mistake. "His [Coppelius] mysterious labors along with your father at nighttime," she writes back, "were, I daresay, nothing more than secret experiments in alchemy."[71] The interpretation is corroborated by Nathanael's own memory of a scene set around a forge in his father's study, which he witnessed from a hiding place behind closed curtains. Spying on his father and Coppelius, he observed with horror that both men wore "ugly, repulsive Satanic masks" and he watched how "Coppelius plied the red-hot tongs and drew bright glowing masses out of the thick smoke and began assiduously to hammer them."[72] The exact type of alchemy practiced by the men remains unclear. Indeed, the only eyewitness testimony is provided by a traumatized child. What is clear is that the experiments conducted by Nathanael's father and Coppelius involve the creation of a living being, though scholars disagree on the precise nature of the creature: some argue in favor of a homunculus,[73] others for an

70. On Clara's automaton-like quality and her resemblance to Olimpia, see John M. Ellis, "Clara, Nathanael and the Narrator: Interpreting Hoffmann's *Der Sandmann*" *The German Quarterly* 54, no. 1 (1981): 1–18.
71. E.T.A. Hoffmann, "The Sandman," 191.
72. E.T.A. Hoffmann, "The Sandman," 188.
73. See Susan Brantly, "A Thermographic Reading of E. T. A. Hoffmann's *Der Sandmann*," *The German Quarterly* 55, no. 3 (1982): 324–335. See also Claudia Liebrand,

automaton.[74] Homunculi and dolls are both small models of human figures with the difference being that the first – *der Homunkulus* – is gendered masculine in German and deemed to be organic while the second – *die Puppe* – is feminine and generally regarded as mechanical. Interestingly, the chemical creation of a little man not only failed but led to an explosion that cost Nathanael's father his life, whereas the mechanical construction of a human-sized female doll succeeded but only at the cost of the son's life. Hoffmann's story presents the full scope of the different procedures for the making and animating of man-made creatures, to which both Nathanael and his sorcerer's apprentice father irrevocably succumb.

The second pair of doll-makers is composed of the physics professor, Spalanzani, and the glass peddler, Coppola. "This Professor Spalanzani is a very queer fish," wrote Nathanael to Lothair, going on to compare his physics professor to Alessandro Cagliostro, an infamous eighteenth-century occultist and alchemist. In acknowledging Spalanzani's likeness to Cagliostro, Nathanael links the physics professor with occult practices, a link subsequently underscored by the narrator. At the end of the ball scene, just as Nathanael is about to bid farewell to Olimpia, the narrator describes the professor striding through his apartment, "his figure had, as the flickering shadows played about him, a ghostly awful, appearance."[75] As for the uncanniness of the Piedmontese mechanician Giuseppe Coppola, Nathanael acknowledged from the start that he had mistaken him for the advocate Coppelius as both men look very much alike. Indeed, his opening letter to Lothair was prompted by the terrifying belief that the Italian glass peddler might well be the evil Coppelius in disguise.

It is only towards the end of the story that the reader finds out about the construction process of Olimpia and the involvement of Spalanzani and Coppola in it. When Nathanael plucked up his courage and headed to the physics professor, Spalanzani, to ask for his daughter's hand, "he heard an extraordinary hubbub; the noise seemed to proceed from Spalanzani's study."[76] As the two men, wrestling bitterly over the ownership of Olimpia, curse one another, the reader learns that Spalanzani engineered the automaton's mechanism while Coppelius/Coppola designed the eyes. After being defeated by Coppola, who ran away with the automaton slung over his shoulders, the injured professor

"Automaten/Künstliche Menschen," in Christine Lubkoll and Harald Neumeyer, eds., *E.T.A. Hoffmann Handbuch: Leben-Werk-Wirkung* (Stuttgart: Verlag J.B. Metzler, 2015) 242–246.

74. See John Fletcher, "Freud, Hoffmann and the Death-Work," *Angelaki: Journal of Theoretical Humanities* 7, no. 2 (2002): 125–141.

75. E.T.A. Hoffmann, "The Sandman," 207.

76. E.T.A. Hoffmann, "The Sandman," 210.

exclaims, "Coppelius – Coppelius – he's stolen my best automaton – at which I've worked for twenty years – my life work – the clockwork – speech – movement – mine," before ordering Nathanael to fetch Olimpia back.[77] By cursing Spalanzani: "Go to the devil with your clockwork" and by calling him "damned dog of a watchmaker," Coppola calls attention to the limitations of mechanics and engineering. Spalanzani might well be a "skillful mechanician and fabricator of automata," as the narrator informs the reader, but he nevertheless needed the collaboration of a glass peddler versed in occult practices to animate his automaton. If one is to believe Spalanzani's account, which ought to be taken with a grain of salt, Coppelius/Coppola stole Nathanael's eyes and inserted them into Olimpia's eye sockets. The collaboration between these pairs of male doll-makers (Nathanael's father and Coppelius versus Spalanzani and Coppola) suggest that doll making combines science with alchemy and the occult. To put it differently, doll making requires quantum mechanics to construct the doll as much as magical beliefs to animate it. Doll making aims at breaking the boundaries between natural and artificial life in the same way that doll thinking means breaking the boundaries between reality and fantasy. This similarity underscores further the inherent link between doll making and thinking.

In addition to these two pairs of doll-makers, another character turns out to be a doll-maker, namely the narrator himself. At the end of the correspondence between Nathanael, Clara, and Lothair, the first-person narrator breaks abruptly with the epistolary mode with which the narrative had opened. Addressing the reader directly, he confesses his difficulty in figuring out how to begin to tell the tragic story of Nathanael. In his excursus, which foremost deals with the processes and the different conventions of storytelling before giving a satirical account of Clara's appearance and character, the omniscient narrator asks the reader a question: "Have you ever experienced anything that took complete possession of your heart and mind and thoughts to the utter exclusion of everything else?"[78] Thereupon followed a description of symptoms: "Your gaze was so peculiar, as if seeking to grasp in empty space forms not seen by any other eye, and all your words ended in sighs betokening some mystery."[79] Oddly enough, both statements by the narrator revolve around the

77. E.T.A. Hoffmann, "The Sandman," 211.
78. For an analysis of the role of the narrator, see John Ellis, "Clara, Nathanael and the Narrator: Interpreting Hoffmann's *Der Sandmann*," *The German Quarterly* 54, no. 1 (1981): 2.
79. E.T.A. Hoffmann, "The Sandman," 194–195.

doll: the experience depicted foreshadows Nathanael's obsession with Olimpia, while the breakdown of the organs of sight and speech prefigure an account of her empty gaze and poor speaking skills, limited to the interjection "Ah!" Not only does the narrator ask whether the reader was ever infatuated with a doll, but moreover whether he himself ever felt like one. In this case, the doll in question is not the wooden automaton Olimpia but her story, that is, the narrative of "The Sandman" itself. Telling in this regard are the feelings the narrator asks the reader about and the symptoms he describes; for this is precisely what and how the reader of "The Sandman" feels after reading the story: obsessed, haunted, and confused like Nathanael, speechless and blind like Olimpia. The narrator advances as a doll-maker not merely because the creative process of storytelling is very similar to that of doll making, but also and above because his story ultimately turns the reader into a doll thinker.

Following Nathanael's bout of madness during which he attempted to strangle his physics professor after realizing with dismay that Olimpia was an automaton, the narrator again addresses the reader, this time interrupting the story with a second excursus. Surveying the different reactions of the town residents after the disclosure of Olimpia's real identity, the narrator lets the professor of poetry and eloquence speak about the issue: "My most honorable ladies and gentlemen, don't you see then where the rub is? The whole thing is an allegory, a continuous metaphor. You understand me? Sapienti sat."[80] Clearly, the narrator is poking fun at the professor of rhetoric, whose nebulous insights seem to keep the reader in the dark instead of opening his eyes to Olimpia's esoteric significance. And yet, the professor of poetry and eloquence may nevertheless provide a hermeneutic clue to the story. By inviting the audience to regard Olimpia as "an allegory and a continuous metaphor," the professor suggests that the doll is indeed merely a vessel and above all the symbol of a higher meaning, yet to be deciphered. Still, he refrains from divulging the meaning hidden behind Olimpia, claiming merely that, "a word to the wise is enough." The quotation of Plautus is particularly telling in this regard: for the phrase "sapienti sat" alludes to a reader already in the know, one able to decipher the doll's hidden meaning and have access to its higher significance. Thus, only an esoteric reader like the doll thinker Nathanael can see past the doll and uncover its allegorical significance. This suggests in turn that the relationship between the esoteric reader and the story of Olimpia is identical to the relationship between the main character Nathanael and the doll Olimpia.

80. E.T.A. Hoffmann, "The Sandman," 212.

Aligning the reader's perspective onto Nathanael's contributes to further blurring the line between madness and sanity, fantasy and fiction.

Because the automaton is an artificial creature as well as an artistic creation, it bears striking similarities to the work of art, to which it is ultimately related. Olimpia as a mechanical artifact stands metaphorically for the literary artifact that is "The Sandman," of which the doll is the intra-textual mirror image: like Olimpia, the literary text has two makers/story tellers (the narrator and the author), it is deceitful and manipulative, it requires the reader's imagination to come alive and must be seen through a particular lens in order to be activated.[81] Like the automaton, Hoffmann's text remains ambiguous and mysterious, leaving many questions about Nathanael's state of mind and Olimpia's liveliness unanswered. In the course of the story itself, the doll is repeatedly mistreated: figuratively, "torn to pieces" by the ball attendees, it is in turn wrenched back and forth between characters claiming ownership over it. Obviously, such mistreatment stands metaphorically for the reception of a literary text that has in the German-speaking context a long history of being misunderstood, starting with Goethe's dismissal and followed by Freud's misreading.

However, a creative avant-garde mind like Oskar Kokoschka's did not misinterpret "The Sandman." On the contrary, the story of Olimpia and the doll thinker Nathanael were certainly not lost on the Expressionist Austrian painter when he tried his hand at doll thinking and making. Many key aspects articulated in E.T.A. Hoffmann's tale, such as the role played by imagination and the senses of sight and touch, the nexus between doll thinking and making, as well as the issue of paternity and ownership of the doll, clearly informed and influenced Kokoschka's desire when he commissioned the crafting of his fluffy Alma doll.

81. See Monika Schmitz-Emans, "Eine schöne Kunstfigur: Androiden, Puppen und Maschinen als Allegorien des literarischen Werkes," *Arcadia* 30, no. 1 (1995): 1–30.

Chapter 2

Doll Thinking: An Aesthetic Investigation
Oskar Kokoschka's Fluffy Alma Doll by Hermine Moos

> Ich reiß' der Puppe den Kopf ab
> Ja, ich reiß' der Puppe den Kopf ab
> Und dann beiß' ich der Puppe den Hals ab
> Es geht mir nicht gut, nein!
> —Rammstein, *Puppe*, 2019

"It is not known," writes Nathan Timpano, "if [Oskar] Kokoschka was familiar with Freud's or Ernst Jentsch's essays on the *Unheimliche* [the Uncanny] when he was working on his own interpretation of uncanny objects such as his painted studies of the Alma doll. This point may be inconsequential, as Viennese artists and playwrights were all generally familiar with E.T.A. Hoffmann's *The Sandman*."[1] And even if Kokoschka did not know Hoffmann's story, he had almost certainly attended a performance of *Tales of Hoffmann*, the opera adaptation by Jacques Offenbach.[2] *Tales of Hoffmann* had acquired a bad reputation after a fire broke out during the second performance at the Vienna Ringtheater on December 8, 1881, killing hundreds of audience members. Twenty years

1. Nathan J. Timpano, *Constructing the Viennese Modern Body: Art, Hysteria, and the Puppet* (New York: Routledge, 2017), 167–168.

2. The connection between Kokoschka and E.T.A. Hoffmann was not lost on art critics, such as in one review from the first exhibit of Kokoschka's portraits at the Zürich Kunsthaus in 1913. Underscoring Kokoschka's racy Expressionism and the disturbing appearance of his portraits in his review for the Swiss newspaper *Die Zürcher Post*, the critic joked that they were "as if characters straight from E.T.A. Hoffmann had surfaced in the flickering light of the pub": https://www.nzz.ch/was_ich_nur_ertraeumen_malen_und_dichten_kann-1.10182095?reduced=true.

later, on November 11, 1901, the opera returned, this time at the Royal Opera in Vienna, with one Gustav Mahler as conductor. That production would run 188 times at the Vienna opera between 1901 and 1926, with Kokoschka likely in attendance at least once.[3] During this period, after briefly experimenting with shadow puppets and marionettes, the artist commissioned a life-sized doll-like replica of his ex-lover, Alma Mahler, Gustav's widow.[4]

The Alma Doll: Interpretations

Dismissed at first as the artistic expression of a lunatic, and still regarded as an anomaly in Kokoschka's body of work, the "Alma doll" was, for the artist, an abiding passion.[5] The work drew on his talents as a painter and a writer, explored his preoccupation with the battle of the sexes and, through his correspondence with the doll-maker Hermine Moos, ignited and articulated his doll thinking.[6]

In this chapter I will consider some of Kokoschka's 12 letters to Moos, his preliminary sketches, such as *Standing Female Nude, Alma Mahler* (1918), and finally his two doll paintings: *Woman in Blue* (1919) and *Painter with Doll* (1922). The oil paintings, in particular, illustrate how the artist used his own creations to reckon with the Alma doll and everything it meant to him. In my analysis of the Alma doll, I will focus particularly on the sense of touch, which I believe was dominant in Kokoschka's conception and experience of the doll, and in his doll thinking generally.[7]

3. See Oswald Panagl, "Hoffmanns Erzählungen im Repertoire der Wiener Staatsoper," in the program bill for *Jacques Offenbach: Les Contes d'Hoffmann* (Vienna: Wiener Staatsoper, 2014), 96–100.

4. For more details about Kokoschka's interest in puppet theater and shadow puppets, see Timpano, *Constructing the Viennese Modern Body*. Also see Thomas Schober, *Das Theater der Maler: Studien zur Theatermoderne anhand dramatischer Werke von Kokoschka, Kandinsky, Barlach, Beckmann, Schwitters und Schlemmer* (Stuttgart: M&P Verlag für Wissenschaft und Forschung, 1994).

5. See Bernadette Reinhold's essay, "... sonst ist es kein Weib, sondern ein Monstrum: Anmerkungen zu Mythos und Rezeption der Kokoschka-Puppe," cited in Bernadette Reinhold und Eva Kernbauer, eds., *Zwischenräume Zwischentöne* (Berlin: De Gruyter, 2018), 179–185.

6. See for example Kokoschka's dramas *The Sphinx and the Strawman* (1907), *Murder, Hope of Women* (1909) and *Orpheus and Eurydice* (1919).

7. Marquard Smith, "Touching: Oskar Kokoschka's Alma Mahler," in *The Erotic Doll: A Modern Fetish* (New Heaven: Yale University Press, 2013), 109–135.

Though informed by various critical approaches to art history – among them trauma, gender, and cultural studies – my interpretation of the Alma doll departs considerably from existing readings: I do not regard Kokoschka's doll as a symbol or as a symptom.[8] Instead, I will concentrate on the unstable nexus between doll thinking and doll making. For the Alma doll tells a suspenseful story in three acts: first, how the painter's eager doll thinking was disrupted by the dollmaker's rebellion; second, how Kokoschka reclaimed the fluffy doll-thing and re-appropriated it as his own object in *Woman in Blue* (1919) and *Artist with Doll* (1922); third, how doll making and doll thinking resurfaced in a later exchange of letters between Kokoschka and Alma Mahler, demonstrating that the capacity to blur subject and object, doll and human, was still persistent in Kokoschka, even in old age.

Origins of the Doll

Alma Mahler and Oskar Kokoschka's affair lasted from 1911 to 1914, ending when Alma married Bauhaus founder Walter Gropius. During that time, Mahler became central to Kokoschka's work and life: in three years he sent her nearly 400 letters, and devoted 20 paintings, 70 drawings, and seven fans to their love affair.[9] Thus, in the summer of 1918, a convalescent Kokoschka, still recovering from a war injury, and still scarred by his losses (before leaving him for Gropius, Alma had aborted their child) sought out Hermine Moos and initiated the doll project. Moos had not been his first choice. Kokoschka had already approached the renowned Munich-based doll-maker Lotte Pritzel (see Chapter 3), but she had declined the offer after seeing his initial

8. See for instance Mario Praz, "La poupée de Kokoschka," in *Le pacte avec le serpent, tome III Serpent* (Paris: Christian Bourgeois,1991); Ingried Brugger, "Larve und 'Stille Frau': Zu Oskar Kokoschkas Vorlage für die Puppe der Alma Mahler," in *Oskar Kokoschka und Alma Mahler, Die Puppe: Epilog einer Passion* (Frankfurt am Main: Städtische Galerie im Städel, 1992); Peter Gorsen, "Pygmalions stille Frau: Oskar Kokoschka und die Puppe," in *Sexualästhetik: Grenzformen der Sinnlichkeit im 20. Jahrhundert* (Reinbeck: Rowohlt Taschenbuch Verlag, 1987); Lisa J. Street, "Oskar Kokoschka's Doll: Symbol of Culture" (Ph.D. diss., Emory University, 1993); Bonnie Roos, "Oskar Kokoschka's Sex Toy: The Women and the Doll Who Conceived the Artist," *Modernism/Modernity* 12, no. 2 (2005): 291–309.

9. See Harold P. Blum, "Oskar Kokoschka and Alma Mahler: Art as Diary and as Therapy," in Robert A. King et al., eds., *The Psychoanalytic Study of the Child* (Yale University Press, 2011), 293–309.

sketches.[10] Pritzel knew of Moos through the neurologist Dr Gerhard Pagel, who was Pritzel's husband and Kokoschka's friend and physician. Moos was also rumored to have been Alma Mahler's seamstress; if true, this direct (or nearly direct) bodily contact between Moos and his beloved would likely have elevated her candidacy.[11]

Because Moos' responses to Kokoschka were not published or preserved, little was known about her until Bavaria public service radio (Bayerischer Rundfunk) journalist Justina Schreiber uncovered the doll-maker's identity: a Jewish-German artist, Moos had trained as a painter, and lived in Schwabing, the bohemian quarter in Munich. *The Photograph of Hermine Moos with the skeleton of Oskar Kokoschka's Alma Doll* (Fig. 2) is one of the rare remaining photographs of her, most likely taken by her sister Henriette Moos. It depicts the young doll-maker clad in a black winter coat with a fur collar, posing next to a life-size skeleton made of papier mâché, in an outdoor setting that looks like a balcony, most likely in her parents' Munich apartment. She is holding the doll's upper arm bone with her right hand, tilting her head towards its shoulder bone, while fully smiling at the camera.

Her artwork had been exhibited in Berlin and Dresden, and her crocheting in particular had captured art critics' attention.[12] Kokoschka's letters suggest that he had met Moos in person in July 1918, and attended her show at the Emil Richter Gallery in Dresden in September of that year.[13]

10. Pritzel made exquisite wax dolls for the vitrine of department stores, and her dolls became so successful and sensational that they inspired the poet Rainer Maria Rilke to compose the essay *Zu den Wachspuppen von Lotte Pritzel* (Leipzig: Verlag Der Weißen Bücher, 1914).

11. This is also the assumption Whitford makes in his biography of Kokoschka. See Frank Whitford, *Oskar Kokoschka: A Life* (New York: Atheneum, 1986), 119: "Kokoschka heard, perhaps from Käthe Richter's family, about a seamstress and doll-maker who lived in Stuttgart and, if some reports are to be believed, was better qualified for the job that anyone else alive: she had once been Alma Mahler's dressmaker."

12. Justina Schreiber, "Hermine Moos, Painter: On the Occasion of Discovering a Hitherto Unknown Photograph of Kokoschka's Alma doll," in Bernadette Reinhold and Patrick Werkner, eds., *Oskar Kokoschka: Ein Künstlerleben in Lichtbildern* (Vienna: Ambra Verlag, 2013), 91.

13. See Kokoschka's first letter dated July 22, 1918: "Ich [...] legte auch die Puppe bei, die eine reizende Arbeit ist"; and his fourth letter dated September 19, 1918: "Heute sehe ich mir Ihre Puppen bei Richter an." Reprinted in Olda Kokoschka und Heinz Spielmann, eds., *Briefe I: 1905–1919* (Düsseldorf: Claasen Verlag, 1984), 290, 295.

Fig. 2. Photographer unknown, *Photograph of Hermine Moos with the Skeleton of Oskar Kokoschka's Alma Doll.* **From the photo album of Alfred Mayer. © Schloßmuseum Murnau, Bildarchivr.**

The Letters of a Doll thinker: Oskar Kokoschka to Hermine Moos

The most striking feature of Kokoschka's letters to Moos is the clarity of his vision for the doll. Including sketches and drawings in his letters, the artist was blending media from the start, and inserting his own tactile presence into the instructions for the project.[14]

Already a public figure in the German-speaking world, Kokoschka, who at the time was cultivating his "mad artist" image, was most likely counting on his letters to be published. And, indeed, they were, six years later,

14. Note the striking similarities between Kokoschka's letters and those of Michelangelo's or Leonardo da Vinci's. This perhaps indicates that the painter self-consciously positioned himself as a male genius on a par with his Renaissance forerunners.

under the sensational title *The Fetish, Confessions of Artists* (*Der Fetisch, Künstlerbekenntnisse*).[15]

In his very first letter to Moos, dated July 22, 1918, Kokoschka plainly conveyed his doll thinking: his hope for a doll that could transport his senses to a direct experience of Alma: "Should you be successful, dear Miss Moos, in projecting such a feat of legerdemain that the woman of my dreams will seem to come alive to my eyes and touch, I shall be deeply indebted to your inventiveness and feminine sensibility."[16] Thus, the doll to be crafted should, through its feel and resemblance, deceive his senses and reanimate the mental image the painter has of his ex-lover. Clearly, Kokoschka wanted an uncanny artifact, powerful enough to trigger an emotional response and activate a visual process in him, that would blur fantasy and reality, and erase the distinctions between human and non-human, woman and doll, animate and inanimate. In other words, he was yearning for a life-sized replica of Alma Mahler that would serve as a conduit to private doll thinking. At the end of his first letter, he enjoined Moos to doll think along, to give herself over to the process: "I urge you to continually apply your whole feminine imagination to this work."[17]

Hands Are Not for Hitting

A close reading of Kokoschka's correspondence reveals a fixation on the hands of his would-be doll. Encouraging Moos to pursue her work, he concludes his fifth letter, dated late September/early October 1918, with an idiom: "I wish you a lucky hand and may your enthusiasm continue."[18] At the end of the ninth letter, dated January 15, 1919, he conveys his impatience: "When am I to get my hands on all this?"[19] Exhorting Moos to focus on the particular texture of the skin, he writes in his third letter, "For me, it's about an experience that

15. Although Paul Westheim, critic and editor of the art journal *Das Kunstblatt*, published an incomplete and faulty version of Kokoschka's letters to Moos in 1925, their reduction in number and the removal of Moos' response already belies an agenda on the painter's and the editor's part: that the nine letters written during a nine-month period are meant to suggest pregnancy. For further details, see Street, "Oskar Kokoschka's Doll," 60.
16. Susan Keegan, *The Eye of God: A Life of Oskar Kokoschka* (London: Bloomsbury, 1999), 106.
17. Keegan, *The Eye of God*, 291: "Ich bitte Sie, [...] daß Sie Ihre ganze weibliche Phantasie andauernd an diese Arbeit wenden wollen [...]."
18. Keegan, *The Eye of God*, 296.
19. Keegan, *The Eye of God*, 304.

I need to embrace."[20] In his eighth letter, dated December 10, 1918, Kokoschka objects to the doll's lack of articulation, and urges Moos to pay greater attention to the extremities:

> The hands and feet still have to become better articulated. Just take your own hand as a model. Or think of the hand of a cultivated Russian lady, say a horsewoman. And the foot should be something like that of a dancer, say Karsavina. You must also take into account that, even bare, the hands and feet should exert an element of fascination – they should be alive and sensitive rather than dead lumps.[21]

In asking the doll-maker to "take her own hand as a model," the painter encourages Moos to call upon her own demiurgic power, to channel something of herself that transcends craftsmanship. He later went a step further in his fetishization, asking her to touch and feel her own body parts wherever his sketches were not enough to convey the desired form: "Should any part of the drawing still not be sufficiently clear – the tension of a muscle or the placing of a bone – please don't look it up in an anatomical atlas, but find the place on your own bare body ... Hands and fingertips often see more than the eyes."[22] Kokoschka's recommendation here underlines both the sensual nature of his doll-making project and the erotic nature of his relationship to the doll-maker. By affirming that "the hands and fingertips often see more than the eyes," Kokoschka suggests that touch, above all other senses, should guide a phenomenological investigation. He goes on: "Please make it possible for the sense of touch to revel in those places where layers of fat or muscle suddenly yield to the sinewy integument, through which some bony prominence may be felt – the shins, the pelvis, the shoulder-blade, the collarbone, the arm joints."[23] In the ninth letter, dated January 15, 1919, he exhorts Moos to use her own skin as a guide for the pigment of the doll's surface, and orders her to apply the pigment only by her own hand: "Color may only be applied by means of powder, fruit juice, gold dust, layers of wax, and so discreetly that you can only imagine them; please take your own body as an example. And can only be applied with fingers, not with an instrument."[24] Kokoschka forced

20. Keegan, *The Eye of God*, 294.
21. Keegan, *The Eye of God*, 110–111.
22. Keegan, *The Eye of God*, 107.
23. Keegan, *The Eye of God*, 106.
24. Keegan, *The Eye of God*, 106.

44 Uncanny Creatures

the correspondence with the doll-maker into a tactile exchange. In the letters, Moos' molding and writing hand meets Kokoschka's sketching and writing hand. The two even swapped samples of the limbs and textile fibers for the filling.[25] The hand, as body part and organ of touch, lay at the core of Kokoschka's doll-making project, and would remain a prominent feature and motif for the rest of his career as an artist.[26]

The Peak of Doll Thinking and Doll Making: *Standing Female Nude, Alma Mahler*, 1918

In his third letter to Moos, dated August 20, 1918, Kokoschka mentioned that he had completed a life-size painting of Alma Mahler, and that his physician friend, Dr Pagel, would deliver the painting to Moos:[27] "Dear Miss Moos, Yesterday, I sent you through my friend Dr. P. a life-sized picture of my beloved one, which I beg you to imitate nicely and, mobilizing all your patience and sensuality, to transform into reality."[28] Though he had already given Moos a detailed description of his ex-lover's physique, this would be a very particular illustration. It is telling that the painter's concern about the texture of the doll's skin arose in this letter. His first letter had been mainly about the doll's bones and hair color, the second about filling materials. The third focused mostly on skin texture. As usual, the painter was quite explicit: in anticipation of a sensuous doll-thinking experience, he requested delicate and soft materials, either silk or linen: "The skin will probably be made from the thinnest fabric available, gossamer silk or the very finest linen, and will have to be built up in

25. See Kokoschka's first letter dated July 22, 1918: "Liebes Frl. Moos, Ich sandte Ihnen heute gleich nach Erhalt den Kopf zurück und legte auch die Puppe bei, die eine reizende Arbeit ist." See his second letter to Moos dated August 8, 1918: "Beiliegend eine Probe von Baumwoll-Zellstoff. Wenn Sie diese gebrauchen, vielleicht kombiniert mit echter Watte für die äußeren Partien, so kann ich Ihnen davon eine größere Menge senden." Reproduced in Kokoschka and Spielmann, eds., *Briefe I*, 290–291.

26. For a detailed analysis of the significance of hands in Kokoschka's portraits, see Nils Ohlsen, "Forels Hände: Bemerkungen zu den Händen im Werk Oskar Kokoschkas," in *Kokoschka: Werke der Stiftung Oskar Kokoschka* (Heidelberg: Wachter Verlag, 2001), 21–32.

27. He alluded to the oil sketch once more in his eighth letter dated December 10, 1918: "Im Allgemeinen wieder so nervig wie in der großen Ölskizze mit möglichst allen Details. […] die Kontur muß genau wie auf der Ölskizze sein." Reproduced in Kokoschka and Spielmann, eds., *Briefe I*, 300.

28. Edith Hoffman, *Kokoschka: Life and Work* (London: Faber and Faber, 1947), 145.

small patches."[29] Kokoschka had delivered a life-size pictorial representation of Alma Mahler, and he expected in return not only a faithful imitation, but one transfigured into three dimensions. The *Standing Female Nude* (Fig. 3) is the master copy, on which the doll should be based.[30] While painting *Standing Female Nude*, Kokoschka himself became a doll-maker: his oil painting, the first step to his ex-lover's dollification, is a doll-like artifact in its own right.

Standing against a reddish-brown background, the nude figure is at once profile, frontal and three-quarter view: Alma's upper body is shown from the side, while her face and lower body – pelvis and legs – are shown in three-quarter view; only her joined hands and one of her feet are turned fully toward the viewer. The fleshy woman, with long, unbound red hair, turns her head slightly toward us. The voluptuous body is reminiscent of Renaissance depictions of Venus, while her body language – the long loose hair and joined hands – recalls images of the sinner and penitent Mary Magdalene.[31] Kokoschka's lost lover is a love goddess, a prostitute, and a repenting saint, her orientation to the viewer coy, ambivalent, and confrontational.

Perhaps more striking than the complexity of the form is the painting's texture: the flesh seems to radiate from the reddish-brown background. The formless technique and the sharp contrast between dark background and light-colored body give Alma a luminescence, rendered in white, ocher, yellow, red, and orange. She seems to give off flames, and her figure itself appears as one tall flame, burning its way through the canvas. Indeed, between 1912 and 1914, flames appeared often in Kokoschka's work as a metaphor of all-consuming love, including in two of the painted fans he crafted for Alma. Representing the antagonism between man and woman, the fire as a destructive force was the central theme of his 1911 Expressionist drama *The Burning Bush* (*Der brennende Dornbusch*).[32] Here Alma's burning body is eerie, supernatural, almost like a divine apparition – a body of light, a body of resurrection. So, when Kokoschka sends his portrait to Moos, he is sharing with her his first effort to reignite an old flame, to resurrect his lover and their love through doll thinking. He laid on many layers of paint, thick and compact, enough to conjure a

29. Keegan, *The Eye of God*, 106.
30. See Brugger, "Larve und Stille Frau," 69–78.
31. See the paintings of Venus by Lucas Cranach the Elder and Hans Baldung (around 1525), Peter Paul Rubens (around 1630), and the sculpture of Mary Magdalene by Gregor Erhart (around 1515).
32. See Dorle Meyer, *Doppelbegabung im Expressionismus: Zur Beziehung von Kunst und Literatur bei Oskar Kokoschka und Ludwig Meidner* (Göttingen: Universitätsverlag, 2013).

Fig. 3. Oskar Kokoschka, *Standing Female Nude, Alma Mahler*, 1918. Private collection, London. Courtesy of Caroline Schmidt Fine Arts LLC.

three-dimensional surface. And yet, with its nervous brush strokes and irregular daubing, his rendering also seems to dissolve and decay on the canvas.[33]

This effect – Alma's simultaneous resurrection and decomposition – is mainly the result of Kokoschka's use of the impasto, which invited shadow and dimension into the painting's surface, while also providing a haptic quality. The *Standing Female Nude* welcomes a caressing gaze, a bodily relationship between image and viewer. While the uneven surface defies any single, universal angle on Alma, it also invites the gaze to wander and linger. Kokoschka engages the viewer in a different type of sensuous experience, one that scholar Laura Marks describes as "haptic" visuality, where "the eyes themselves function like organs of touch."[34] The primary viewer, however, was Kokoschka himself, attempting to repossess his lover. By dissolving the boundaries between sight and touch and by inviting the onlooker to have a sensorial and aesthetic experience, the *Standing Female Nude* of Alma Mahler certainly prompts him to doll think.

In his eighth letter, dated December 10, 1918, Kokoschka comments on the doll photographs he has received from Moos:[35] "And now to the photos. […] What appears to be still unfinished in the photograph, I can tell you as well in writing."[36] Although Kokoschka was already startled by what he saw of his Alma doll in the photographs, he continued to delude himself about the chances of his doll project to succeed, and pressed on with instructions:

> Finally, the skin must be peach-like in its feel. There mustn't be seams at any place where you have reason to believe it will offend me, reminding me that the fetish is nothing but a wretched ragbag. […] Dear Miss Moos, please don't let them torment me for many years of my life, don't let those mean realities – cotton, fabric, yarn, chiffon, whatever their dreadful names may be – obtrude their mundane presence, when what my eyes seek to encompass is precisely an equivocal creature, dead and at once spiritually alive.[37]

33. For a detailed analysis of the oil painting, see Brugger, "Larve und 'Stille Frau'," 69–78.
34. Laura U. Marks, *Touch: Sensuous Theory and Multisensory Media* (Minneapolis: University of Minnesota Press, 2002), 44.
35. See his eighth letter, dated November 20, 1918: "Also, bitte, schicken Sie womöglich eine Photographie von einigen Seiten meiner Geliebten." Reproduced in Kokoschka and Spielmann, eds., *Briefe I*, 298.
36. "Und nun zu den Fotos. […]. Was mir in der Photographie noch nicht fertig scheint, kann ich Ihnen also auch schreiben," Kokoschka and Spielmann, eds., *Briefe I*, 299. Translated by author.
37. Keegan, *The Eye of God*, 113.

While conveying his excitement, arousal, anxiety, fear, and impatience – he refused to touch the doll before its completion – these sentences lay bare Kokoschka's obsession with a skin that will enable doll thinking. He cannot have his desired experience without the perfect feel: "It is the skin," Smith writes, "that is bothering him, inciting him, consuming him, frustrating him."[38] Not to mention the hair.[39] In his letter dated January 23, 1919, he requests that the doll be anatomically correct, right down to the vulva and pubic hair: "Although I feel ashamed I must still write this, but it remains our secret (and you are my confidante): the *parties honteuses* must be made perfect and luxuriant and covered with hair, otherwise it is not to be a woman but a monster."[40]

The Fluffy Doll by Hermine Moos: The Doll-Maker's Rebellion

Despite Kokoschka's tremendous efforts to convey his criteria for the skin, the resulting doll was not at all what he had expected. Judging from the four remaining photographs of the Alma doll (Figs 6, 7, 8 & 9), Moos seems to have engaged with the *Standing Female Nude* of Alma Mahler, and her choice of fluffy skin instead of silk fabric might well be her artistic response to Kokoschka's impasto paint.[41] The scarcity of raw materials after World War I may also have influenced her choices. However, I do believe, as Bonnie Roos argues, that her rendition of Alma as a monstrous plushy doll was, to some extent, an act of defiance. Kokoschka's instructions did not move Moos to doll thinking. A closer look at her staged photographs of the doll suggests in fact that she was poking fun at Kokoschka, mocking his obsession. We see the doll sitting cross-legged (Fig. 6), reclining on a bed (Fig. 7), or holding a miniature doll in its hand (Fig. 5). In another image we see a woman kneeling in front of the doll (Fig. 4). The presence of Kokoschka's sketches in two of the images, and the recurrence of the Oriental rug, suggest that the four staged photographs were part of a series. Schreiber's investigation revealed that the doll photographs were taken by Moos herself, with the exception of one, shot by her sister Henriette, in which the doll-maker knelt before the doll.[42]

38. Smith, *The Erotic Doll*, 117.
39. Kokoschka and Spielmann, eds., *Briefe I*, 301: "Die behaarten Stellen nicht sticken, sondern wirkliche Haare einziehen, sonst wirkt es, wenn ich eine nackte Figur danach malen will, nicht lebendig, sondern wie Kunstgewerbe."
40. Hoffman, *Kokoschka*, 147.
41. Brugger, "Larve und 'Stille Frau," 69–78.
42. Schreiber, "Hermine Moos, Painter," 91–95.

With biting irony, the fluffy doll is set up either as an object of worship (Buddha in lotus position, enthroned queen, reclining Venus) or a figure of mise-en-abîme (large doll playing with a miniature doll). These humorous tableaux vivants pastiche Edouard Manet's *Olympia* (1863) (Fig. 7) or Erich Heckel's *Girl with Doll/Fränzi* (1910) (Fig. 5).

These overtly parodic doll photographs – most likely taken by Moos herself in her Munich apartment, with help from her sister Henriette – also call attention to the relationship between femininity and photography, on one hand, and to the subject of mimicry on the other. Here the doll-maker steps into the role of a doll photographer: she stands not only behind the lens, but also in front of it, even posing with her own doll in one double portrait photograph. Moos takes and calls the shots, playfully manipulating and observing her own doll, staging her in various poses and tableaux vivants reminiscent of so many reclining female nudes in Western art that catered to the male gaze, such as Titian's *Venus of Urbino* (1534). Moos mimics that voyeuristic male gaze, by exposing the doll's frontal nudity to the viewer, while also subverting the fetishization of the female figure, by displaying its furry body. In the photographs, the doll seems completely absorbed in its own activity, whether meditating (Fig. 6), daydreaming (Fig. 7), doll playing (Fig. 5), or gazing at the doll-maker (Fig. 4) – in every case oblivious and indifferent to the external gaze. Moos' images give the impression that her doll has a life of its own, that it remains inaccessible and impenetrable to the viewer, an impression reinforced by the fur itself.

It remains unclear whether the photographs were meant as a message to Kokoschka, who demanded that Moos document all of her progress with the Alma doll, or just for herself. The photograph (Fig. 4) where the doll-maker kneels adoringly beside her doll, gazing at her intently, reveals the contrast and hierarchy between the craftswoman and her artifact: the crouching doll-maker clad in a black dress with a white collar, and the unclothed furry doll, seated in an armchair with her legs crossed.

The doll looks like a queen on a throne, granting an audience to a loyal subject. Moos presents herself as a supplicant, which is most likely how she felt Kokoschka perceived her – a mere surrogate, to be quickly dismissed, silenced, and negated once she delivered his long-awaited doll. Kokoschka's doll episode was recorded for posterity, but the doll-maker was lost until fairly recently, when her identity was rediscovered and her work rehabilitated. This tableau vivant could be read, however, as an enactment of a quote from one of Kokoschka's letters: in his sixth letter, dated October 16, 1918, he shares his dream of enthroning his fantasy princess in his new apartment

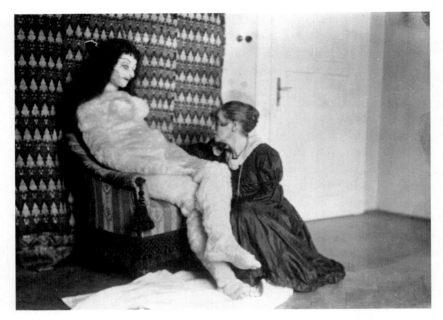

Fig. 4. Photographer unknown, *The Dollmaker Hermine Moos in front of the Doll in her Parents' Apartment*, Munich 1919. Gelatin silver print. © Birgit & Peter Kainz, Oskar Kokoschka Zentrum, Universität für angewandte Kunst Wien.

in Dresden.[43] Here, the doll-maker in the role of an adoring doll fetishist most likely impersonates her patron Kokoschka, poking fun at the painter's fantasy, while reclaiming agency in her relationship with her creation. Paradoxically, her staged impersonation of a doll fetishist is a better imitation than her life-sized doll replica of Alma Mahler, which verges on the grotesque. Except for the woman's kneeling and adoring gesture, this photograph cannot be clearly deciphered or put into context.

The next photograph (Fig. 5), most likely shot at night by Moos, depicts the doll sitting upright on a sofa, one leg stretched out in the front, arms resting by its sides.

43. Kokoschka and Spielmann, eds., *Briefe I*, 298: "Ich ziehe im Winter nach Hellerau hier bei Dresden und würde mich schrecklich freuen, wenn ich meine Phantasiefürstin schon dort in die neue Wohnung inthronisieren könnte."

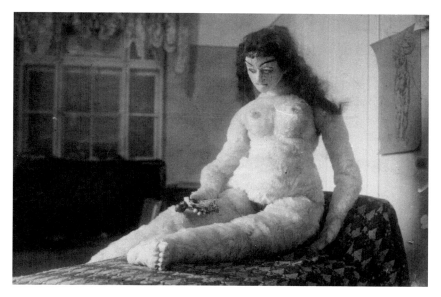

Fig. 5. Photographer unknown, *The Doll*, Munich 1919. Gelatin silver print. © Oskar Kokoschka Zentrum, Universität für angewandte Kunst Wien.

Lost in thought, the doll seems to turn its gaze to a black-headed miniature puppet held in its right hand. Pinned to the wall on the right behind the doll hangs a sketch of a female figure, presumably by Kokoschka. The image composition here stages three levels of representation: a two-dimensional drawing meant to serve as a master, a three-dimensional anatomical doll meant to stand in for Alma Mahler, and a three-dimensional miniaturized toy puppet, meant to represent a black person. The photograph raises the issue of mimesis versus mimicry by calling attention to the disconnect between the artifact and its representation. The two three-dimensional objects are perfect examples of mimicry: the doll is a grotesque representation of Alma Mahler the same way the puppet is an outrageous depiction of a black person. Kokoschka's drawing was meant to represent Mahler's body, but his rendition ends up distorting her with its lines and truncations, and ends up demonstrating a profound discrepancy between image and representation. And Moos' photograph capturing this succession of images further complicates this relationship. Analyzing the return of life-size dolls in contemporary visual culture under a Lacanian lens in *Dolls, Photography, and the Late Lacan*, Rosalinda Quintieri recalls that, from a semiotic point of view, photography, as an index, is closely connected to its referent, and therefore can be considered as "a message without a code,

a message for which an interpretive code is not needed since the referent is presented in its integrity."[44] And yet, Moos' photograph, which documents the presence and existence of the Alma doll, paradoxically overturns the traditional definition of photography as index. Moos' photograph is indeed an index – a record of the doll's existence – and yet, in documenting the Alma doll, the image also banishes the referent, and disrupts the traditional link between image, person, and object. Furthermore, the viewer needs context as well as an interpretive code to make sense of the photograph. By calling attention to the gap between image, person, and object, Moos' photograph displays a proto-Surrealistic sensibility that reaches its peak with Hans Bellmer's doll photographic experimentations. Above all, the photograph shows that the doll-maker-turned-doll-photographer doll thinks, or rather that photography turns the doll-maker into a doll thinker. In the next staged photograph (Fig. 6), which represents the doll seated in a lotus position, looking up, meditating (and perhaps even levitating), next to a sketch of a head, presumably by Kokoschka, Moos is clearly doll thinking.

Engaging playfully with the Alma doll, she dissolves boundaries between subject/object, animate/inanimate, reality/imagination. Exposing the disconnect between Kokoschka's sketch and Moos' doll, as well as the absence of referentiality for both artifacts, the photograph collapses any distinction between image/person/object. Looking at Moos' uncanny doll photographs, the confused viewer cannot help but doll think in turn. The last photograph (Fig. 7), showcases the doll in the nude, reclining on a sofa, covered with the oriental rug.

The absent-minded, reclining doll, with its left hand resting under its head and the right arm stretched on its side, offers its furry body to the viewer, in an image reminiscent of turn-of-the-century pornographic postcards from France. Forced into a caressing gaze on the doll's soft and plushy skin, the unsettled viewer is compelled into doll thinking. The doll's position recalls famous modernist paintings of female nudes, such as Francisco Goya's *The Nude Maja* (*La Maja Desnuda*) (1800) and Édouard Manet's *Olympia* (1863). By alluding to so many different canonical images (Alma Mahler, Maja, Olympia), the photograph in the end alludes to none of them. The viewer is overwhelmed by resonances, and left in the end with no sense of context. Because Moos' image of the doll duplicates and replicates previous depictions of female nudes, it is

44. Rosalinda Quintieri, *Dolls, Photography, and the Late Lacan: Doubles Beyond the Uncanny* (New York: Routledge, 2021), 18.

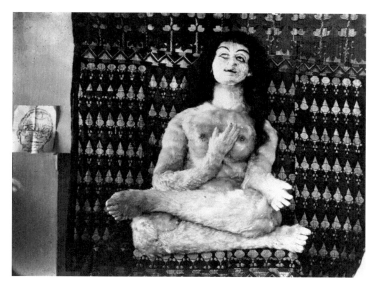

Fig. 6. Photographer unknown, *The Doll Seated Next to a Head Study by Oskar Kokoschka*, Munich 1919. Gelatin silver print. © Birgit & Peter Kainz, Oskar Kokoschka Zentrum, Universität für angewandte Kunst Wien.

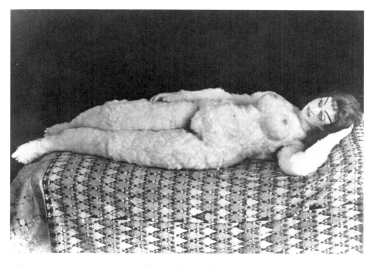

Fig. 7. Photographer unknown, *The Doll Reclining*, Munich 1919. Gelatin silver print. © Birgit & Peter Kainz, Oskar Kokoschka Zentrum, Universität für angewandte Kunst Wien.

both a tribute to and a critique of the ways the Western canon fosters male voyeurism. And, because the life-size anatomical doll is both seductive and repulsive, sublime and grotesque, it blurs the line between mimesis and mimicry. By photographing a doll she crafted for a painter, Moos inscribes herself twice onto her work: as a doll and an image maker. Moos, a craftswoman, an avant-garde doll-maker, and a trained painter, has turned to photography in a gesture that recalls the medium's connection to the movement of women's emancipation throughout the twentieth century. She did not use the camera for the sole purpose of documenting her artwork, but rather as a means of self-expression and artistic experimentation. Ironically, the doll did not survive, but the images did, leaving an indexical trace of her work and her existence, traces that ultimately rescued her from oblivion. Through her staged doll photographs, Moos critiques the established visual conventions of gender, exposes the voyeuristic gaze of male artists, and denounces the sexualization and orientalist fetishization of the female body. In many regards, Moos' black-and-white images foreshadow Bellmer's doll photographs: not only by crafting, photographing, manipulating, staging, and doll playing, but also by interrogating the medium's complex relationship to mimesis, indexicality, and referentiality.

Drawing on Bernstein's concept of the "scriptive thing," that is "an item of material culture that prompts bodily behaviors," I argue that the doll-maker intentionally constructed the doll as a cuddly, anti-sexual object, to frustrate the painter's desire and to establish her own authorship.[45] In crafting a fluffy, life-sized doll, she scripted an ironic performance in which the painter, like a child separated from his mother, would snuggle up to something both grotesque and obscene. Inscribing herself on the doll – Moos means "moss" in English – the doll-maker reclaimed her work and scolded Kokoschka for all his fevered mansplaining.[46] In the process, she neutered his fetish and scuttled his doll thinking.

The Final Letter of a Frustrated Doll Thinker

No surprise, then, that Kokoschka was deeply dissatisfied with her work. In his last letter, dated April 6, 1919, he resorted to a typewriter to vent his

45. See Robin Bernstein, *Racial Innocence: Performing American Childhood from Slavery to Civil Rights* (New York: New York University Press, 2011).
46. That is the argument put forth by scholar Bonnie Roos in her article "Oskar Kokoschka's Sex Toy: The Women and the Doll Who Conceived the Artist," *Modernism/Modernity* 12, no. 2 (2005): 291–309.

frustration: "What shall we do now, your doll ... has *quite taken me aback*. I was prepared to make allowances to subtract from my fancy in favor of reality; but in too many ways she belies what I demanded of her and expected from you."[47] Just as he had lectured her throughout their nine-month correspondence, he went on to list each of the doll's defects and imperfections: "The outer shell is a polar-bear-pelt, suitable for a shaggy imitation bedside rug rather than the soft and pliable skin of a woman."[48] He bemoaned the doll's lack of a skeleton, and the floppiness of the limbs:

> Then there is the skeleton. I asked you repeatedly to reinforce it with glue or something of the kind; but soon upon arrival it grew so soft that arms and legs now dangle like stockings stuffed with flour rather than resembling limbs of flesh and bone, an effect I certainly had not looked for. Yet this was the crucial element to enable me to use the doll as a model ... indeed this was the very reason why I had her made. [...] The arms have no real shape, the upper arms and forearms being quite at odds. The knees seem to be afflicted with elephantiasis and the legs have no style at all. The result is that I cannot even dress the doll, which you knew was my intention, let alone array her in delicate and precious robes. Even attempting to pull on one stocking would be like asking a French dancing master to waltz with a polar bear.[49]

The sarcastic tone in the letter conveys Kokoschka's disillusionment with the doll-maker, who had refused to channel his doll thinking. Focusing on the cause of the painter's disappointment, my interpretation differs considerably from those of Kokoschka biographers and scholars. Hoffman and Keegan, who rely on inaccurate translations of the letters, misread Kokoschka's disappointment: he was not startled because the doll was monstrous, ghostly, grotesque, or lifeless; he was bothered that it did not allow for doll thinking. Although he was convalescing, Kokoschka was not demented; he did not believe he could actually bring Alma to life! Unlike Roos, I doubt that he was disappointed with the doll as an outlet for erotic and sexual fantasies. Kokoschka's intention from the start was to use the doll, not exclusively as a sex toy, but as a life model for painting, as he reminds Moos in his eighth and

47. Keegan, *The Eye of God*, 114.
48. Keegan, *The Eye of God*, 115.
49. Keegan, *The Eye of God*, 115.

twelfth letters. In that regard, the final line of his tenth letter, dated January 23, 1919, is telling: "Only a woman can inspire me to create works of art, even when she only lives in my imagination."[50]

What the painter wanted, in my opinion, was an object with which he could experience the uncanny, a fetish that would magically activate his wish to blur fantasy and reality.[51] He even requests that Moos insert something of herself inside the doll's body to activate its magical power.[52] Far from being "stunned, enraptured because it [the doll] was not alive," as Smith argues, Kokoschka was actually horrified ("erschrocken" is the German term he uses in his final letter): instead of the magical fetish he was expecting, he was delivered a thing.[53] In this context, thing theory provides a useful framework for the painter's horror and disillusionment, as well as the effect of this doll-thing on his work.[54] Things rest outside of the order of objects, Bill Brown explains, in a state of liminality and amorphousness: they are uncertain, ambiguous, excessive, and unspecified.[55] Brown captured this instability when he wrote that thingness is revealed and confronted when objects break, or no longer work in recognizable ways.[56] In his argument, the work things do is to rearticulate the subject–object relation.[57] Brown's explanation befits Moos' furry, amorphous doll: as a failed object (of doll thinking), it did not work for Kokoschka, nor did

50. Hoffman, *Kokoschka*, 147.
51. The term "fetish" recurs, in fact, in his letters to Moos from September to December 1918. For example, Kokoschka starts and ends his fourth letter to Moos, dated September 19, 1918, referring to his doll as his fetish: "Der Fetisch ist am 18.9. von hier nach mehrmaligem Beanstanden glücklich abgereist. [...] Ich empfehle Ihnen noch meinen Fetisch an's Herz." Reproduced in Kokoschka and Spielmann, eds., *Briefe I*, 295–96.
52. See Kokoschka's letter to Moos, dated December 10, 1918: "so bitte ich Sie wieder, Ihre mir zugedachte geisterhafte Gesellschafterin so mit allem aufgeregtesten Spürsinn zu erraten und zu animieren, daß am Ende, wenn Sie den Körper fertig haben, auch nicht ein Fleckchen bleibt, auf welchem nicht eine Seltsamkeit, ein raffinierter Belebungsversuch auf der toten Materie fehlt und alle so zarten und innigen Verschwendungen des Lebens am weiblichen Körper mir in der und jener verzweiflungsvollen Stunde wieder einfallen, durch irgendein stellvertretendes Monogramm, Zeichen, welches Sie in das Fetzenbündel hineingeheimnist haben." Reproduced in Kokoschka and Spielmann, eds., *Briefe I*, 302.
53. Smith, *The Erotic Doll*, 129.
54. Smith, *The Erotic Doll*, 129.
55. See Bill Brown, "Thing Theory," *Critical Inquiry* 28, no. 1 (2011): 1–16.
56. See Fiona Candlin and Raiford Guins, "Introducing Objects," in *The Object Reader* (New York: Routledge, 2009), 1–18.
57. Brown, "Thing Theory," 4; "the story of objects asserting themselves as things, then, is the story of a changed relation to the human subject and thus the story of how the thing really names less an object than a particular subject-object relation."

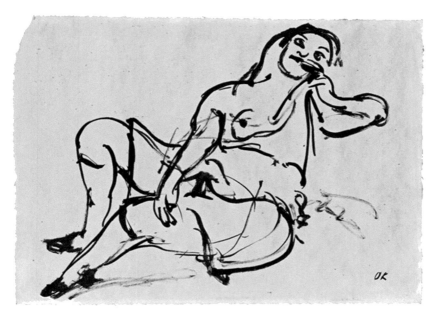

Fig. 8. Oskar Kokoschka, *Study for Woman in Blue*, 1919. Ink on paper. © Auktionshaus im Kinsky GmbH, Wien. © 2023 Fondation Oskar Kokoschka / Artists Rights Society (ARS), New York / ProLitteris, Zürich.

he know what to do with it; as a doll-thing, it forced the painter to renegotiate the relationship. And, indeed, this is exactly what Kokoschka did in the next 18 months. Once he had overcome his initial horror, he used the doll as he had always intended to, as a lifelike model, and made about 30 (surviving) pen-and-ink drawings and one oil painting. His graphic work of that year featured thick and large strokes (Fig. 8).

Since he could not doll think in its presence, Kokoschka focused on its surface instead. In his effort to render the doll-thingness, he continued to explore a "haptic visuality," to which he had already turned his hand while executing the *Standing Female Nude* of Alma Mahler.

Kokoschka's Doll Paintings

We see this continuation of haptic visuality in *Woman in Blue*, the half-length portrait of his doll from 1919 (Fig. 9). The painting features a female figure wearing a navy-blue bustier dress, from which her breasts are bursting forth.

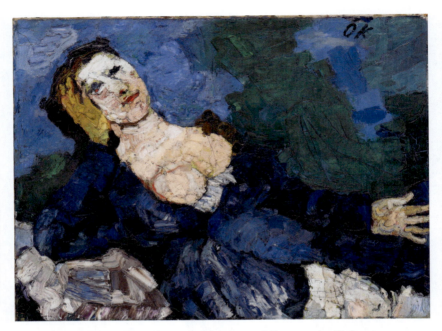

Fig. 9. Oskar Kokoschka, *Woman in Blue*, **1919. Oil on canvas. Foto: © Staatsgalerie Stuttgart.**

The figure is reclining, her left arm supported by cushions, her head leaning on one hand while the other aligns with her torso. The full-breasted *Woman in Blue* looks absent-minded and self-absorbed, with no concern for the viewer.[58] The subject is indeed the Alma doll, or rather the "Silent Woman" ("die stille Frau") as the painter came to call her, a nickname underlining its stillness, as well as its to-be-looked-at-ness. *Woman in Blue* is Kokoschka's first attempt at rendering the doll-thingness on the canvas with impasto: the thick application of paint, in broad overlapping strokes, conveys the doll's fluffy texture. Though some of the brushwork is similar here to *Standing Female Nude*, the intent is entirely different: in the earlier painting, the thick strokes aimed at creating a three-dimensional image conducive to doll thinking, rendering

58. The female's pose and her bustier dress in *Woman in Blue* recall Edouard Manet's two scandalous paintings: his female nude *Olympia* (1863) and the portrait of a barmaid and prostitute in *Bar at the Folies Bergère* (1882).

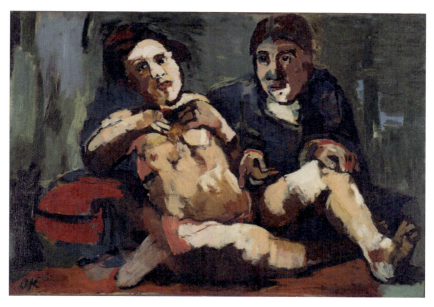

Fig. 10. Oskar Kokoschka, *Painter with Doll*, 1922. Oil on canvas. © VG Bild-Kunst, Bonn 2022. © Staatliche Museen zu Berlin, Nationalgalerie, 1974 erworben durch das Land Berlin / Foto: André van Linn.

shadows and protrusions that invited the viewer to *experience* the body of the subject; in the later painting the brushwork simply renders the quality of fluffiness in two dimensions, a thingness without psychological depth. Though he positioned his doll like a human female, reclining and daydreaming, her face is lifeless, her eyes dark and unseeing, her body contorted. With his emphasis on thickness, flatness, and amorphousness, Kokoschka renders his doll as a thing, apparently unsuited for doll thinking.

In his second doll painting, entitled *Painter with Doll* (1922), Kokoschka attempted once more to objectify the doll-thing, this time adding his own image to the picture (Fig. 10).

Three years on from *Woman in Blue*, the doll's appearance and position have significantly evolved. Though it retains some opaqueness and stiffness, the expression, figure, and limbs now appear distinctly. Kokoschka is seated behind his doll, both of them on a red bed in an interior setting. The naked doll is covering her breasts, while the painter is fully dressed, resting one hand on

its knee while pointing to its crotch with the other.[59] The doll's body occupies the center of the picture, and Kokoschka renders the skin with large, blockish patches of warm flesh tones – ocher, red, and white. The impasto is not as generous here as in the 1919 oil painting, however; the relationship between the painter and his doll-thing has shifted. In *Painter with Doll* Kokoschka portrays himself as a subject in relation to an object. The doll-object has lost its magic, and is reduced now to a prop.[60] By pointing to the doll's genitals, Kokoschka indicates a sterile womb, presided over by the potent and fertile artist.[61] His pointing finger harkens back again to Renaissance renderings of resurrection – the artist has become the creator.[62] While the doll fixes its gaze on the viewer, the painter stares outside of the frame (most likely into a mirror, as this is a self-portrait). The configuration also calls to mind a pietà in reverse. In the role of mater dolorosa, Kokoschka shows himself as parent and creator to a stillborn creature. Though *Painter with Doll* features Kokoschka as an artist disillusioned with his doll-object, it also announces the doll's shift from artwork to dismissible commodity, and finalizes the erasure of the original doll-maker. He has claimed authorship of the Alma doll and completely erased Moos from history.

From Doll Making to Unmaking

In doing so, Kokoschka also added a chapter to his own legend. The stories told about the Alma doll would evolve over the years, but always centering the painter as a mad artist with a doll fetish. In his two autobiographies, *A Sea Ringed with Visions* (1962) and *My Life* (1974), Kokoschka told different stories of how the doll came to be, and how it was destroyed.[63] His biographers, Hoffman and Keegan, also differ considerably in their accounts.

59. The configuration of a naked woman with a dressed man recalls another scandalous painting by Edouard Manet, *Luncheon on the Grass* (1863).
60. See Gorsen, "Pygmalions stille Frau," 255.
61. See Roos, "Oskar Kokoschka's Sex Toy," 303–305.
62. See for example the painting *St John the Baptist* by Leonardo Da Vinci (1513) or the fresco painting *The Creation of Adam* by Michelangelo (1508–1512).
63. In his memoirs, he recalls his maid Hulda/Reserl, who assisted in his fantasy games with the Alma doll. In their role-plays, she acted as the doll's maid, attending to its every need – at least when she was not out spreading rumors in Dresden: that the mad painter "had hired a horse and carriage to take her out on sunny days, and rented a box at the Opera in order to show her off." See Oskar Kokoschka, *My Life*, David Britt, trans. (New York: MacMillan Publishing, 1974), 116–118.

Kokoschka had originally planned to travel to Munich and pick up the doll himself, but his health made that impossible, and so he asked Moos to ship the doll to Dresden.[64] Though his final letter suggests he was profoundly disappointed when he saw the doll, his 1974 autobiography provides a scene of enchantment and delight:

> The packing-case was brought into the house by two men. In a state of feverish anticipation, like Orpheus calling Eurydice back from the Underworld, I freed the effigy of Alma Mahler from its packing. As I lifted it into the light of the day, the image of her I had preserved in my memory stirred into life. The light I saw at that moment was without precedent. [...] Now, the cloth-and-sawdust effigy, in which I vainly sought to trace the image of Alma Mahler, was transfigured in a sudden flash of inspiration into a painting – *The Woman in Blue*. The larva, after its long winter in the cocoon, had emerged as a butterfly.[65]

The 85-year-old painter's recollections are completely at odds with the response he described to Moos in April, 1919. We cannot know for sure which one is accurate, but Kokoschka's later account sheds a different light on the doll, and invites a new reading of Moos' craft. If indeed, as he laid his eyes and hands on the doll, "the image of [Alma Mahler] [he] had preserved in [his] memory stirred into life," then Hermine Moos succeeded in her task. This ecstatic moment of doll thinking is exactly what he had wished for at the start. If it is true that Moos' work provoked a light apparition on first contact, and inspired him thereafter, then Moos' work is due for a reappraisal.

We also have differing accounts of the infamous party Kokoschka threw for his doll in Dresden. In one of his letters to Moos, dated October 16, 1918, the painter envisioned a ceremony to welcome and celebrate the doll's arrival, something like the enthronement of a queen.[66] Kokoschka did hold a ceremony

64. See Kokoschka's 11th letter to Moos, dated February 22, 1919: "Ich glaube es nicht, kränklich wie ich bin, riskieren zu können, schon jetzt die Reise nach Wien anzutreten und noch mit Gepäck außerdem. [...] Ich bitte Sie, liebes Fräulein Moos, nun noch das letzte Liebeswerk für mich zu tun, und mit aller Sorgfalt und Umsicht, Schutz gegen Feuchtigkeit, gegen Zerstörung, Schloß gegen Einbruch und mit hohen Versicherungen und expreß die Puppe an mich senden lassen zu wollen." Reproduced in Kokoschka and Spielmann, eds., *Briefe I*, 309.

65. Kokoschka, *My Life*, 117.

66. See Kokoschka's sixth letter to Moos: "Ich ziehe im Winter nach Hellerau hier bei Dresden und würde mich schrecklich freuen, wenn ich meine Phantasiefürstin schon dort in die neue Wohnung inthronisieren könnte." Reproduced in Kokoschka and Spielmann, eds., *Briefe I*, 298.

with the doll at his house in Dresden, though the details are disputed. According to Hoffman, the artist threw a burial ceremony for the doll soon after receiving it, to formalize his rejection of her.[67] Kokoschka, however, recalled a sacrificial ceremony, which his biographer Keegan dates in the summer of 1920 – suggesting that he kept the doll for 18 months at least:

> I decided to have a big party, with champagne for all my friends – male and female – and there put an end to my inanimate companion, about whom so many wild stories were circulating in Dresden. I engaged a chamber orchestra from the Opera. The musicians, in formal dress, played in the garden, seated in a baroque fountain whose waters cooled the warm evening air. We all had a lot to drink. Torches were lit. [...] Reserl paraded the doll as if at a fashion show.[68]

The champagne party with orchestra mimics a religious offering where the furry doll functioned as a sacrificial lamb to be executed in front of Kokoschka's guests. Like the rumors about Kokoschka parading the doll in a coach through the city or seating it in an opera box – the procession to execution must be regarded as an art performance: on the one hand, its farcical provocations recall the Dada performances at Cabaret Voltaire in Zurich around 1916; on the other, the uncanny dreamlike eroticism foreshadows the burgeoning Surrealist movement.

Kokoschka told different stories of the doll's demise. In his 1961 autobiography, the Alma doll becomes a sort of Winnicottian transitional object, assigned a therapeutic function and, once that function was fulfilled, no longer of use to him. But simply dismissing the doll was not enough. He had declared himself the creator, and he would be the destroyer:

> Finally, after I had drawn it and painted it over and over again, I decided to do away with it. It had managed to cure me completely of my Passion. So I gave a big champagne Party with chamber music, during which my maid Hulda exhibited the doll in all its beautiful clothes for the last time. When dawn broke – I was quite drunk, as was everyone else – I beheaded it out in the garden and broke a bottle of red wine over its head.[69]

67. Hoffman, *Kokoschka*, 148–149.
68. Kokoschka, *My Life*, 118.
69. Oskar Kokoschka, *A Sea Ringed with Visions* (New York: Horizon Press, 1962).

In the 1974 version of his autobiography, the doll was still beheaded, but this time by accident:

> In the course of the party, the doll lost its head and was doused in red wine. We were all drunk. Early the next morning, when the party was almost forgotten, the police appeared at the door, investigating a report that a headless body had been seen in the garden. [...] The dustcart came in the gray light of dawn, and carried away the dream of Eurydice's return. The doll was an image of spent love that no Pygmalion could bring to life.[70]

Both accounts emphasize the theatricality of the death scene, along with a sadistic, misogynistic violence inflicted by the painter upon his doll. The image of the beheaded doll, red wine/blood drenched and lying in the open, brings to mind the sex crime pictures produced by Georg Grosz and Otto Dix during the same period – both of them recently returned from World War I.[71] Whether Kokoschka was the murderer or just a witness, the doll's death was an act of revenge by a frustrated doll thinker. Moreover, it was a victory by the male genius over the muse – the doll and Alma herself – and over the female artist who brought her to life for him. The doll's tragicomic end was a turning point in Kokoschka's artistic development: it put an end to his work as an Expressionist playwright, dramatizing erotic desire under the lens of Viennese fin-de-siècle misogyny.

Epilogue: Doll Thinking is Alive and Well

Kokoschka claimed in both his autobiographies that the death of the doll released him from Alma Mahler, and enabled him to move on personally and artistically. His biographers accepted this claim, until German historian Oliver Hilmes, biographer of Alma Mahler, told a completely different story. Based on newly discovered letters between Mahler and Kokoschka, he revealed that the two never stopped communicating: they kept in touch on and off through

70. Kokoschka, *A Sea Ringed with Visions*, 118.
71. Portraying themselves as slayers of prostitutes in their drawings, Grosz and Dix express their sadistic violence and misogynistic rage, both a symbol of castration anxiety and a symptom of war trauma. See Georg Grosz, *Sex Murder in Acker Street* (1916–1917) and Otto Dix's *Lust Murder* (1920). For a detailed analysis, see Maria Tatar, *Lustmord: Sexual Murder in Weimar Germany* (Princeton: Princeton University Press, 1997).

their entire lives, and even exchanged erotic letters in old age. Still nostalgic for their affair, a 65-year-old Kokoschka wrote to his old love on June 7, 1951:

> If I ever find the time, then I'll make you a life-size wooden figure of myself, and you should take me to bed with you every night. The figure should also have a member in the position you made it for me, so you can remember me better and through practice also acquire a lust for the real thing again. We will get together again some time.[72]

Whether the life-size wooden figure was ever built, the story does not say. But the excerpt reveals that doll thinking was alive and well in Kokoschka's mind, 30 years later. In 1918 he had her reconstructed for his pleasure (and without her consent); in 1951 he was offering to return the favor, inviting her to doll think. The image, though, casts the former lovers in new roles: Kokoschka is the doll-maker, and Alma the doll thinker, embracing her wooden Oskar as she had long ago embraced the man.

72. Oliver Hilmes, *Malevolent Muse: The Life of Alma Mahler*, Donald Arthur, trans. (Boston: Northeastern University Press, 2015), 273.

CHAPTER 3

Doll Thinking: A Kinetic Approach
Lotte Pritzel's Wax Dolls

> Je n'suis qu'une poupée de cire
> Qu'une poupée de son
> Sous le soleil de mes cheveux blonds
> Poupée de cire, poupée de son
> —France Gall, *Poupée de cire, poupée de son*, 1965

Charlotte (aka Lotte) Pritzel (1887–1952) was a German doll-maker, costume and set designer who found her greatest fame during the twilight years of the Wilhelmine Empire for a series of wax dolls. She was famous enough by 1918, in fact, that she turned down a commission from the painter Oskar Kokoschka, who asked her to create his "Alma doll," a life-sized replica of his ex-lover Alma Mahler. Pritzel knew about Kokoschka and his difficult temperament, through her husband, the neurologist Dr Gerhard Pagel, who had been the artist's physician since Kokoschka came to Dresden to recover after the war.[1]

In this chapter, I offer a close reading of Pritzel's doll photographs (which appeared in the periodical *Deutsche Kunst und Dekoration* between 1910 and 1922), and their reception by writers, poets, and performing artists. Based on early reviews of Pritzel's doll work, I argue that a sense of the uncanny began emerging in her "Dolls for the Vitrine" around 1910, and with it an impulse toward doll thinking in their viewers. By fashioning the dolls' flesh out of wax, staging them in sexy elaborate poses and dance movements, and showcasing them behind a vitrine, Pritzel lured the viewer into an unsettling sense of their aliveness. Pritzel's dolls belonged to the domestic sphere, but were also

1. For an in-depth analysis of Kokoschka's Alma doll crafted by Hermine Moos, see Chapter 2.

designed to disrupt it: lively, androgynous, and languidly erotic, they hit a raw nerve with artists, art critics, and connoisseurs, who were seduced by the mere sight of them into pure doll thinking.

Only by examining her "Dolls for the Vitrine" through the lens of doll thinking can one truly assess the aesthetic transformation of her miniature wax dolls showcased in the *Kunst und Dekoration* periodicals and measure the increase of their seductive force and uncanny power over the viewer. I will examine how her dolls perturbed the writers for the *Kunst und Dekoration* magazine, disturbed even Rainer Maria Rilke (whose essay on the subject I will consider below), and inspired the famous dancers Niddy Impekoven and Anita Berber, who performed solo pieces based on these wax figures under glass.

Pritzel's Story

Before falling completely into obscurity after World War II, Pritzel was a key figure of the pre-war Munich-Schwabing bohemia scene, the locus of a group of young and wild avant-garde artists and party animals, referred to as "the debauched doll clique of the young Lotte Pritzel."[2] Pritzel was known as the "cougar," for her round face, high cheekbones and small, piercing eyes, all framed by a bob, the distinctive hairdo of the New Woman. A muse to photographers, illustrators, and poets of the Schwabing bohemia, she became the quintessential free-spirited, independent woman of the pre- and interwar period, but early in her career she was known mostly for her dolls. Frequently featured in the illustrated periodical *Deutsche Kunst und Dekoration*, edited by Alexander Koch, the wax dolls captured the interest of Hermann Bahlsen, the cake and cookie company founder, who commissioned Pritzel to craft some as marketing props for the 1913 World's Fair in Ghent, Belgium. As a result of that commercial exposure, her wax dolls by 1914 were for sale and on display at the trendy Kunstgewerbehaus Friedmann & Weber, a Berlin-based Decorative Arts shop, whose owner, architect Ernst Friedmann, promoted Pritzel's work and helped her rise to fame. In her prime, she earned the admiration and respect of major German-speaking male artists: Austrian Expressionist painter Egon Schiele

2. Hanna Wolfskehl to Albert and Kitty Verwey, March 20, 1907, reprinted in *Karl Wolfskehl (1869–1969): Leben und Werk in Dokumenten* (Darmstadt: Hessische Landes-und Hochschulbibliothek Darmstadt, 1969), 184. See also Barbara Borek, "Die Pritzelpuppen der Puppenpritzel," in Antonia Voit, ed., *Ab nach München: Künstlerinnen um 1900* (Munich: Münchner Stadtmuseum, 2014), 316.

(1890–1918) collected her dolls[3]; German Symbolist poet Rainer Maria Rilke (1875–1926) published an essay, "Dolls. On the Wax Dolls of Lotte Pritzel," in 1914, shortly after visiting an exhibit of her work in Munich;[4] and, finally, German Surrealist artist Hans Bellmer (1902–1975) turned to her for advice and support between 1933 and 1935, while making his first and second dolls.[5]

As with Kokoschka and Bellmer, Pritzel's work comes with a founding myth: as she told it, the young Pritzel was alone in Paris Jardin du Luxembourg around 1909, playing with chestnuts. She began to make small figures out of them, to kill time, or perhaps to compensate for the lack of a cigarette.[6] Since there is no record of such a trip to Paris in the artist's biography, the Pritzel specialist Barbara Borek has suggested that Lotte Pritzel concocted the legend as part of her persona, seeking to establish some legitimacy in artistic circles, where she was exceptional for her lack of formal training.[7] The story of this humble beginning was picked up again by R. Coester, a critic at the periodical *Deutsche Kunst und Dekoration*, who, in the journal's 1919 issue, highlighted Pritzel's lack of formal training, and outed her as an autodidact.[8] Though they were once coveted as art objects among collectors and connoisseurs from the upper class (a single doll figure was reckoned at 34,000 Reichsmark, and a group at 1,275,000 Reichsmark, in the 1920s) most of her "Dolls for the Vitrine" have been lost or destroyed, the work as a whole largely forgotten.[9] While the wax material almost guaranteed the

3. A 1912 wax doll by Lotte Pritzel is listed in Egon Schiele's possessions; see Shiele's Autograph Database: http://www.schiele-dokumentation.at/recordlist_en.php.

4. Rilke's essay appears in *Die weißen Blätter*, a monthly Expressionist journal edited by German-French writer René Schickele.

5. See Chapter 4.

6. Lotte Pritzel, "Ich und meine Puppen," mit Aufnahmen von Pritzelpuppen aus der Ausstellung bei Friedmann & Weber. Source Unknown. Reprinted in Barbara Borek, "Geschöpfe meiner selbst – die Puppen der Künstlerin Lotte Pritzel (1888–1952) zwischen Kunst und Gewerbe" (Ph.D. diss., Technische Universität Berlin, 2003), 5: "An einem schönen Pariser Oktobernachmittag ... im Jardin du Luxembourg ... begann ich aus purer Spielerei, vielleicht in Ermanglung einer Zigarette, [mit Kastanien kleine Gestalten zu fertigen]".

7. See Barbara Borek, *Geschöpfe meiner selbst*", 5.

8. R. Coester, "Lotte Pritzel–Munich," *Deutsche Kunst und Dekoration: illustrierte Monatshefte für moderne Malerei, Plastik, Architektur, Wohnungskunst und künstlerisches Frauen-Arbeite* 45 (October, 1919): 347: "Der Anfang war keine Zeichenschule sondern eine Bastelei aus Kastanien im Luxemburg Garten"

9. Barbara Borek inventoried 213 dolls created by Pritzel, of which approximately 47 remain in museums and private collections.

objects would deteriorate over time, images of them have survived in magazine illustrations, reviews, and essays.

Pritzel's Dolls and Doll-Pritzel: Confusing the Doll-maker with Her Dolls

Few records exist of Pritzel discussing her work or her wax dolls. In one of the few personal statements she wrote for a catalog exhibit, she revealed that "her dolls were created in her own image, and that they were mirror reflections of her world, her language, and a mode of expression of herself":

> Die Puppen sind in Goetheschen Worten gesprochen 'Menschen nach meinem Bilde,' sie sind Spiegelungen der Welt, wie ich sie sehe, Ausdrucksformen meiner Person, Sprache, die ich spreche, Bekenntnis. Wenn ich meine Puppen kostümiere, so ist sozusagen jeder Faser Stoff, jede Scherbe Glas, jeder Stein, jedes Metall, das ich dazu wähle – Material gewordene innere Vision.[10]
>
> [My dolls are in the Goethean sense of the word "people in my image", they are reflections of the world as I see it, forms of expression of me as a person, a language I speak, a confession. When I dress up my dolls in costumes, it is, so to speak, as if every fiber of textile, every shard of glass, every stone, every metal I choose, was the materialization of my inner vision.]

Among the renowned female photographers Pritzel commissioned to take her portrait with the dolls, Madame d'Ora, aka Dora Kallmus (1881–1963), is of great significance. D'Ora was a pioneer in her time, and rapidly established herself as the photographer of the New Woman of the Weimar period. She chronicled the radical transformation of women, and published photographs of this new look in numerous illustrated magazines from the Ullstein Verlag publishing house, such as *Die Dame* and *Uhu*.[11] Many of the rich and famous of the interwar period came to her studios in Vienna and Paris to have their portrait

10. Lotte Pritzel, "Ich kostümiere Menschen," in Editha Mork and Wolfgang Till, eds., *Lotte Pritzel, Puppen des Lasters, des Grauens und der Extase* (Munich: Puppentheatermuseum Verlag, 1987), 85. English translation by the author.

11. See Esther Ruelfs, "D'Ora's Photographs of Women in the Illustrated Magazines of the 1920's," in Monika Faber, ed., *Madame d'Ora* (New York: Prestel Publishing, 2020), 87–96.

Fig. 11. Atelier Madame d'Ora, *The Dollmaker Lotte Pritzel*, 1924.
© Österreichische Nationalbibliothek.

taken, including the socialite Alma Mahler, the painter Oskar Kokoschka, the dancer Anita Berber, and the doll-maker Lotte Pritzel. D'Ora's dual portrait of Pritzel and her doll (Fig. 11) attests to Pritzel's celebrity status during the Weimar Republic, and solidifies her image as a New Woman, successful, independent, and emancipated.

The 1924 black-and-white image captures the intimate, almost organic, relationship between doll-maker and doll by arranging them in a manner that emphasizes the resemblance between "doll-Pritzel" and a "Pritzel-doll": during her lifetime, the doll-maker was known as "Puppen-Pritzel" and her dolls were called "Pritzel-Puppen." Set against a dark background, both are positioned at eye level: Pritzel's chin rests on her hand, which rests in turn on the corner of a velvet platform, where the doll is seated with its legs crossed. While the ornamental motif on the doll's garment echoes the arabesque pattern of Pritzel's lace blouse, the doll's facial features (the oval of the face, the almond-shaped dark eyes) resemble Pritzel's own. The photograph focuses on Pritzel's face, neck, and hand, and foregrounds the same features in the doll, showcasing their likeness on a different scale. By staging the Pritzel doll as the spitting image of its

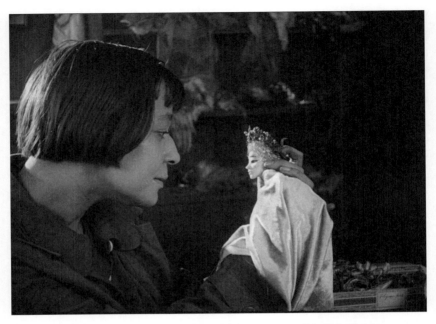

Fig. 12. Still from the Universum Film AG Documentary, *Die Pritzelpuppe* (*The Pritzel-Doll*), 1923. © Friedrich-Wilhelm-Murnau-Stiftung.

maker, D'Ora's portrait echoes Pritzel's statement: "My dolls [...] are people in my image."[12] In doing so, the photograph unsettles the viewer by orchestrating the confusion between the doll image (the doll is a miniature replica of its maker), the person (the sitter Lotte Pritzel), and the object (the Pritzel doll). In addition to emphasizing the resemblance between the doll and its maker, D'Ora's complex image brings to light the similarities between portrait photography and doll-making since both practices are about capturing and replicating the image of a person. This link between doll and photography explains why the medium has played such a significant role in avant-garde doll-making and why photography quickly became a key component in doll thinking.

In another image, a still shot from the 1923 short documentary film *The Pritzel-Doll* (*Die Pritzelpuppe*), commissioned by the UFA film company (Fig. 12) we see the doll-maker at work in her atelier.[13]

12. Lotte Pritzel, "Ich kostümiere Menschen," 85.

13. *Die Pritzelpuppe* (*The Pritzel Doll*) (DE 1923), dir. Ulrich Kayser, scen. Maria Elisabeth Kähnert, photog. Max Brinck, cast. Lotte Pritzel, Blandine Ebinger, Niddy

The screenplay for the film was written by the author and film critic Maria Elisabeth Kähnert, and directed by Ulrich Kayser, head of technical production for UFA. In it, Kähnert and Kayser take us behind the scenes, explain Pritzel's techniques, speculating on her artistic inspirations, and locating her work within a tradition of experimental puppet design and avant-garde dance. In the sequence from which the still is taken, the camera follows Pritzel through various stages of doll-making: the molding of the skeleton, designing of the costume, and painting of its face. In the photograph, Pritzel, clad in a work coat, is shown in profile, carefully holding with both hands a doll's head topped by a blonde curly wig and a crown of flowers. The doll-maker is gazing directly at the doll's head. The gaze is intense, intimate, and seems to go both ways: the two heads are shot in perfect symmetry, and the doll seems about to speak to its creator. In contrast, Pritzel's body looks rigid, almost frozen. The juxtaposition of Pritzel with her doll in both photographs has the effect of freezing the doll-maker and animating the doll, which resembles a homunculus. These two photographs seem to approach the realm of the occult, linking artistic creation with alchemy, the transformation of matter and the creation of life. Blurring the line between animate and inanimate, these dual portraits trigger the viewer's intellectual uncertainty and fire their imagination at the same time.

"Dolls for the Vitrine" (1910/1911): Early Stages of Doll Thinking

From the beginning, Pritzel provided her wax dolls with a vitality that passed for aliveness. The 14 photographs of her 1910 "Dolls for the Vitrine" ("Puppen für die Vitrine"), featured in the periodical *Deutsche Kunst und Dekoration* with a rave review by Wilhelm Michel (1877-1942), German writer and editor of *Deutsche Kunst und Dekoration,* displayed dolls clad in historical costumes in tableau vivant settings. Positioned in a group setting against a dark background, the wax dolls are featured in motion. While there is no proof that Pritzel photographed her wax dolls for the periodical herself, it seems fair to assume that she was involved in the image-making, and most likely arranged the dolls. A decade later, Pritzel's hands-on approach would be publicly revealed by the 1923 UFA documentary, which shows her manipulating and positioning her dolls in front of the camera. Walking, bending forward, leaning back, kissing and embracing

Impekoven, prod. Ufa (Universum-Film AG), v.c./censor date August 10, 1923, copy 35mm, 381 m., 18'31" (18 fps), titles GER, source Bundesarchiv-Filmarchiv, Berlin.

one another, they look like puppets performing theatrical sketches, while the pictorial frame serves as a proscenium. The doll's costumes, featuring pantaloons and knickers with frills, shirts with ruffles made of satin and lace, and cotton wigs, conjure up the porcelain figures of the Rococo period during the first half of the eighteenth century,[14] as well as Rococo paintings by Antoine Watteau, François Boucher, and Jean-Honoré Fragonard, whose masterpieces were a source of inspiration for Pritzel.[15] And the doll scenes do resemble scenes of idealized courtship parties in Watteau's paintings: coupled wax figures are shown conversing amicably, whispering, kissing, embracing one another affectionately while watching others perform musical or sexual acts. A photograph (Fig. 13) represents a group of three black dolls dressed in baroque attire, which seem to be dancing, singing, and clapping in their hands.

Other doll photographs reveal that Pritzel does not shy away from staging sexual tension and sexualized violence between genders. In her vignettes though, unlike Watteau's, women are perpetrators as much as victims. For example, a closer look at the photograph of a loving couple exchanging a passionate kiss (Fig. 14) reveals that the man pressing towards his female partner is grasping his crotch to masturbate as he leans in to steal a kiss.[16]

Another photograph (Fig. 15) shows a younger male bystander exchanging glances with a woman in black, who is walking arm in arm with another man, and pointing with her finger toward his crotch. Another photograph, of a female bystander and a couple kissing, appears chastely romantic at first glance (Fig. 15), until you notice the hand of the female reaching towards her partner's crotch to fondle him.

In still another, we see the sexual activities of a group of four figurines (Fig. 16).

A male figure is flanked by two females: he affectionately puts his arm around a smaller younger female, who reaches for his crotch, while another, older female leans on his shoulder and slightly bends forward; a fourth, androgynous

14. See Wilhelm Michel, "Puppen von Lotte Pritzel," *Deutsche Kunst und Dekoration: illustrierte Monatshefte für moderne Malerei, Plastik, Architektur, Wohnungskunst und künstlerisches Frauen-Arbeiten* 27 (October, 1910): 329–338.

15. Michel, "Puppen von Lotte Pritzel," 338: "Nur das stumpfe Näschen legitimiert sie als Europäerinnen, als Nachkommen der liebenswürdigen Damen von Watteau und Bouchers Gnaden"

16. For a detailed analysis of Pritzel's 1910 *Dolls for the Showcase*, see Francesca Roe, "The Satanic Sex: Lotte Pritzel and the Puppet as Gendered Body," *Academia. Edu*, https://www.academia.edu/19587485/The_Satanic_Sex_Lotte_Pritzel_and_the_Puppet_as_a_Gendered_Body.

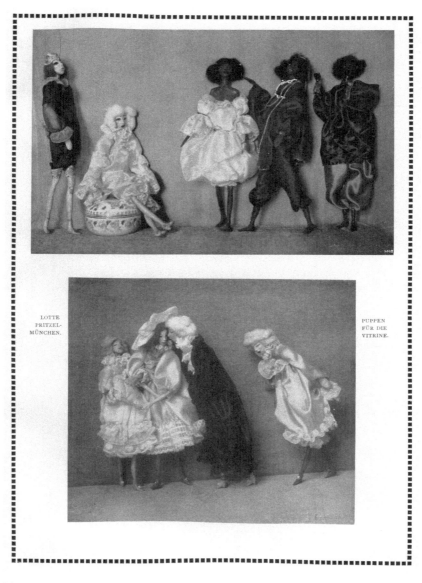

Fig. 13. Lotte Pritzel, *Dolls for the Vitrine*, 1910. *Deutsche Kunst und Dekoration: illustr. Monatshefte für moderne Malerei, Plastik, Architektur, Wohnungskunst u. künstlerisches Frauen-Arbeiten*, vol. 27. © Universitätsbibliothek Heidelberg.

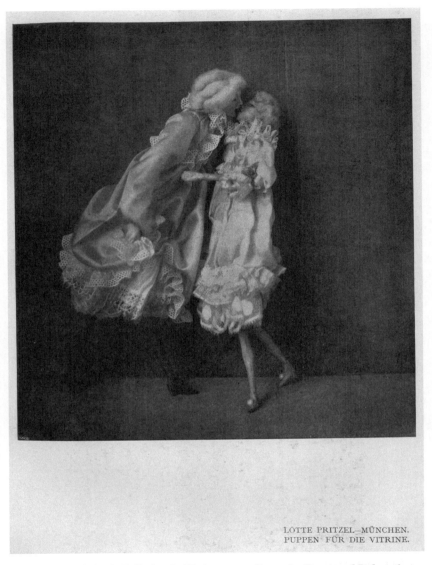

Fig. 14. Lotte Pritzel, *Dolls for the Vitrine*, 1910. *Deutsche Kunst und Dekoration: illustr. Monatshefte für moderne Malerei, Plastik, Architektur, Wohnungskunst u. künstlerisches Frauen-Arbeiten*, vol. 27. © Universitätsbibliothek Heidelberg.

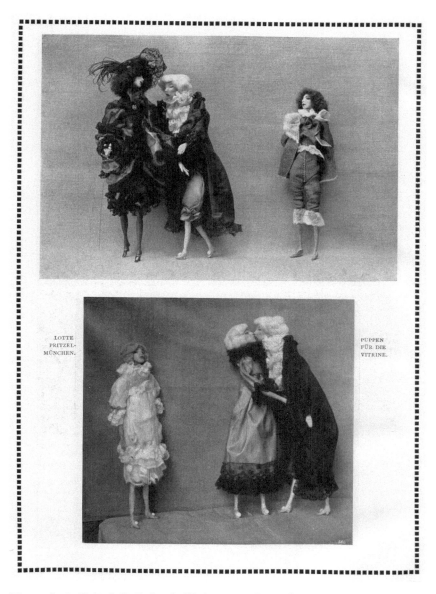

Fig. 15. Lotte Pritzel, *Dolls for the Vitrine*, 1910. *Deutsche Kunst und Dekoration: illustr. Monatshefte für moderne Malerei, Plastik, Architektur, Wohnungskunst u. künstlerisches Frauen-Arbeiten*, vol. 27. © Universitätsbibliothek Heidelberg.

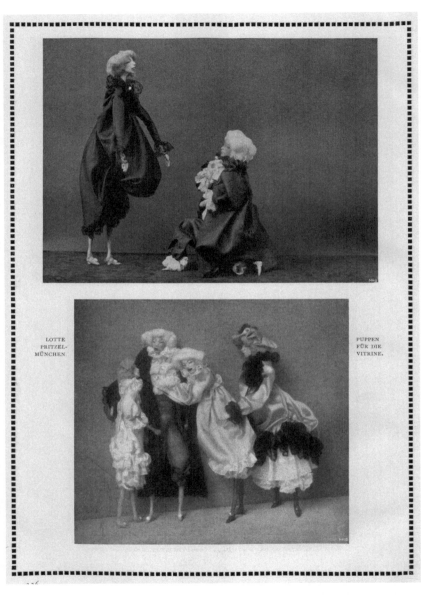

Fig. 16. Lotte Pritzel, *Dolls for the Vitrine*, 1912. *Deutsche Kunst und Dekoration: illustr. Monatshefte für moderne Malerei, Plastik, Architektur, Wohnungskunst u. künstlerisches Frauen-Arbeiten*, vol. 31. © **Universitätsbibliothek Heidelberg.**

figure presses itself against her, holding on to her hips. The crude depiction of sexual gestures, at odds with the refinement and luxury of the clothes, bring to mind the dark erotic drawings by English artist Aubrey Beardsley (1872–1898), to whom Wilhelm Michel compared Pritzel in a 1910 review.[17] Michel's attempt at identifying Pritzel's artistic influences in early eighteenth-century Rococo and late nineteenth-century decadence shows that her miniature wax dolls cannot be easily pinned down. This ambiguity is certainly reflected in the "Dolls for the Vitrine" photographs, where the referent of these depicted figures clad in historical costumes remains obscure to the viewer. Although the dolls featured in the 1910 issue of *Deutsche Kunst und Dekoration* were represented without a vitrine – the photograph's format and frame served as a substitute – the caption nevertheless read: "Dolls for the Vitrine" ("Puppen für die Vitrine"). This designation, invented by Pritzel, turned out to be a savvy marketing strategy, and accelerated her commercial success. The vitrine presentation gave the dolls an interior decorative purpose, and signaled to the wealthy bourgeoisie as the target clientele. Beneath that purpose, though, I posit a more subversive meaning for the title "Dolls for the Vitrine": as an allusion to prostitution. The dolls are literally set up before the viewer, exposed publicly and offered for sale to well-to-do consumers. The viewer, construed as male and positioned as a voyeur, is offered an eyeful of these sexual acts performed for their viewing pleasure. The wax dolls, with their movable arms and legs, invite manipulation and encourage participation: they tease the viewer and arouse his fantasy, inviting him to join in the foreplay. These theatrical vignettes present a comment on the loose mores of the Schwabing bohemia scene, from the perspective of an independent, emancipated, and free-spirited woman. Unconventional, non-normative love relationships were the norm in Pritzel's artist clique, and they often led to complicated romantic arrangements, such as the triangular relationship between Pritzel, the poet Jakob van Hoddis (1887–1942), and the performer Emmy Hennings (1885–1948).[18] Pritzel's claim that her dolls were "mirror reflections of her world" must be taken at face value: the intricate erotic and sexual activities mirror the private behavior of the Schwabing bohemia. Beyond that, though, Pritzel sought to give her wax dolls a sex drive, a vital force, and thus to bring them to life. Oddly enough, Wilhelm Michel did not register the dolls' sexual activity in his review, though he did notice their autonomy and self-sufficiency. Indeed, the wax dolls seemed to him to have a life of their own: they engaged in all sorts of

17. Michel, "Puppen von Lotte Pritzel," 239: "Ist es ein Zufall, daß hier bei Lotte Pritzels Puppen immer dieselbe, an Beardsley erinnernde Physiognomie wiederkehrt?"

18. See Wolfgang Glüber, "Puppen für die Vitrine. Zu den Arbeiten der Puppenkünstlerin Lotte Pritzel," *Kunst in Hessen und am Mittelrhein* 36, 37 (1998): 139–150.

romantic and erotic activities and went about their own business with no regard for the viewer. Inward looking and self-absorbed, they remained impenetrable to us, as if the vitrine, for which they were designed, were shielding them from scrutiny and intrusion, even while displaying them publicly. Michel concluded that Pritzel's dolls were empty and meaningless, inviting the viewer to both inject and project meaning onto them; but he noted that the surface of projection was not the wax doll, but the vitrine or the photograph. Tellingly, he compared Pritzel dolls to "flowers, butterflies, and soap bubbles," emphasizing their beautiful, delicate, and ephemeral nature.[19] The most striking part of the review is Michel's praise of Pritzel's artistic talent at the end, where he described her as "the first to write poetry out of wax, silk, lace and wigs."[20] To put it differently, Michel in the presence of Pritzel dolls literally waxes poetic! Poetry, which Aristotle in his *Poetics* defines as mimetic, imitating life and recreating pleasurable images, is similar to doll-making, which is also about imitating life and recreating life-like replicas. By reproducing the human body in miniature form and by recreating erotic scenes, the doll-maker turned "poet" according to Michel, managed to animate her wax dolls by fostering the viewer's imagination, by exciting his desire, and inspiring him to wax poetic. As Michel's review reveals, Pritzel's precious dolls were, from the early stages on, triggering doll thinking.

New Dolls for the Vitrine (1912/1913): The Next Level of Doll Thinking

This universe of eroticism was still present in Pritzel's new doll series from 1912, evident in the 11 photographs of her "New Dolls for the Vitrine," featured in the 1912/1913 issue of *Deutsche Kunst und Dekoration*. As in 1910, these dolls were still clad in historical costumes from the Baroque and Rococo periods, wearing wigs and clothes with ruffles and frills, but the 1912 figures were no longer placed in group settings; they were mostly in couples. No longer engaging in sexual acts, the androgynous-looking couples were performing scenes of courtship, while holding hands or leaning their heads together (Fig. 17).

With their closed eyelids and smiling lips, the faces conveyed bliss and rapture – an inward-facing happiness that excluded the viewer, who is instead invited to invent stories about the dolls and animate them himself. Still, the erotic

19. Michel, "Puppen von Lotte Pritzel," 330: "Diese Puppen sind leicht und hold wie Schmetterlinge, wie bunte Seifenblasen,... Sie [Lotte Pritzels Puppen] sind 'nichtssagend' und 'unbedeutend' wie Blumen, die nur um ihrer selbst willen leben, verliebt in ihre eigene Schönheit und gleichsam heimlich in sich hineinlächelnd."

20. Michel, "Puppen von Lotte Pritzel," 338: "Daß Lotte Pritzel die erste war, die in größerem Umfange mit Wachs, Seide, Spitzen und Perücken zu dichten begann? Das möge denn noch hier verzeichnet werden."

Neue Puppen von Lotte Pritzel–München.

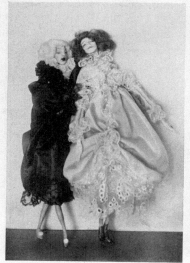
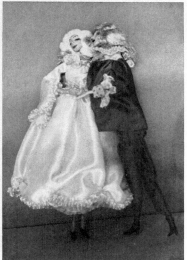
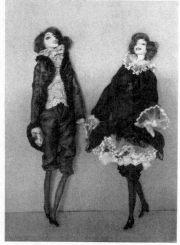

sie haben müssen, um richtige Puppen zu sein, bekommen sie von ihr. Kopf und Glieder, die unverhüllten Teile, werden kunstreich in Wachs modelliert und getönt, wie die kleinen Seelen es fordern. Der Körper unter dem Kleid besteht aus Draht und Watte. Ganz körperlos dürfen die Puppen nicht sein, damit nicht unkünstlerisch ein interessanter Kopf auf einem hübschen Kleid sitze, Glieder ohne lebendigen Zusammenhang an Spitzensäumen baumeln. Man muß eine Konsistenz unter dem Kleide fühlen, die weich genug ist, um warmes Leben vorzutäuschen. Andererseits haben Kopf und Glieder

LOTTE PRITZEL–MÜNCHEN. »PUPPEN FÜR DIE VITRINE«

nicht die entschiedene Plastik einer Bildhauerarbeit. Der feine Instinkt der Künstlerin hütet sich vor dem „Ernst" und will seine Spielfreude auch den anderen großen Kindern lassen. Keine starren Bronzestatuetten — wächserne Puppen mit beweglichen Gliedern deuten das geheimste Leben an. Sie stammen meist aus Lotte Pritzels persönlichstem Phantasiekreis, aber auch die Zeit des großen Menschenspiels, das achtzehnte Jahrhundert, hat ihren Teil an ihnen. Ein kleiner Kavalier in schwarzem Seidenfrack, mit Spitzenbüscheln an den Händen — ein bleicher Abbé,

Fig. 17. Lotte Pritzel, *Dolls for the Vitrine*, 1912. *Deutsche Kunst und Dekoration: illustr. Monatshefte für moderne Malerei, Plastik, Architektur, Wohnungskunst u. künstlerisches Frauen-Arbeiten*, vol. 31. © Universitätsbibliothek Heidelberg.

permeated the scenes, and the luxurious clothes are often employed to hint at unseen desires. For example, in one of two photographs representing a bride and a groom against a floral background (Fig. 18), each member of the couple is depicted separately in a full-length portrait: the androgynous-looking groom is clad in a brocade overcoat, whose open layers recall the shape of a vulva; his veiled bride wears a satin gown whose numerous folds and pleats are reminiscent of labia.

An ostensibly innocent doll portrait alludes to defloration, showing plucked flowers at the groom's feet, and cut blooms in the bride's hand. Oblivious to the sexual undertones, the positive review of Pritzel's new dolls by German writer Georg Hirschfeld (1873–1942) reveals that the author is doll thinking. While listing the materials they were made of (wire, wax, and cotton) he attributed to them "tiny souls," and secret inner lives.[21] His conclusion captured perfectly the tension inherent in the dolls: held separately and seen up close, they looked to him like lifeless toy puppets; set in pairs and seen from a distance, they seemed animated by a demonic (uncanny) force and they regained a life of their own:

> Hält man Lotte Pritzels Puppen einzeln in der Hand, so sind sie ein Spielzeug, mit dem man machen kann, was man will. Läßt man sie frei aufeinander wirken, so gewinnen sie dämonisches Eigenleben, und ihre Bewegungen geben mehr als starre Bildwerke.[22]
>
> [When you hold Lotte Pritzel's dolls one by one in your hand, you notice that they are toy dolls, with which you can do whatever you want. However, if you let them freely interact with one another, they take on a demonic life of their own, and their movements convey more than stiff imagery.]

Hirschfeld's review marked a turning point in the reception of Pritzel's dolls: Whereas Michel had compared them to insects, relegating them to the domain of tiny life forms, Hirschfeld considered them entirely human, with very small bodies, thoughts, and souls. Together with Michel, Hirschfeld was one of the first writers to doll think in the presence of Pritzel's dolls: he regarded them as living creatures and identified the demonic force inhabiting them.

21. Georg Hirschfeld, "Neue Puppen von Lotte Pritzel," *Deutsche Kunst und Dekoration: illustrierte Monatshefte für moderne Malerei, Plastik, Architektur, Wohnungskunst und künstlerisches Frauen-Arbeiten* 31 (October 1912): 259: "die unverhüllten Teile werden kunstreich in Wachs modelliert und getönt, wie die kleinen Seelen es fordern. Der Körper unter dem Kleid besteht aus Draht und Watte. ... wächserne Puppen mit beweglichen Gliedern deuten das geheimste Leben an."

22. Hirschfeld, "Neue Puppen von Lotte Pritzel," 260.

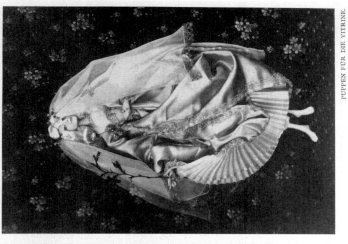
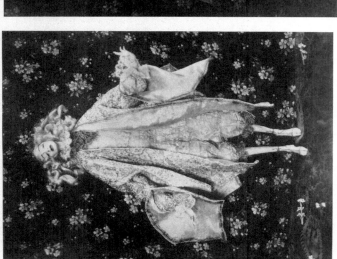

Fig. 18. Lotte Pritzel, *Vitrine-Dolls*, 1913. *Deutsche Kunst und Dekoration: illustr. Monatshefte für moderne Malerei, Plastik, Architektur, Wohnungskunst u. künstlerisches Frauen-Arbeiten*, vol. 31. © Universitätsbibliothek Heidelberg.

"Vitrine-Dolls" (1914): The Ultimate Vessel for Doll Thinking

While Pritzel's wax doll series from 1910 and 1912 remained very similar in costume, posture, and setting, the dolls underwent a significant transformation in 1914. As Michel noted in his review "New Wax Dolls by Lotte Pritzel," published in the 1914 issue of *Deutsche Kunst und Dekoration*, a plastic and aesthetic evolution was underway in the dolls.[23] As demonstrated by the six photographs illustrating Michel's article – one in color, the rest in black and white – Pritzel's new dolls were elongated, and showed much more skin. They gained in expressivity, grace, and movement, assuming grand theatrical gestures. Their facial features were more detailed and their make-up more elaborate. They were now presented individually and on plinths, which justified their designation as "Dolls for the Vitrine," while underscoring their decorative status as artworks. It is worth noting a change in captions under the photographs: while a few dolls were named after pantomime characters, such as Pierrot or Harlequin, or religious figures, all now bore the designation of "Vitrinen-Puppe," a German compound replacing "Puppen für die Vitrine." The dolls were now seen as artworks. Michel even addressed the issue of their decorative utility by asking the following question:

> Was fängt der Käufer mit diesen leichtsinnigen, schmiegsamen Kunstwerken an? Die Künstlerin sagt es selbst: Puppen für die Vitrine. Irgendwo, zwischen zwei Fenstern oder zwei Türen, gibt es fast überall jene leeren Flächen, die der Belebung durch Möbel so schwer zugänglich sind.[24]
>
> [What is the customer supposed to do with these frivolous, pliable artworks? The artist says it herself: Dolls for the Vitrine. Somewhere between two window or two door frames, one can find almost everywhere these empty spaces which pieces of furniture, intended to enliven them, make more difficult to access.]

According to the reviewer, the function of the wax dolls is to fill the empty space between two windows or two doors, where furniture would not suffice. The dolls had been branded as precious decorative artifacts, aimed at bourgeois

23. Wilhelm Michael, "Neue Wachspuppen von Lotte Pritzel," *Deutsche Kunst und Dekoration: illustrierte Monatshefte für moderne Malerei, Plastik, Architektur, Wohnungskunst und künstlerisches Frauen-Arbeiten* 33 (October 1913): 312–315.

24. Michel, "Neue Wachspuppen von Lotte Pritzel," 315.

interiors. Their status as works of art evolved as their uncanniness intensified. In imagining these eerie wax dolls with contorted limbs set up in a cozy home setting, we can conjure the very definition of Freud's uncanny: something unnerving because unhomely and homely at the same time. The "Vitrine Dolls" embody another Freudian ambiguity, too – this one sexual. In *The Interpretation of Dreams* (1899), Freud, who often reads utensils and pieces of furniture in dreams as sexual symbols, writes, "all elongated objects represent the male member," while "boxes, cases, chests, cupboards and ovens correspond to the female organ."[25] Thus, the combination of an elongated doll sculpture (phallic) with a glass case display (vulval) uncovers the hermaphrodite anatomy of the "Vitrine Dolls." And the insertion of a long wax doll into a waiting vitrine can represent heterosexual intercourse, emphasizing the auto-eroticism of the whole scene. While underscoring the new wax figures' technical improvement and their more kinetic design, Michel dwelled mostly on their eroticism, enhanced by their androgyny and self-sufficiency. In his opinion, the erotic impulse played a key role in Pritzel's doll aesthetics, and explained why gauze and lace were among her favorite materials.[26] The fabrics cover and uncover the body of the wearer, teasing and enticing the viewer. Because "it is the veiling of nakedness that entices," explains feminist theorist Elizabeth Grosz, "the lure of eroticism – the props, veils, adornments, the half-dressed, the near-naked (that is the naked in promise alone) – is the body adorned by representation."[27] As the color photograph featuring a dancer couple, which opened Michel's review, illustrates, the dolls invite the viewer to doll think by exuding eroticism through gestures of abandon, phallic posture, and oriental costumes (Fig. 19).

The elongated, androgynous, and oriental-looking figure standing on a plinth is clad in see-through blue gauze with a golden trim, which uncovers his entire torso and reveals his pointed nipples, rib cage, and navel. As for the shorter female companion on his right, she is wrapped in pink see-through gauze, which reveals her breast and red nipples. Pritzel's "Dolls for

25. Sigmund Freud, *The Interpretation of Dreams*, A. A. Brill, trans. (New York: Random House, 1978), 242.

26. Michel, "Neue Wachspuppen von Lotte Pritzel," 314: "Das erotische Sentiment spielt wohl in Lotte Pritzels gesamter Puppenplastik die ausschlaggebende Rolle, soweit der Inhalt, das Literarische, in Frage kommt."

27. Elizabeth Grosz, "Naked" in Joanne Morra and Marquard Smith, eds., *The Prosthetic Impulse: From a Posthuman Present to a Biocultural Future* (Cambridge: MIT Press, 2005), 195.

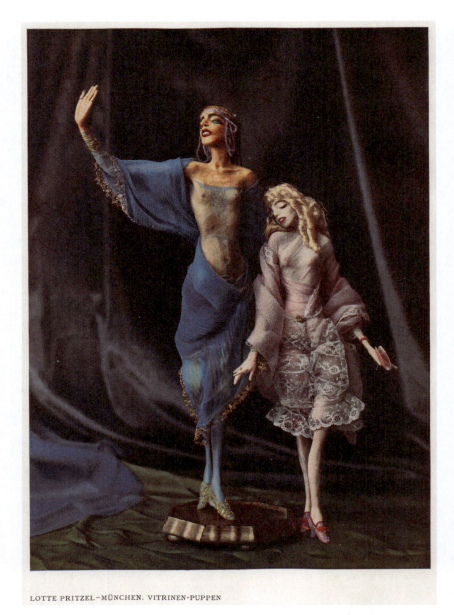

Fig. 19. Lotte Pritzel, *Vitrine-Dolls*, **1914.** *Deutsche Kunst und Dekoration: illustr. Monatshefte für moderne Malerei, Plastik, Architektur, Wohnungskunst u. künstlerisches Frauen-Arbeiten*, **vol. 17. © Universitätsbibliothek Heidelberg.**

the Vitrine" were never meant for children, nor were they designed to provide amusement or entertainment, but rather a sensorial or – etymologically speaking – aesthetic experience. Michel thus concludes his article on an aesthetic consideration: he credits Pritzel with initiating the start of a brand-new German wax doll aesthetics: "Lotte Pritzel marks the emergence of a new German wax doll aesthetics."[28]

Wax as the Conduit to Doll Thinking

I posit that the erotic, sensuous experience Pritzel dolls offered to the viewer emerged to a great extent from the materials of their creation. Wax has an uncanny resemblance to human skin, and thus invites identification from the viewer, as well as a sensuous/tactile form of looking.[29] As Joanna Ebenstein, author of *The Anatomical Venus*, observes, "wax is, by nature, contradictory: solid and molten, stable and ephemeral, 'flesh' and yet simulacrum, seemingly alive, yet merely material."[30] Because of its fragility and transience, regarded as a symbol of human life, wax has always been connected with corpse and death rituals, as Ebenstein notes. Wax was an essential part of Egyptians' mummification technique; Romans molded funeral masks out of wax; Catholics worship life-size wax statues of saint martyrs; and scientists studied anatomy from life-like wax models.[31] The wax material of the dolls thus accounts for both their macabre aspect and their stirring vitality. Oddly enough, associating the wax figures with corpses amounts to accepting the idea that they were alive at some point in time. The vitrine brings to mind the glass shrines in which wax statues of saint martyrs were kept, as well as the glass display cases for anatomical wax models of beautiful female figures, so-called Venuses, which imitated life.[32] Wax can be an imprint of the dead body, or a

28. Michel, "Neue Wachspuppen von Lotte Pritzel," 315 "Von Lotte Pritzel her datiert das Aufkommen einer neuen deutschen Wachspuppenplastik."
29. See Georges Didi-Huberman, "Viscosities and Survivals: Art History Put to the Test by Material," in Roberta Panzanelli, ed., *Ephemeral Bodies: Wax Sculpture and the Human Figure* (Los Angeles: Getty Publications, 2008), 154–169.
30. Joanna Ebenstein, *The Anatomical Venus* (London: Thames & Hudson, 2016), 70.
31. See Ebenstein, *The Anatomical Venus*, 66–118.
32. See, for example, the *Demountable Venus* or *Medici Venus* from the workshop of Clemente Susini (Italian, 1780–82) at La Specola, Museum of Physics and Natural History, Florence, Italy, or the *Anatomical Venus* from the workshop of Clemente Susini (Italian, 1784–1788) at the Josephinum, Museum of the Medical University of Vienna, Austria.

repository of the living one – as with hair removal practice. Pritzel's doll bodies were an imprint of the doll-maker's hands and fingers – she sculpted their body parts by hand – as well as a repository of her living body. In an earlier review of Pritzel's "Dolls for the Vitrine," Michel touched on the haptic quality of the wax dolls, noting the warmth of the doll-maker's hands and the figures' demiurgic power:

> Man fühlt, wie leicht und unmittelbar die Phantasie der Hand sie hervorgebracht und hervorgespielt hat. Nicht der Geist und das Ausdrucksstreben eines Künstlers haben diese feinen, bunten Wesen geschaffen, sondern [...] der Geist der duftigen Spitzen und des Wachses, das so rührend bildsam ist, daß die Wärme der Hand genügt, um seine Sprödigkeit zu besiegen.[33]
>
> [One feels the ease and the immediacy with which the imagination of the hand has playfully produced them. It is not the mind and the expressiveness of an artist that generated these fine and colorful creatures, but [...] the spirit of lofty lace and wax, which is so pliable by touch that the warmth of the hand suffices to overcome its brittleness.]

In a 1924 black-and-white photograph by Germaine Krull we see a representation of the creative power of Pritzel's hands. Here, one of her wax dolls stands on a plinth, with a giant, upraised hand on either side (Fig. 20).

A lithe female dancer, partially wrapped in gauze, with a crown of flowers on her head and a lace of flowers around her neck, surrenders herself to the rhythm of the music: eyes shut, a look of ecstasy on her face, head tilted to the left and both arms raised, she seems caught in her own world, oblivious and indifferent to the viewer. The pair of human hands – presumably the doll-maker's own – open around her, seeming to form a protective gesture while echoing the figurine's own open hands. The palms also recall the shape of a lotus flower. Krull's composition suggests that the doll emerged from Pritzel's creative and protective hands, like an Indian deity erupting from a flower, or the goddess Venus from the sea.

Much more than relics of the creator's talent and creativity, Pritzel's wax dolls were an imprint of her corporeality. In that regard, the dolls' uncanny presence is linked to the notion of aura, which Walter Benjamin re-introduced in his 1936 essay "The Work of Art in the Age of Its Technological Reproducibility."

33. Michel, "Puppen von Lotte Pritzel," 330.

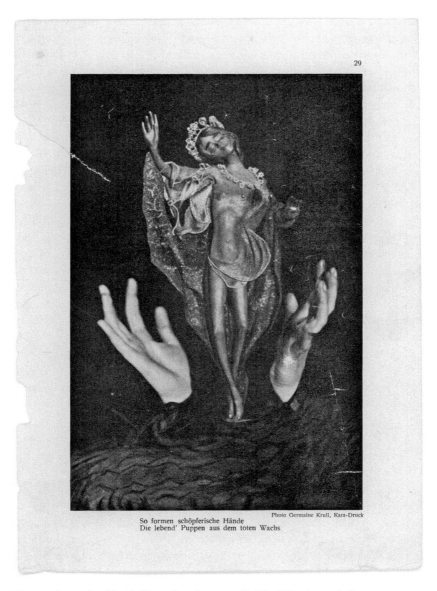

Fig. 20. Germaine Krull, Kara Druck, 1924. Untitled Photograph for an unknown magazine. © Deutsches Tanzarchiv Köln [Obj. 54225].

88 Uncanny Creatures

According to Benjamin, the aura is a quality integral to an artwork, something that cannot be communicated through mechanical reproduction techniques. "Even the most perfect reproduction of a work of art," he argues, "is lacking in one element: its presence in time and space, its unique existence at the place where it happens to be."[34] The aura is connected to the idea of authenticity and uniqueness, and includes a sensory experience of distance between the viewer and the work of art. Pritzel's "Vitrine Dolls" fit Benjamin's description: they were not mass-produced but handcrafted, unique, and authentic. Drawing inspiration from religious iconography (Madonna, Catholic saints, angels) to design her dolls and by placing them behind glass, Pritzel channeled a traditionally ritualistic practice of art: she aligned her wax dolls with relics and fetishes, and protected their aura with a vitrine, shielding it from the viewer. Yet she also relied on mechanical reproduction techniques of her time, print media and photography, to introduce her "Vitrine Dolls" to a larger audience, and disseminate their discarnate image. These copies stood the test of time, whereas the originals faded: the photographs of Pritzel's dolls from *Deutsche Kunst und Dekoration* constituted a more tangible proof of Pritzel's creativity than the few originals that survive in museums and private collections. To understand their aura more directly, we can turn to a first-hand witness, Austrian writer and poet, Rainer Maria Rilke (1875–1926), who published in 1914 an essay "Dolls. On the Wax Dolls of Lotte Pritzel" ("Puppen. Zu den Wachspuppen von Lotte Pritzel"). In 1921, the essay was reprinted in a book format with 15 colored doll illustrations by Lotte Pritzel, and published by Hyperion Verlag under the title *Dolls* (*Puppen*).

A Tormented Doll Thinker: Rainer Maria Rilke's "Dolls. On the Wax Dolls of Lotte Pritzel," 1914

Rilke wrote his essay in response to an exhibit of Pritzel's dolls in Munich in September, 1913. The writer met the doll-maker for the first time on September 7, and corresponded with her during the winter months of 1913–1914. Pritzel sent Rilke a few photographs of her dolls in preparation for his essay. After its publication in *Die weißen Blätter*, an Expressionist journal edited by

34. Walter Benjamin, "The Work of Art in the Age of Its Technological Reproducibility," Harry Zohn, trans., in Hannah Arendt, ed., *Illuminations: Essays and Reflections* (New York: Schocken Books, 1968), 220.

German-French writer René Schickele, they met again and kept in touch. Rilke's essay granted Pritzel's dolls instant exposure and artistic recognition on the eve of World War I, and ultimately assured their lasting reputation. Rilke's prose has become intimately associated with Pritzel's dolls, but here the poet alludes only to her early "Dolls for the Vitrine," i.e. the wax figures with moveable limbs in Baroque and Rococo outfits, not the later ones in elaborate poses.[35] Rilke's essay is a very peculiar text: with the exception of the title, the opening and closing paragraphs, the author did not really address the wax dolls. He took them as a point of departure for a nostalgic meditation on the toy dolls of his childhood. He noted that Pritzel dolls were neither intended as toys nor suited for children: "we have to conclude from their appearance that there are no children in their lives, that the precondition for their origin would be that the world of childhood is past."[36] He observed that "it [the Pritzel doll] is independent, grown up, prematurely old."[37] Like other reviewers, he perceived that the dolls lived a life of their own, independent of the viewer, and he remarked on their historical costumes and long bodies. From the second paragraph on, though, he turned away from his ostensible subject, wondering: "Are these the adult versions of those doll childhoods cosseted by genuine and feigned emotions?" Pritzel's dolls represented a point of departure, from which he went on to settle a score with the childhood toy doll. He made no attempt to bring the wax dolls to life with his creative imagination, asserting instead that "the doll was utterly devoid of imagination."[38] Despite his disclaimers, though, the Pritzel dolls obviously stirred up strong emotions in Rilke, attesting to their aura and proving their aliveness in spite of his assertions. Against all odds, it looked like Rilke did not doll think in the presence and contemplation of Pritzel's dolls. The poet seemed initially immune to their uncanny power: he was not troubled by intellectual uncertainty about whether they were alive or lifeless; he was not disconcerted by the confusion between reality and fantasy; he was not even troubled by their sensuality and androgyny. Rilke looked through the dolls of Lotte Pritzel into his own past. The vitrine became a

35. Rilke was not the only literary talent of his time to write on Pritzel's dolls. Michel Wilhelm, Georg Hirschfeld, Max von Boehn, and Paul Fechter reviewed her work for *Deutsche Kunst und Dekoration* between 1910 and 1922, and Theodor Däubler later published an essay entitled "Die Puppen der Lotte Pritzel" in a 1921 edition of *Das Puppenbuch*, featuring 32 illustrations of Pritzel's dolls.

36. Rainer Maria Rilke, "Dolls: On the Wax Dolls of Lotte Pritzel," in Kenneth Gross, ed., *On Dolls* (London: Notting Hill Editions, 2018), 51.

37. Rilke, "Dolls," 51.

38. Rilke, "Dolls," 51.

projection screen for the poet, while the dolls conjured memories of hatred, separation, and abandonment. Thus, though he did not seem to realize it at the time, Rilke had been struck by the uncanny powers of the Pritzel doll, according to Freud's later definition: the experience had triggered the return of repressed impulses and primitive fears.[39] In reality, Rilke was doll thinking all along, engaging with the Freudian uncanny, with repressed infantile impulses. In his compelling psychoanalytical reading of Rilke's essay, German scholar Eckart Goebel described the artistic and personal crisis Rilke was undergoing at the time, and the paradigm shift that this text signified within Rilke's work: a move away from the so-called "Ding-Gedicht," the thing-poem, and an attempt to reconcile his conflicted feelings towards his own mother through the transitional object doll.[40] According to Goebel, Pritzel's dolls function here as nesting dolls: the wax figures stand as a substitute for the dolls of his childhood, which in turn stand in for an absent mother. Considering the poem through a Freudian lens, scholar Eva-Maria Simms notes that Rilke is coming to terms with the separation from his mother through his relationship to the doll: "a large part of the rage, hatred, and aggression against the doll is the memory of the lost union with the mother, for which the doll is merely a poor substitute."[41] This explains the violent language the poet hurled at the toy doll: "If we became aware of all of this [that the doll is false, insensitive, inert, unreceptive, and passive] [...] it would almost enrage us by its horrible dense forgetfulness, and the hatred which must always have been an unconscious part of our connection with it would burst to the surface."[42] Goebel noted that, although the connection to the lifelike replica feels very intimate, it nevertheless remains a dead, distant, and foreign thing. As something essentially lifeless, the toy doll

39. See Sigmund Freud, "The Uncanny (1919)," in James Strachey, ed., *The Standard Edition of the Complete Psychological Works of Sigmund Freud, Volume XVII (1917–1919): An Infantile Neurosis and Other Works* (London: Hogarth Press, 1955), 240: "if this is indeed the secret nature of the uncanny, we can understand why linguistic usage has extended *das Heimliche* ['homely'] into its opposite, *das Unheimliche*; for this uncanny is in reality nothing new or alien, but something which is familiar and old-established in the mind and which has become alienated from it only through the process of repression."

40. Eckart Goebbel, "'Herzpause'. Rainer Maria Rilke über Puppen," in Friederike Pannewick, ed., *Martyrdom in Literature: Visions of Death and Meaningful Suffering in Europe and the Middle East from Antiquity to Modernity*, vol. 17 (Wiesbaden: Reichert Verlag, 2004), 283–297.

41. Eva-Maria Simms, "Uncanny Dolls: Images of Death in Rilke and Freud," *New Literary History* 27, no. 4 (1996): 671.

42. Rilke, "Dolls," 54.

threatens Rilke's poetry of things, and subverts his poetic enterprise of ensoulment and religiosity of things. The doll, Simms notes, inspires such fear and hatred because "the doll grasps the possible absence of transcendence, the possible unreality of a spiritual invisible realm, the possible meaninglessness of our life beyond the fragile clearing of the present."[43] Thus Rilke is the rare doll thinker unable to animate dolls through his prose; instead, he regards them as a harbinger of death. And therein lies the originality of his essay. He compared the toy doll with "the gruesome foreign body on which we squandered our purest affection," and "the superficially painted watery corpse borne up and carried away along on the floodwaters of our tenderness."[44] Although this macabre comparison refers to the toy of his childhood, it could also be applied to Pritzel's dolls. "For hours, for weeks on end, we must have been content to lay the first fine silk of our hearts in folds around this immobile mannequin," he wrote, in language that could as easily call to mind the fine fabrics wrapping Pritzel's figures. Rilke's gaze oscillates between Pritzel's dolls and the toy dolls of his childhood, or rather it zooms in and out, as the opening and closing paragraphs directly address the triggering subject. "Looking at these," Rilke wrote at the beginning of the last paragraph, "one might describe them as tiny sighs, so faint our ears are not attuned to hear them."[45] He is describing the whispers passing between the pairs of dolls, but in the process he is literally *breathing* life into them. In the sentences that follow, the poet, against all odds, animates Pritzel's dolls by comparing them to winged insects receding from his view: "They swarm and fade at the uttermost limit of our vision. For their only concern is to dwindle away. [...] It is as if they yearned for a beautiful flame, to throw themselves into it like moths."[46] The sentence is a quote from Goethe's 1814 poem "The Holy Longing" ("Selige Sehnsucht"), whose third stanza reads: "No distance deters you/you come flying and spellbound,/and at last, greedy for the light,/butterfly, you are burnt up" and whose final verse ends with the injunction "Die and become." Rilke is alluding to the cycle of life,[47] and this analogy of decay refers back to the moth-eaten soul of the childhood doll ("– look [doll soul], now the moths have got into you [...] – look, look, all the little moths are fluttering out of you"). At the same time, it points

43. Eva-Maria Simms, "Uncanny Dolls: Images of Death in Rilke and Freud," 673.
44. Rilke, "Dolls," 61.
45. Rilke, "Dolls," 61.
46. Rilke, "Dolls," 61.
47. Johann Wolfgang von Goethe, *West-Eastern Divan*, Eric Ormsby, trans. (London: Gingko, 2019), 40–41.

to Pritzel's dolls in two ways: first by the association between wax and a (candle) flame; and then through the semantic connection between doll and moth: the German noun "Puppe" is etymologically related to pupa, the chrysalis of a moth. Noting their androgyny and perpetual sensuality, he writes: "Sexless like our childhood dolls themselves, they experience no decline in their permanent sensuality, into which nothing flows and from which nothing escapes."[48] (Of course, Pritzel's dolls did not stand the test of time; their waxen composition was the very agent of their decay. Like the moths disintegrating in a flame, Pritzel's dolls were doomed to disappear.) At the end of the essay, Rilke admits his unease at the sight of Pritzel's dolls: "Thinking these thoughts and raising our eyes, we stand almost unnerved as we contemplate their waxen nature."[49] It appears in the end that Rilke did experience their uncanniness. As if there were an elective affinity between the poet and the wax dolls, they animate him so that he animates them in return. I argue that Rilke's doll-thinking essay engages (often unconsciously) with the feeling of the uncanny in Pritzel's dolls: at first, they are the vehicle for the return of the repressed (Freud's theory), and at the end they summon Jentsch's concept of intellectual uncertainty – are they alive or dead?

"Vitrine Dolls" (1916–1922): Snapshots of Dancing Dolls

If Rilke stood "almost unnerved" in front of the 1912 "Dolls for the Vitrine," he was literally at a loss for words before the 1916 "Vitrine-Dolls," which he saw in December 1917 at the gallery Caspari in Munich. In his journal, he wrote: "Die Lotte Pritzel-Puppen sind erstaunlich diesmal, wirklich mehr als alle früheren, auf eine unsagbare Art um irgendein Unbeschreibliches mehr" ("The Pritzel dolls this time are astonishing, truly much more than all the previous ones, in an unutterable manner with something more indescribable").[50] The ineffable appeal of the new wax dolls lay in their expressiveness, grace, and movement, even though, by 1916, the Pritzel dolls had become fully static – standing figures fixed on baroque plinths, frozen like salt statues (Fig. 21).[51]

48. Rilke, "Dolls," 61.
49. Rilke, "Dolls," 61.
50. Ingeborg Schnack, *Rainer Maria Rilke, Chronik seines Lebens und seines Werkes* (Frankfurt: Insel Verlag, 1975). Cited in Borek, *Geschöpfe meiner selbst*, 21.
51. The dolls recall the way Gotthold Ephraim Lessing conceived sculpture in his 1766 aesthetic treaty *Laokoön*. See Gotthold Ephraim Lessing, *Laokoön oder Über die Grenzen der Malerei und Poesie* (Berlin: Christian Friedrich, 1766).

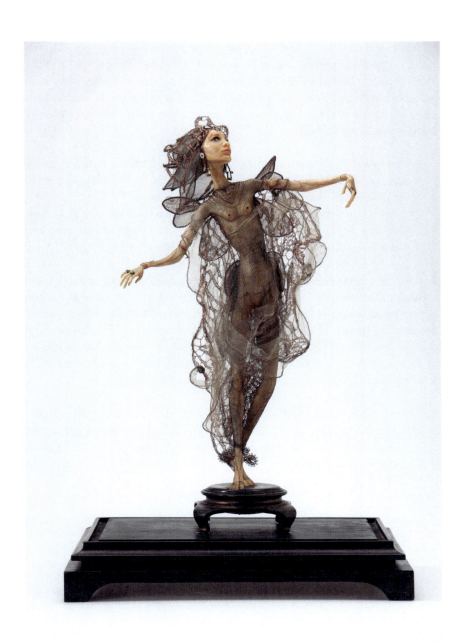

Fig. 21. Lotte Pritzel, *Female Dancer/Bayadere,* c. 1923. © Münchner Stadtmuseum.

94 Uncanny Creatures

The architect Ernst Friedman, long-time friend and patron of Pritzel's, is credited with instigating the evolution of her technique.[52] The 1916 Vitrine Dolls certainly looked more accomplished, suggesting that the doll-maker had found her style and perfected her art. Sebastian, a writer for *Deutsche Kunst und Dekoration*, noted the improvement in technique in his 1916 review "Neue Puppen von Lotte Pritzel":

> Heute sind diese Menschlein in ihrem Organismus so kompliziert geworden, daß sie sich nicht mehr bewegen dürfen; sie sind gestärkt und gefestigt, wie jede Falte und Verästelung ihrer Garderobe.[53]
>
> [Today these little human creatures' organism has become so complex that they are no longer moveable; they are starched and tightened, and so is each crease and ramification of their wardrobe.]

It is worth noting Sebastian's language. He regards the wax dolls as living creatures ("Menschlein") with an organism ("Organismus"). He ends his rave review by pointing out the significance of the form of the dolls, which he compared to the stanzas of an erotic poem from Casanova's time.[54] Oddly enough, another reviewer, "W.F.," also likened the wax dolls to poems in the 1922 issue of *Deutsche Kunst und Dekoration*. In his opinion, Pritzel's dolls were not of statuary but of lyric nature, each doll similar to a short poem:

> Dem Wesen nach sind diese Kunstwerke nicht statuarischer, sondern lyrischer Art. Jedes ist ein Lied von wenigen Zeilen, in duftigen, gehauchten Worten hingesagt, die alle vom gleichen Rhythmus zärtlich ergriffen sind.[55]

52. Borek makes the assumption: "Es ist davon auszugehen, dass es Friedmann war, der Pritzel zu einer Veränderung ihrer Technik riet." See, Borek, *Geschöpfe meiner selbst*, 16.

53. Sebastian, "Neue Puppen von Lotte Pritzel," *Deutsche Kunst und Dekoration: illustrierte Monatshefte für moderne Malerei, Plastik, Architektur, Wohnungskunst und künstlerisches Frauen-Arbeiten* 38 (September 1916): 422–425.

54. Sebastian, "Neue Puppen von Lotte Pritzel," 425: "Sicherlich sind diese Puppen weit über den flüchtigen Anschein hinaus von formaler Bedeutung: ähnlich wie kleine erotische Strophen aus dem Zeitalter Casanovas"

55. W.F., "Vitrinen-Puppen von Lotte Pritzel," *Deutsche Kunst und Dekoration: illustrierte Monatshefte für moderne Malerei, Plastik, Architektur, Wohnungskunst und künstlerisches Frauen-Arbeiten* 50 (April 1922): 112–115.

[Essentially, these artworks are not of statuary but of lyrical nature. Each one is a song made of a few verses, recited in fragrant, breathy words, which are moved tenderly by the same rhythm.]

Many of the dolls in the photographs from 1916, 1919, and 1922 are either labeled as dancers or shown dancing. The reader of *Das Puppenbuch* (*The Book of Dolls*), a 1921 book devoted exclusively to avant-garde dolls and featuring numerous illustrations of Pritzel's wax dolls as well as Erna Pinner's elongated rag dolls, would notice that some of the dolls are non-white, racialized, and orientalized and would note captions such as "Asian idol, Temple Dancer, Indian Dancing Figure, Exotic Female Dancer" (Fig. 22).[56]

The few non-white Pritzel dolls are by no means an oddity: the 1910 "Dolls for the Vitrine" (Fig. 13) already featured a group of three Black dolls dressed in baroque attire. The making of these racialized dolls (first African- and later Asian-looking) is certainly a colonial gesture (the German colonial empire included territories in East and West Africa as well as in the West Pacific) and an act of cultural appropriation on the doll-maker's part. However, the recurrence of these racialized dolls as exotic dancers from South and South East Asia (Javanese Dancer, Indian Dancer, Asian Idol) at a time when Germany had been entirely stripped of its colonial possessions by the Treaty of Versailles (1919), attests to what historians refer to as "Weimar Colonialism," the colonial imagination that continues during the Weimar Republic.[57]

The black-and-white doll photographs from *Das Puppenbuch* look like snapshots of dancers in motion, giving the impression that the dolls themselves were actually dancing at the time the photograph was taken. Paradoxically,

56. In her prime, the doll-maker Lotte Pritzel had two competitors: Erna Pinner (1890–1987), who crafted elongated grotesque rag dolls, and Käthe Kruse (1883–1968), who made realistic toy dolls for children. Their creations were regularly featured in the magazine *Deutsche Kunst und Dekoration*. Even though their dolls could not look more different, these three successful female doll-makers were often mistaken for one another, an anecdote Pritzel recalls not without irony. See Lotte Pritzel, "Was mir so alles passiert. Aus einem nach meinem Tode erscheinenden Werke 'Kaleidoskop meines Lebens'," in *Lotte Pritzel, Puppen des Lasters, des Grauens und der Extase*, 78.

57. See Volker Langbehn, *German Colonialism, Visual Culture, and Modern Memory*, (New York: Routledge, 2010) and Florian Krobb and Elaine Martin, eds., *Weimar Colonialism, Discourses and Legacies of Post-Imperialism in Germany after 1918* (Bielefeld: Aisthesis Verlag, 2014).

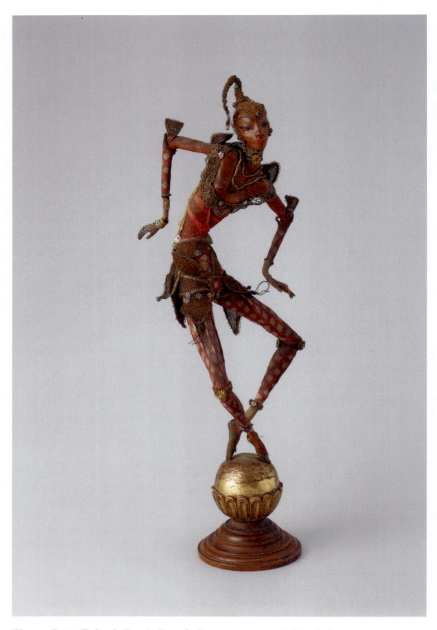

Fig. 22. Lotte Pritzel, *Exotic Female Dancer*, c. 1920. © Hessisches Landesmuseum Darmstadt.

by freezing movement in time and space, the photograph animates the dolls, conjuring the illusion of vitality in suspension. It freezes and unfreezes them. And, because the dolls are now fixed on a plinth, the doll-maker is free to fully explore movement, to imagine the elaborate, dynamic postures with which the dolls own space. In the illustration of the harlequin (Fig. 23), the dancing figure, who stands on pointe on one leg, knees and arms bent, is shown frozen in a jumping move, the frills of his costume mid-flutter.

While, on the one hand, the frozen posture of a waxen harlequin accentuates his connection to death, the dynamic posture also plays up his aliveness. Thus, again, Pritzel explores, opens up, and pushes the limits of the uncanny, of which each doll is a perfect incarnation.

Embodying a Pritzel Doll: From Doll Thinking to "Self-Doll Making"

The creator of dancing dolls (or dancer dolls) had a lifelong interest in the art of dance. Pritzel worked as a costume and set designer for the theater, and each doll reveals the depth of her understanding of movement and choreography. Indeed, the dolls piqued the interest of several famous German dancers, such as Niddy Impekoven (1904–2002) and Anita Berber (1899–1928), who drew upon them for inspiration. The moving dolls, frozen in their gesture, made the dancers move. From the moment professional female dancers started to incarnate and impersonate the "Vitrine Dolls" on stage, the distinction between human and doll dissolved.

This was not the first time dancers and doll-like artifacts had overlapped in the German-speaking world. A century earlier, the writer Heinrich von Kleist explored the connection in a seminal essay "On the Marionette Theatre" (1810). Kleist's essay stages a lengthy conversation between a first-person narrator and a ballet dancer, in which the latter confesses to a great admiration for puppets. The dancer reveres their "proportion, flexibility, lightness," and envies the absence of affectation, their lifelessness and weightlessness. He considers puppets infinitely more graceful than a living human body: "where grace is concerned, it is impossible for man to come anywhere near a puppet."[58] If, as the dancer says, puppets are far better dancers than humans, then perhaps dancing dolls should outshine Impekoven and Berber. In the black-and-white photographs, these female dancers seem as graceful as the "Dolls for the Vitrine."

58. Heinrich von Kleist, "On the Marionette Theatre," in Kenneth Gross, ed., *On Dolls*, 1.

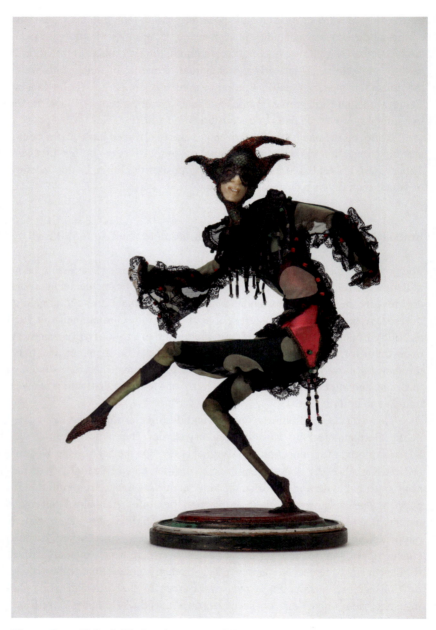

Fig. 23. Lotte Pritzel, *Harlequin,* c. 1917. © Münchner Stadtmuseum.

For their grace derives from their doll thinking – not so much from a pleasurable experience of the uncanny, but from actions that erase the division between subject and object, and blur the boundary between human and doll. Impekoven and Berber's doll thinking enabled them to shed all self-consciousness while choreographing and performing, and to find the state of grace Kleist's puppet-smitten dancer longs for.

The resemblance in scale and pose with Pritzel's "Vitrine Dolls" is unmistakable in the staged photographs of each dancer. Fourteen-year old Niddy Impekoven, a renowned expressionist dancer of the Weimar period, danced the part of a Pritzel doll for a number entitled "Old and New Dolls" ("Alte und Neue Puppen"), in Berlin in 1918 (Fig. 24).

Although the oriental stage costume shown in the 1918–1919 photograph of *Niddy Impekoven as Lotte Pritzel Doll* by Nini and Carry Hess had very little in common with a "Vitrine Doll," Impekoven's posture and the movement of her arms and legs recalled the doll's signature movement, balancing on one foot atop a plinth, while the other is in arabesque.

Anita Berber, who in her dance performances broke social taboos with her nudity, gender and sexual fluidity in Weimar Berlin, also choreographed in 1919 a solo piece called the Pritzel's Doll ("Die Pritzelpuppe.") A 1919 photograph of *Anita Berber as Pritzel Doll* taken by Atelier Madame d'Ora (Fig. 25) shows her standing on one leg, while the other is bent and pointed.[59] Her left arm is bent behind her back while the right one hangs relaxed at her side, her face is turned to the side, eyes closed with an open-mouth smile. She wears a black lace bustier, a see-through black tulle skirt, and black tights with motifs – a revealing costume more reminiscent of a Pritzel doll.

In turn, the 1920 "Vitrine Doll" called "Anita Berber" [Fig. 26] resembles the dancer in its posture, the legs' position in particular, while the see-through fishnet tulle wrapped around her body, recalls Berber's own stage outfit represented in the photograph by Atelier Madame d'Ora.[60] Pritzel constructed the doll after Berber performed her Pritzel doll solo, and the uncanny inspiration came full circle.

Berber published a poem in 1923 that captured the narcissistic, erotic, and macabre characteristics of the "Vitrine Dolls." The body parts (small hands,

59. New Objectivity painter Otto Dix immortalized her in the 1925 portrait *The Dancer Anita Berber*, now in the Kunstmuseum Stuttgart.

60. For a detailed analysis of the Anita Berber Vitrine Doll, see Glüber, "Puppen für die Vitrine," 139–150.

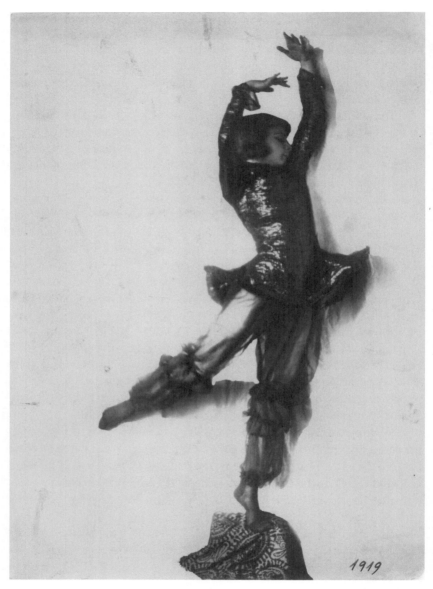

Fig. 24. Nini & Carry Hess, *Niddy Impekoven as Lotte Pritzel Doll*, 1918–1919.
© Deutsches Tanzarchiv Köln [Obj. 54226].

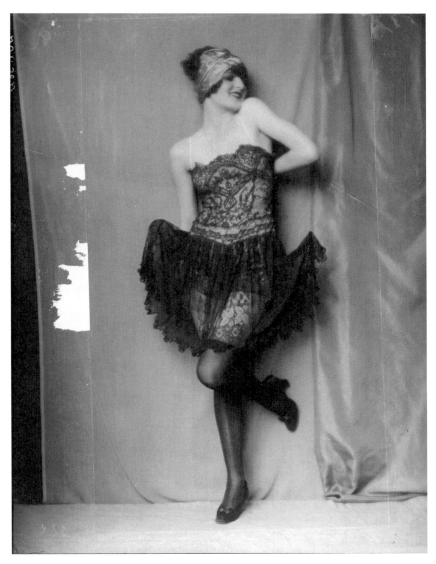

Fig. 25. Atelier Madame d'Ora, *Anita Berber as Pritzel Doll*, 1919.
© Österreichische Nationalbibliothek.

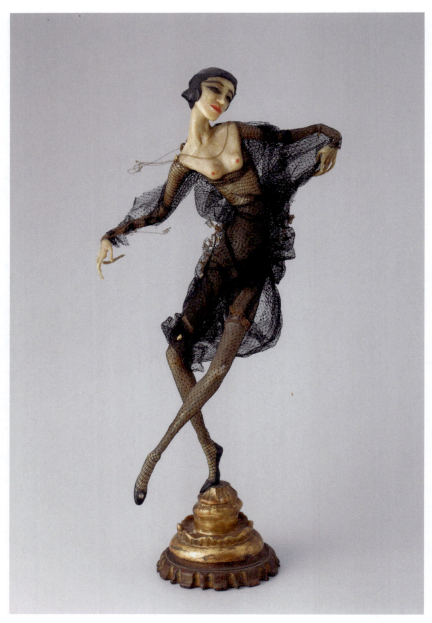

Fig. 26. Lotte Pritzel, *Anita Berber Doll*, c. 1920. © Hessisches Landesmuseum Darmstadt.

powdered hips, slim thighs, groping fingers) or accessories (gemstones, jewels, gold) she singled out in her depiction refer interchangeably to herself and the doll:

Wachsfiguren	[Wax figures
Dekadenz	Decadence
Degenerescence	Degeneration
Schmale Hände	Slender hands
Gepuderte Hüften	Powdered haunches
Schlanke Schenkel und tastende Finger	Slim limbs and groping fingers
Edelsteine	Gemstones
Juwelen	Jewelry
Gold auf nacktem Körper	Gold on the naked body
Narzissten die sich beflecken	Narcissists who stained themselves
Selbstliebe	Self-love
Eitles Spreitzen	Vain straddling
Tändeln und Girren	Dallying and cooing
Doch immer Glas	But ever glass
Viel Glas	Much glass
Geschliffenes Glas[61]	Ground glass[62]]

The poem is a climax of the dolls' uncanny power, as Berber transforms herself from human to doll. But, beyond that, they illustrated the evolution, or rather the revolution, of the reception to Pritzel's wax dolls: doll thinkers, who strove to animate dolls or ended up being animated by them, further blurred the line between reality and fantasy, life and death; doll dancers, who strove to turn into them and merge with them, dissolved any demarcation between categories.

By entering the homes of wealthy collectors, Pritzel's "Vitrine Dolls" became the waxen incarnation of the uncanny. Homely and unhomely, deathly and alive, macabre and erotic, sensual and sexual, their appreciation demanded a creative, novel type of consideration, a surrender to ambiguity – doll thinking.

The "Vitrine Dolls," with their contorting limbs and acrobatic movements, were the harbinger of the "ball-jointed doll" of Hans Bellmer, whom Pritzel had befriended and supported. Pritzel's dolls were an inspiration for

61. Borek, *Geschöpfe meiner*, 54
62. Anita Berber and Sebastian Droste, *Dances of Vice, Horror, and Ecstasy*, trans. Merril Cole (Newcastle Upon Tyne: Side Real Press, 2012).

Bellmer: the interrelationship between doll photographs and lyricism in *Deutsche Kunst und Dekoration*, as well as Rilke's poetic essay conjuring up childhood doll toys and memories, both resonated with him. In my opinion, the connection between text and image, the role of photography, the theme of childhood, the interest in the moving body, all later elements of Bellmer's doll project, can each be traced back to Pritzel's wax dolls.

CHAPTER 4

Doll Thinking: An Epistemological Method
Hans Bellmer's Papier Mâché Dolls

> I am doll eyes, doll mouth, doll legs
> I am doll arms, big veins, dog bait
> Yeah, they really want you
> They really want you, they really do
> Yeah, they really want you
> They really want you, and I do too
> —Hole, *Doll Parts*, 1994

Hans Bellmer was a close friend of the doll-maker Lotte Pritzel, and quite familiar with her uncanny wax dolls. Pritzel encouraged him to construct his first doll, and he was with her, at the Kaiser Friedrich Museum in Berlin, when he experienced an epiphany about the design of his second. Pritzel also introduced Bellmer to Kokoschka's Alma doll, which she had initially been asked to design. We know from Bellmer's correspondence that he had read with great interest Kokoschka's letters to Moos, already published in 1925, and that he was fascinated by the painter's relationship to his doll. This biographical evidence suffices to show that Pritzel's wax dolls as well as Kokoschka' letters and doll paintings were already arousing Bellmer's imagination and stimulating his doll thinking.

Along with his relationship to these earlier doll thinkers, critics cite three major events that led up to the construction of his first doll, a sequence that has now taken on the solemn quality of an origin myth. First, Bellmer received a box of long-forgotten toys from his mother, who was breaking up the household to move the family to Berlin. Second, he reconnected with his teenage cousin Ursula Naguschewski, the subject of his sexual fantasies. Third, he attended Max Reinhardt's production of Jacques Offenbach's *Tales of Hoffmann*. "Bellmer," writes Therese Lichtenstein, "was enthralled by the

story [*The Sandman*] and especially by the depiction of the beautiful Olimpia. [...] Recognizing in the figure of Olimpia many of the qualities that later characterized his dolls," she notes, he was "struck by her combination of mechanical and human qualities, the way she appeared both familiar and unfamiliar, dead and alive."[1] This language describes the beginnings of the artistic and erotic process I will explore here as doll thinking. Having seen the opera based on Hoffmann's story, read Kokoschka's letters, and observed the reception of Pritzel's dolls, Bellmer was positioned to be the culmination of a line of German-speaking doll thinkers and doll-makers.

In this chapter, I examine the nexus between doll thinking and doll-making – a sort of thinking in action – which Bellmer displayed in four different dolls, two series of doll photographs, and three poetico-scientific essays, completed between 1933 and 1972. I analyze in detail the photographs and essays featured in Bellmer's first two albums, namely *The Doll* (1934) and *The Games of the Doll* (1949), and I also examine carefully his doll sculpture *The Machine-Gunneress in a State of Grace* (1937) as well as his last doll *The Half Doll* (1972) in combination with his 1957 treatise "A Brief Anatomy of the Physical Unconscious or The Anatomy of the Image."

Each doll highlights a particular facet of Bellmer's doll thinking, which evolved considerably over those 39 years: after exploring doubling and reassembling with his first doll, he toys with the notion of amalgam with his second, the so-called ball-jointed doll; he translates his interest in writing anagrams into making a doll sculpture before designing a half doll to embody his discovery of the physical unconscious.

Recent Bellmer scholarship has tended to focus on the influence of either political events in Germany in the 1930s or on aspects of his biography, in the latter case reading his work through a psychoanalytic lens. In *Behind Closed Doors: The Art of Hans Bellmer*, Therese Lichtenstein claims, "Bellmer's works are a violent attack on the stereotypes of normalcy evident in Nazi art and culture. They rebel against images of the ideal female Aryan body found in high art and mass culture."[2] For her part, Sue Taylor in *Hans Bellmer: The Anatomy of Anxiety* writes that "psychoanalysis, with its focus on identity formation and sexual subjectivity, offers a theory and a method to begin to explain Bellmer's lifelong obsessions, the anxieties that haunted him, and the violence

1. Therese Lichtenstein, *Behind Closed Doors: The Art of Hans Bellmer* (Berkeley and Los Angeles: University of California Press, 2001), 65.
2. Lichtenstein, *Behind Closed Doors*, 1.

and perversions he fantasizes in his art."[3] While my interpretation is deeply indebted to Lichtenstein's and Taylor's insights, I will read Bellmer's work through the lens of doll thinking. Since the concept of doll thinking incorporates imagination, intellectual uncertainty, and ambivalence, it seems particularly appropriate to address Bellmer's Surrealist sensibilities. The lens of doll thinking helps me to single out the uniqueness of Bellmer's work – he is an artist known primarily for his doll-like artifacts – and track the dolls' transformation from provocative uncanny figures in photographs to thought-provoking artifacts. The shift of course mirrors a transformation in the artist's inquiry: originally a pedophilic fantasy, the doll evolves over time into an object of pseudo-scientific investigation.

Bellmer was aware of his own doll-thinking intentions from the start of his project: "I am going to construct an artificial girl," he said, "with anatomical possibilities which are capable of re-creating the heights of passion even of inventing new desires."[4] One of these "new desires" was to visually impregnate his doll, as I will demonstrate below. As both the creator and the impregnator, Bellmer takes on a hybrid creative role, embodying and subverting at the same time traditionally male and female archetypes throughout his career. What makes Bellmer's doll project unique is its evolution from the erotic to the epistemological realms, an evolution visible in the shape of the four dolls. For it is because his doll thinking led him to push aesthetic boundaries and probe the anatomical limitations of his dolls, that he discovered the "physical unconscious."

The Doll: Duplication and Assemblage as Mechanisms Triggering Doll Thinking

An engineer by training, and a commercial artist, Bellmer in 1933 began the construction of a doll made of papier-mâché, plaster, wood, and glue. Standing about four-and-a half feet tall, the first doll consisted of a molded torso, a mask-like head with glass eyes, and a long unkempt wig. The legs were made of broomsticks, metal rods, nuts, and bolts, the feet carved out of wood. A broomstick arm and one wooden hand completed the doll. As the process

3. Sue Taylor, *Hans Bellmer: The Anatomy of Anxiety* (Cambridge: The MIT Press: 2002), 4.

4. Peter Webb, *Death, Desire, and The Doll: The Life and Art of Hans Bellmer* (London: Solar Books, 2006), 24.

evolved, the artist made a second set of hollow plaster legs, with wooden ball joints for the hips and the knees. His brother Fritz designed a mechanism that could incorporate a panorama disc into the doll's stomach, and a device to make its eyes move, but neither of these designs was carried out.[5]

In October 1934, after completing his first doll, Bellmer published *The Doll (Die Puppe)*, a pink booklet divided into two parts. It opened with an essay entitled "Memories of the Doll Theme" ("Erinnerungen zum Thema Puppe"), which ended with a linocut, and by ten black-and-white doll photographs under the title "The Genesis of the Doll" ("Die Entstehung der Puppe"). The small-format, handcrafted book, produced at the artist's expense and dedicated to his younger cousin Ursula Naguschewski, was published as a limited edition by Thomas Eckstein, a childhood friend. The miniature format and pink-colored paper seemed designed to summon a nostalgia for childhood pleasures/treasures.

"Memories of the Doll Theme:" The reminiscence of a Doll Thinker

Imaginative, playful, and whimsical, "Memories of the Doll Theme" is an early manifestation of doll thinking. The essay reads like a prose poem, conjuring a narrator's childhood memories of candies, toys, and games, along with erotic fantasies about prepubescent girls. From the beginning, the esoteric text links photography with young girls: the narrator's interest in "banned photography," rooted in a pedophilic desire, is the reason why "his thoughts turned to the young maidens." The essay is structured around the notion of play – marbles, hoops, dolls, candies, and girls' games in particular. In terms of form, the text is laid out as a language play, similar to Surrealist automatic writing – non-linear order, no logical progression. In fact, it is a loose assemblage of fragmented memories, thoughts, and fantasies. Each fragment stands on its own, and the collection as a whole could easily be scrambled and assembled in a new order, like the limbs of the doll in the photographs. As I will discuss later in the chapter, an anagrammatic principle, which informs Bellmer's doll thinking, underlies both the doll photographs and the writings and that is why the two must be read together.

Watching girls at play, the narrator's gaze is transfixed by "the casual quiver of their pink pleats," an observation that suggests the folds of genitalia.

5. Webb, *Death, Desire, and The Doll*, 24.

He scrutinizes the girls' legs, knees, and calves, before his attention comes to rest on the knee joints and their "inquisitive curvature."[6] From the start, the narrator is fragmenting and dismembering the young girls' bodies, referring to them as "flexible dolls." His gaze can no longer distinguish between real girls and dolls: the process of doll thinking is already underway. And his interest in joints will become more central to his doll fascination later on.[7]

The poetic introduction is self-referential, alluding to the doll's construction at the beginning and the end. The narrator first mentions "the smell of glue and wet plaster" (i.e. the materials the doll is made of), then turns his focus at the end to the doll's articulations: "Fit joint to joint, testing the ball-joints by turning them to their maximum position in a childish pose" and its "colorful panorama electrically illuminated deep in the stomach."[8] Over the course of the essay, the reader witnesses the doll being built. Moving through descriptions of these different doll parts and phases of construction, the reader understands that they are also reading about Bellmer's process, his own non-linear, disjointed text. A similar process is enacted in the ten doll photographs, as the camera records the making of the doll as well as the actions Bellmer stages for it. The uneasy interplay between text and image activates the reader's doll thinking: occasionally, a motif or image in the essay points to a particular doll photograph, but the images never serve specifically as an illustration of the text. This experience of false familiarity, of oblique and jostling connection, triggers a sense of the uncanny.

The activities Bellmer staged for his doll were rooted in male aggression against a fantasized and deconstructed female body, and they often ended in violent dismemberment. As the narrator explains in "Memories of the Doll Theme," sadism is an integral part of the game, in which the doll-maker "with aggressive fingers, grasping after form" reshapes the doll's anatomy while "distributing the salt of deformation a bit vengefully."[9] The narrator takes a plainly erotic pleasure in turning his doll inside out, looking onto (and into) the doll's body, whose "hollows he gingerly follows." This is the look of a doll thinker, breaking down the boundaries between inside and outside. In probing the inside, his gaze penetrates new orifices, such as the inner ear and navel

6. Lichtenstein, *Behind Closed Doors*, 172.
7. See Taylor, *The Anatomy of Anxiety*, 45. In this analysis Taylor reads legs as phallic emblems.
8. Hans Bellmer, "Memories of the Doll Theme," reprinted in Lichtenstein, *Behind Closed Doors,* 171
9. Bellmer, "Memories of the Doll Theme," 174.

110 Uncanny Creatures

("losing oneself in the clamshell of the ear" – literally the Ohrmuschel, a term that carries sexual overtones relating to female genitalia). And the narrator lingers there, his seeing eye becoming a penetrative organ. What Bellmer presents at the end of his introduction as *the* solution is in fact the layout of his first doll project: casting a penetrating, voyeuristic gaze into the doll's body, reconfiguring its anatomy by re/disassembling its limbs, and inviting the viewer to doll think when confronted with the photographs of *The Doll*.

The Photographs of *The Doll*: Titillating Doll Thinking

With its playful, performative, and self-referential character, "Memories of a Doll Theme" actively calls our attention to the nexus between writing and photography.[10] At first glance, the ten black-and-white photographs featured in the section "The Genesis of the Doll" seem varied in their subject and composition. Upon closer inspection, however, they can be divided into two groups: five of them showcase Bellmer's use of the technique of doubling; the other five rely on the rearrangement of body parts. Though the techniques of doubling and rearrangement may initially seem at odds, both rely on the artist's use of spacing. Photographic duplication, a trademark of Surrealist photography, creates space between the original and the copy. In doing so, the technique fractures the illusion of seamless, spontaneous reality that was thought to be inherent in the medium of photography.[11] Doubling is already present in the label "Puppe." Phonetically, the German phoneme "Puppe" has two syllables, each starting with the stop consonant "p" followed by a cardinal vowel; graphically, it is characterized by a doubling of the letter "p" – further tightening the link between textual and visual signification.

The opening image (Fig. 27) shows the doll as a wooden and metal skeleton seated on a chair in a doorway, with only the head and foot cast in shadow on the wall behind.

The second image (Fig. 28), however, exploits light-and-shadow effects to produce a full double image of the doll.

10. Etymologically speaking, photography is linked to writing and light, a connection Bellmer is fully aware of and which he exploits throughout his work. The French Surrealist André Breton goes as far as to declare that "automatic writing is [...] a true photography of thought." See his introduction to Max Ernst's *Fatagaga* photomontages, reprinted in *Max Ernst, Beyond Painting and Other Writings by the Artist and His Friends* (New York: Wittenborn Schultz, 1948), 177.

11. That is an argument raised by Rosalind Krauss in her famous essay "Corpus Delicti," *October* 33 (Summer, 1985): 31–72

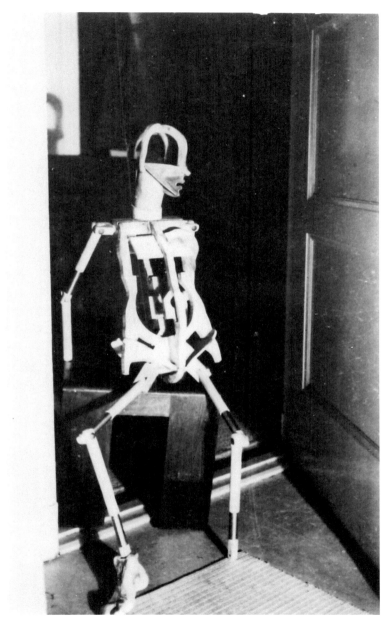

Fig. 27. Hans Bellmer, *Die Puppe* (*The Doll*), 1934. Gelatin silver print. Courtesy of Ubu Gallery, New York. © 2023 Artists Rights Society (ARS), New York / ADAGP, Paris.

Fig. 28. Hans Bellmer, *Die Puppe* (*The Doll*), 1934. Gelatin silver print. Digital Image © The Museum of Modern Art/Licensed by SCALA / Art Resource, NY. © 2023 Artists Rights Society (ARS), New York / ADAGP, Paris.

Bathed in dramatic light and standing against vertically striped wallpaper, the doll casts a shadow of its trunk and head against the background. The shadow highlights the doubling already at work in the process of doll-making (a duplicate of human anatomy) and in the making of the photograph (a duplicate of reality). If one regards the doll as a doppelgänger, and the doll photograph as a copy of the doppelgänger's presence, then the doll's shadow becomes the third layer of doubling. Bellmer's eerie, multilayered images break down the boundaries between reality and fantasy. In photograph 8 (Fig. 29) we see a negative depicting the doll's full bust and bald head posed against a lace-patterned wallpaper.

A long-stemmed rose lies on its side and the doll leans its head slightly forward, as though to sniff it. By including a negative print (read: original) in his booklet and presenting it as a positive (read: copy), Bellmer rearranges the photographic process: the original now becomes the copy, but a copy deprived of any original. The third photograph (Fig. 30), which appears to be a double portrait of the doll and its maker, employs a double exposure, and the artist himself is doubly exposed: dressed in overalls, looking at the camera and bending forward while resting his hands on his knees, he seems to lean his head against the doll's.

In doing so, he appears to appear, appearing only as an absent presence. Through the double exposure, the photographer's ghostly presence seems unreal, and the line between photography and reality, photographer and photographed, is further blurred. The photograph validates the presence of a mechanical doll, while the human figure is nearly erased. The image is no longer an imprint of the natural and the organic, but instead of the artificial and the mechanical. Bellmer's picture is actually a mise-en-abîme: it is the photograph of a ghostly photograph of the doll-maker himself, as well as the image of a blueprint for his doll. The duplication techniques (shadow, double exposure, linocut, image) dissolve familiar ways of looking, thus triggering the viewer's doll thinking. Thus, the only way to apprehend this picture is to resort to imagination, embrace the uncertainty of one's vision, and engage in the uncanny visual experience it creates.

The photographs in *The Doll* draw attention to the medium in several ways, apart from doubling: first a panorama disc mechanism, a proto-photographic device, is fitted into the doll's abdomen; second, the doll's body thus becomes a camera box. Although the idea of a panorama disc mechanism as featured in the doll photograph was quickly abandoned, Bellmer's initial plan was to

Fig. 29. Hans Bellmer, *Die Puppe* (*The Doll*), 1934. Gelatin silver print. Courtesy of Ubu Gallery, New York © 2023 Artists Rights Society (ARS), New York / ADAGP, Paris.

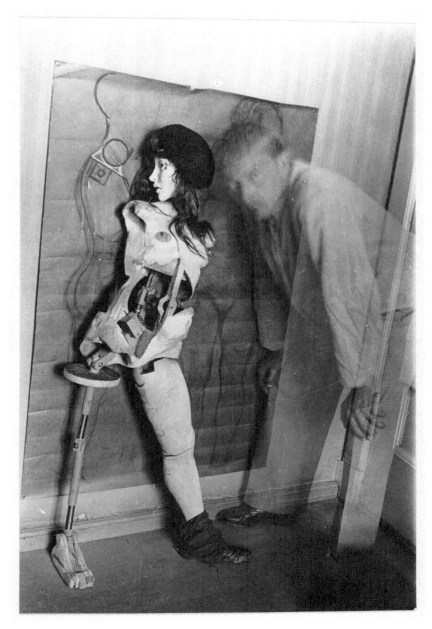

Fig. 30. Hans Bellmer, *La poupée* (*The Doll*), 1936. Gelatin silver print. Digital Image © The Museum of Modern Art/Licensed by SCALA / Art Resource, NY. © 2023 Artists Rights Society (ARS), New York / ADAGP, Paris.

116 Uncanny Creatures

Fig. 31. Hans Bellmer, *La poupée*, 1936. Linocut. Book with illustrations. The Art Institute of Chicago / Art Resource, NY.

make the disk observable through the doll's navel.[12] A linocut of the panorama mechanism in a cut-away view of the doll's torso (Fig. 31) appears in the booklet as a transition from the poetic introduction to the doll photographs.

The diagram presents the headless doll as a peepshow, with a viewer's eye positioned before a pregnant-looking belly, peering into an artificial womb, while a schematic, pointing hand pokes the breast.[13] The image demonstrates Jean Clair's phrase on the phallic interpretation of vision: "the gaze is the erection of the eye."[14]

Pregnancy is a recurrent motif in the making of Bellmer's first and second dolls. The artificial womb of his first doll, which he visually penetrates

12. Lit by tiny colored bulbs and operated by a button in the doll's left nipple, the wheel was to contain six wedge-shaped scenes: a boat sinking into polar ice, sweetmeats, a handkerchief sullied with little girls' saliva, and several diminutive pictures in bad taste evoking the thoughts and dreams of a prepubescent girl.

13. For a detailed analysis of the panorama disk, see Taylor, *The Anatomy of Anxiety*, 24.

14. Jean Clair, "La pointe à l'oeil," Abigail Solomon-Godeau, trans., cited in "Reconsidering Erotic Photography: Notes for a Project of Historical Salvage," in *Photography at the Dock: Essays on Photographic History, Institutions and Practices* (Minneapolis: University of Minnesota Press, 1994), 229.

and inseminates, proves fertile, soon giving birth to three more dolls. Constructing a doll and impregnating it is an integral part of Bellmer's project, and an essential action in his doll thinking. The mechanism in the cut-away view has the look of a camera: the peephole at the navel reminiscent of the viewfinder, with the button situated on the left nipple representing the release.[15] Bellmer's doll is originally made *as a camera*, before being made *for the camera*. Characterized by its duplicating possibility and mechanical apparatus, the doll brings to mind the medium of photography. Made of plaster cast to partially cover the torso, the doll also exhibits one plastered leg in full extension (Fig. 32).

The cast is an index of corporeal presence. Yet, as an imprint of the body, it is also a photographic imprint. Like photography, the cast as a molding device also has the ability to duplicate body parts.

The second group of photographs in *Die Puppe* displays the doll as a *fragmented* body, severed at the joints, lacking limbs, and caught up in constant rearrangement. The fourth photograph (Fig. 33), for example, depicts the doll broken down into body parts ready for reassembly.

Laid out on the blueprint are a plastered open torso, a full plastered leg, a wooden hand, a plastered face mask, two glass eyes, a disc with three panoramas, and a wig, framed by two prosthetic arms at the lower corner and a bent prosthetic leg at the upper corner. The last four photographs of *Die Puppe* attest to Bellmer's substantial progress with the doll – its body now smothered in white smooth plaster and no longer displaying the wooden and metallic skeleton. Yet, the photos above all showcase a doll that is simultaneously complete and dismembered, a *disassembled* doll exhibited in various elaborate and delicate settings. Depicted lying on a bed or a table, the doll is accessorized with veils, lace tablecloths, linens, panties, roses, marbles, and pearls.[16] Photograph 6 (Fig. 34), for example, showcases a tangle of torso, head, leg, and two ball joints, wrapped in black chiffon and white lace, a combination of parts that the following photograph alters.

Image 7 (Fig. 35) depicts a miscellany of white gauze, crumpled bedclothes, cast-off lace panties, and body parts, but now rearranged: a torso with the ball joints in position at the thighs, two leg limbs, two other limbs, two

15. For a thought-provoking analysis of the panorama disk mechanism fitted into the doll's stomach, see Katharina Sykora, *Unheimliche Paarungen: Androidenfaszination und Geschlecht in der Fotografie* (Cologne: Verlag der Buchhandlung Walther König, 1999), 222.

16. These accessories recall the elongated wax dolls adorned with gauze which Bellmer's friend, Lotte Pritzel, crafted for the vitrine.

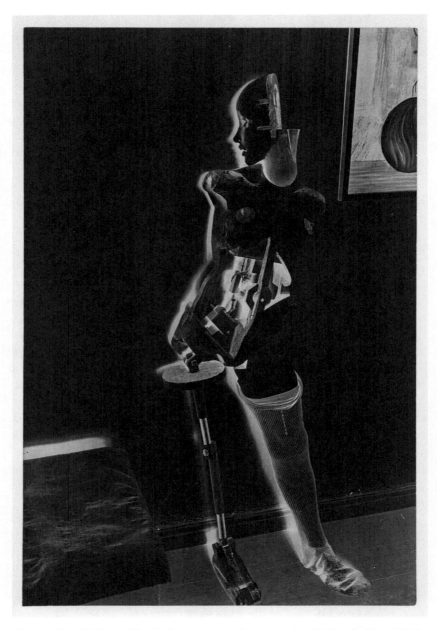

Fig. 32. Hans Bellmer, *The Doll*, 1934–1935. © 2023 Artists Rights Society (ARS), New York / ADAGP, Paris.

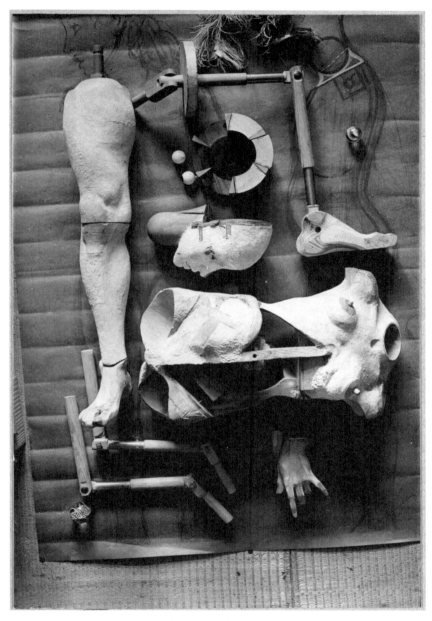

Fig. 33. Hans Bellmer, *La poupée* (*The Doll*), 1933–1936. Gelatin silver print. Image copyright © The Metropolitan Museum of Art. Image source: Art Resource, NY. © 2023 Artists Rights Society (ARS), New York / ADAGP, Paris.

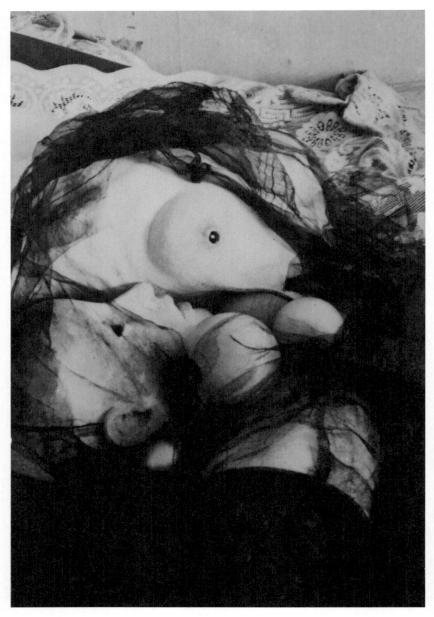

Fig. 34. Hans Bellmer, *Die Puppe* (*The Doll*), 1934. Gelatin silver print. Courtesy of Ubu Gallery, New York. © 2023 Artists Rights Society (ARS), New York / ADAGP, Paris.

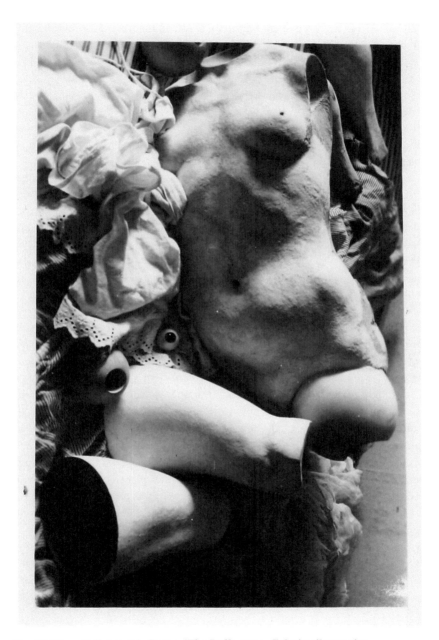

Fig. 35. Hans Bellmer, *Die Puppe* (*The Doll*), 1934. Gelatin silver print. Courtesy of Ubu Gallery, New York. © 2023 Artists Rights Society (ARS), New York / ADAGP, Paris.

ball joints, and a glass eye, all placed on a striped mattress and viewed from a greater distance.

Photograph 9 (Fig. 36) jumbles them again – a full plastered torso, a full head, wig, fragmented limbs, ball joints, a glass eye and a marble, set on top of white lace panties against the background of a striped mattress, now seen from above.

The final photograph of *The Doll* (Fig. 37) depicts a pair of legs in black high heels, wrapped in lace panties with a rose on top, and arranged in the shape of a vulva.

These doll photographs trigger a queasy sense of the uncanny, with their disturbing collision of familiar and unfamiliar, the mutilated body in an intimate, domestic setting, adorned with luxurious accessories (lace and veils), yet violently dismembered. The whiteness, smoothness, and nakedness of the doll's plastered torso invite a lingering, caressing gaze on its surface, while severed limbs force the viewer's attention toward its exposed cavities. These disorienting contradictions, the simultaneous experience of abjection and desire, inside and outside, erotic and macabre, are the essence of Bellmer's doll thinking.

When Bellmer's doll photographs were published on a double-page spread of the Surrealist journal *Minotaure* in the winter issue of 1934, the doll thinking and the anagrammatic principle came into focus together.[17] The 18 images were published under the title: *Variations on the Assemblage of an Articulated Minor* (*Variations sur le montage d'une mineure articulée*) (Fig. 38).

Judging from the title, the French Surrealists seemed to be emphasizing the mechanical qualities and possibilities of Bellmer's doll, as well as the notion of rearrangement. The layout they chose is particularly striking: the verso side shows vertical images of the mechanical doll, featuring the doubling effect, while the recto side displays vertical images of the body parts in serial constant rearrangement. In the middle they placed vertical images of the doll as a wooden skeleton, along with horizontal images of the latter as a truncated corpse lying on a surface. The images do not follow any chronological order, and can be scrambled, flipped upside down, and reassembled without losing any meaning: the layout performs its own anagrammatization. By involving the viewer in a playful, creative activity, centered on disturbing, uncanny images, the *Minotaure*'s double-page spread prompted their readers to doll think.

17. Credits for this seminal publication must be given to Ursula Naguschewski, the artist's younger cousin, who, while studying abroad in Paris, approached Paul Eluard and André Breton with a doll photograph.

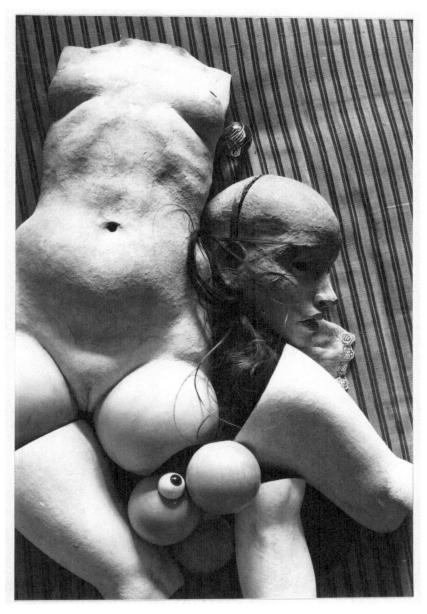

Fig. 36. Hans Bellmer, *La poupée* (*The Doll*), 1936. Gelatin silver print. Digital Image © The Museum of Modern Art/Licensed by SCALA / Art Resource, NY. © 2023 Artists Rights Society (ARS), New York / ADAGP, Paris.

Fig. 37. Hans Bellmer, *Die Puppe* (*The Doll*), 1934. Gelatin silver print. Courtesy of Ubu Gallery, New York. © 2023 Artists Rights Society (ARS), New York / ADAGP, Paris.

An Epistemological Method 125

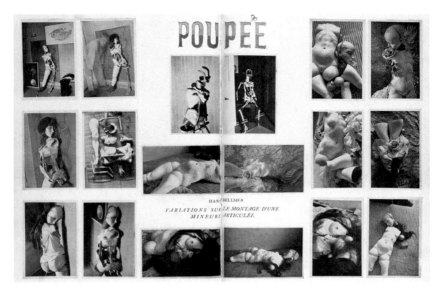

Fig. 38. Hans Bellmer, *Poupée: Variations sur le montage d'une mineure articulée.* Two-page spread, *Minotaure* (December 5, 1934).

The Games of the Doll: Amalgam as Key Feature of Doll Thinking

While the first photo album demonstrated an anagrammatic principle, achieved through doubling and reshuffling, the second, entitled *The Games of the Doll*, employed an amalgamating principle, focused on a ball-jointed doll. The amalgam, a novel concept and an early indication that Bellmer's engagement with his doll is evolving, is a key feature in his doll thinking.

Frustrated with the anatomical limitations of his first doll, and stimulated by his encounter with French Surrealists during his trip to Paris early in 1935, Bellmer started work on a second doll. This construction has its own origin myth, set during a visit to the Kaiser Friedrich Museum in Berlin with Lotte Pritzel. In the museum's collection, Bellmer discovered a pair of fully articulated, ball-jointed wooden dolls used by Renaissance painters in studying the human figure. Having experimented with wooden ball joints for the thighs of his first doll, Bellmer realized that the stomach sphere, around which the whole body could be articulated, would be the solution to his first doll's anatomical limitations (Fig. 39).[18]

18. See Webb, *Death, Desire, and The Doll*, 47.

126 Uncanny Creatures

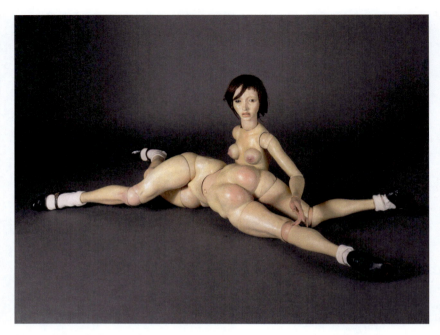

Fig. 39. Hans Bellmer, *The Doll*, 1935. Digital Image © CNAC/MNAM, Dist. RMN-Grand Palais / Art Resource, NY. © 2023 Artists Rights Society (ARS), New York / ADAGP, Paris.

One might say that the first doll was already pregnant with the second, carrying the ball-jointed doll in its mechanized belly. The insertion of a panorama disk into the first doll's belly was like a surgical intervention, a mechanical insemination procedure. The male artist chose a girly-looking doll-like artifact as a surrogate, and planted the seed for a second doll. More concerned this time with the naturalistic resemblance of the doll's Caucasian body, he employed papier mâché as a material, and changed his construction technique. The use of ball joints triggered a paradigm shift in the photographs: the duplication and anagrammatic principles are no longer achieved through photographic duplication; instead they take place within the body of the doll itself.

Responding to the enthusiasm for his first series, Bellmer published photographs of the ball-jointed doll on two later occasions in *Minotaure*.[19] Shortly

19. Bellmer published his doll photographs in two of the most prominent art magazines of interwar France: in the eighth issue of *Minotaure* in 1936 and the special issue of *Cahiers d'Art* devoted entirely to the Surrealist Object; and the tenth issue of *Minotaure* in 1937. As a

after moving to Paris in the aftermath of his wife's death from tuberculosis in February 1938, he started collaborating with Surrealist poet Paul Eluard on a book project dedicated to his doll. But the outbreak of war halted the project.[20] The book was not finally launched until November, 1949, in Paris, under the title *The Games of The Doll* (*Les jeux de la poupée*). It features Bellmer's introduction "Notes on the Subject of the Ball Joint" ("Notes au sujet de la jointure à boule"), six drawings and diagrams, and 15 hand-colored photographs of the ball-jointed doll, followed by 14 of Eluard's prose poems. By including the poems as an "illustration" of the photographs, Bellmer inverts the traditional relation between text and image – yet another act of creative disorientation in his doll project.

"Notes on the Subject of the Ball Joint" or the Considerations of a Doll Thinker

Despite the title announcing a scientific inquiry, Bellmer's essay is foremost a Surrealist introduction to the doll photographs of *The Games of the Doll*. The text unfolds a pseudoscientific history of mechanical forces and engineering feats, from Biblical times through the Renaissance to the present, while also presenting an amalgam of objects – Hellenistic sculptures, children's toys (the top and the diabolo), optical devices, and mathematical formulae.[21] Like the introduction to *The Doll*, "Notes on the Subject of the Ball Joint" opens with the idea of play as a creative activity, making explicit the connection between games and "experimental poetry." A toy is introduced as a "provocative object," and Bellmer considers the doll to be the ultimate one: lacking any predetermined function it lures the viewer/player into an interaction without boundaries – the definition of doll thinking.[22] Like the game with the rolling marble in "Memories

result of this media exposure, Bellmer's doll photographs started to circulate internationally within Surrealist circles, coming into contact with other Surrealist images and causing clear influence. For instance, images by Marcel Duchamp and Claude Cahun can be traced back to Bellmer's doll photographs of *Les Jeux de la poupée*. For a further publishing history, see Webb, *Death, Desire, and The Doll*, 50.

20. Christian Zervos, critic, gallerist, and editor in chief of *Cahiers d'Art*, planned to publish Bellmer's 14 photographs and essay together with Eluard's 14 poems under the title *Jeux vagues de la poupée* (*Vague Games of the Doll*). Webb, *Death, Desire, and The Doll*, 143.

21. Taylor, *The Anatomy of Anxiety*, 99.

22. Hans Bellmer, "Notes on the Subject of the Ball Joint," translated and reproduced in Taylor, *Appendix C, The Anatomy of* Anxiety, 212.

128 Uncanny Creatures

of the Doll Theme," playing games with the doll creates an amalgam "formed of the objective reality that is the chair and the subjective reality that is the doll, an amalgam endowed with a superior reality since it is objective and subjective at once."[23] Bellmer here gives an excellent account of his own doll thinking: undoing hierarchy, and erasing the boundary between subject and object, reality and fantasy. The doll, he says, "occupies any place [...] on the nearest or farthest see-saws of the confusion between the animate and the inanimate."[24]

Situated between object and subject, animate and inanimate, "I" (author) and "You" (reader/viewer), the flexible ball-jointed doll is the image of a body in metamorphosis. The photographer chronicles these unfolding configurations and permutations. Toward the end of the essay, Bellmer develops his theory of the reversibility of the body, describing how the center of gravity can shift from one body part to another:

> [...] the body, like the dream, can capriciously displace the center of gravity of its images. [...] it superimposes on some what it has taken from others, the image of the leg, for example, on that of the arm, that of the sex onto the armpit, in order to make condensations, proofs of analogies, ambiguities, word games, strange anatomical calculations of probability.[25]

Bellmer is already toying with the idea of a further articulation between body and language – the notion of "word games", i.e. anagrams.[26] His anagrammatical thinking only goes so far, however, limiting the incorporation of extra parts into the body of his doll, a process comparable to adding extra letters to a word and, as such, not yet quite an anagram. Adding a second pelvis and an extra pair of legs to a human-shaped, anatomically correct doll, he is still more interested here in amalgam than anagram.

The Photographs of *The Games of the Doll*: Provoking Doll Thinking

The second photo album goes a step further than the first in its eroticism: while *The Doll* represented doll games with a note of desire and titillation, *The Games*

23. Bellmer, "Notes on the Subject of the Ball Joint," 212.
24. Bellmer, "Notes on the Subject of the Ball Joint," 212.
25. Bellmer, "Notes on the Subject of the Ball Joint," 212.
26. In 1957 Bellmer developed his theory of the reversibility of the body and its analogy in language in a major study entitled *Petite anatomie de l'inconscient physique: ou l'anatomie de l'image* (Paris: Le Terrain vague, 1957).

of the Doll openly stages adult erotic doll games. The photographs in Bellmer's second series are all hand-tinted, with pale and delicate colors, giving the images the stagey, artificial quality of turn-of-the-century erotic postcards. The colors also underline the latent violence, cruelty, and sadism inflicted upon the doll, which is successively bound, beaten, tied to a tree, hung on a hook, dismembered and scattered on a stairway.[27] Bellmer is particularly inventive in his orchestration of light and shadow, and the stark chiaroscuro heightens the drama in each scene. Set uncannily amid domestic or familiar settings, indoors and outdoors, the ball-jointed doll invites, then unsettles, the viewer's expectations. Like the marble in the opening essay of *The Doll*, the doll's spherical stomach, with limbs accumulated and articulated around it, makes this anatomical amalgam possible. The sphere of the stomach is both a joint and a center of gravity. The duplication of a pelvis and a pair of legs reveals the reversibility and interchangeability of body parts (the buttocks become breasts, the legs arms, and vice versa). The combination creates an ana- and polymorphic doll body, the photographs of which can be rearranged and rearticulated according to three interconnected topoi: doll play, duplication, and amalgam, each one a facet of doll thinking.

As the title suggests, playfulness is the leitmotif of *The Games of the Doll*. The French title (*Les jeux de la poupée*) is ambiguous, in so far as its possessive can refer either to the games the doll-maker plays with his creation, or the games the doll plays with the viewer. Bellmer stages the sadistic games with his doll in tableau vivant settings, so that the viewer, positioned as a voyeur, is compelled to take part.

In photograph 13 of the album (Fig. 40), we see the four-legged doll pinned against a doorframe, while a large rug-beater looms in the foreground.

A rug-beater was commonly used in German-speaking countries to discipline children. The naked doll, legs clad in white socks, offers its amorphous body, two pelvises and buttocks, to the viewer for punishment – the doll seems to expect a whipping in our presence. The doll is defenseless, resigned to a beating from an absent tormentor. The red tint on its duplicated buttocks suggests bruises, while the crimson spilling like blood over the lower right-hand side of the photograph signals a brutal flagellation about to unfold. The viewer is a passive witness to brutality, while the doll is an active, consenting player. Photograph 7 (Fig. 41), shot in the woods, typifies the triangular relationship linking doll, photographer, and viewer.

27. Taylor, *The Anatomy of Anxiety*, 74.

130 Uncanny Creatures

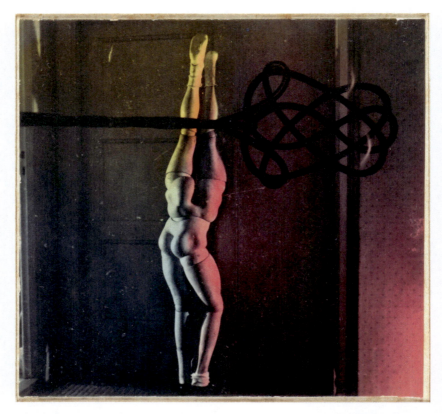

Fig. 40. Hans Bellmer, *Les Jeux de la Poupée* (*The Games of the Doll*), between 1938 and 1949. Gelatin silver print. Digital Image © CNAC/MNAM, Dist. RMN-Grand Palais / Art Resource, NY. © 2023 Artists Rights Society (ARS), New York / ADAGP, Paris.

The four-legged doll, wearing only white socks and black Mary Janes, is leaned against a tree in the woods, with a garment lying at its feet, while a man hiding behind a tree appears to spy on it. The man is dressed in a black coat and hiding from the viewer's gaze, while the reddish doll has turned its bare body toward the viewer. And yet, their bodies mirror one another: the man's half-hidden body is aligned symmetrically with the doll's, and he too is missing a head, with two arms, and two legs. The three trees create a triangle of which the viewer is an integral part: the third tree, set in the background, stands in the middle of the image, halfway between the man and the doll, drawing the viewer's eye to the space between them. Is the viewer a witness to a game of hide-and-seek, or a player? Like the doll, the viewer is caught between

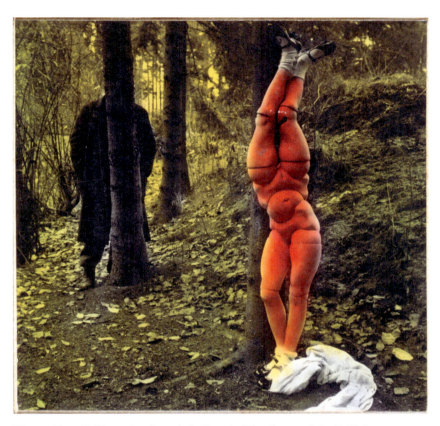

Fig. 41. Hans Bellmer, *Les Jeux de la Poupée* (*The Games of the Doll*), between 1938 and 1949. Gelatin silver print. Digital Image © CNAC/MNAM, Dist. RMN-Grand Palais / Art Resource, NY. © 2023 Artists Rights Society (ARS), New York / ADAGP, Paris

two gazes. Bellmer's staging incorporates the external viewer into the image, holding the related gazes in suspense, and imbuing the image with a powerful ambiguity and tension. As they play with the viewer's gaze, doll photographs 13 and 7 titillate his doll thinking: the viewer finds himself anthropomorphizing a non-human four-legged body, then scrambling to devise a story that can explain the coexisting desire and fear generated by the scene.

With duplication inscribed in his twofold project of constructing and photographing a doll, the games with the ball-jointed doll lead Bellmer deeper into his exploration of the doll body. The various reconfigurations, now including an extra pair of legs, buttocks, or breasts, give the body a distinctly polymorphous

132 Uncanny Creatures

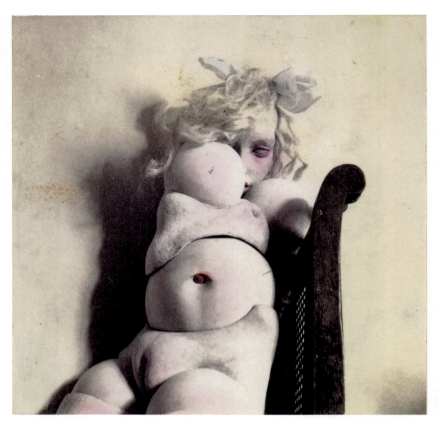

Fig. 42. Hans Bellmer, *Les Jeux de la Poupée* (*The Games of the Doll*), between 1938 and 1949. Gelatin silver print. Digital Image © CNAC/MNAM, Dist. RMN-Grand Palais / Art Resource, NY. © 2023 Artists Rights Society (ARS), New York / ADAGP, Paris.

and erogenous feel. Photograph 3 of *The Games of the Doll* (Fig. 42), the color duplicate of the black-and-white frontispiece, shows the duplicated limbs highlighting the doll's pregnant belly. The doll, crouching unclothed on a wicker chair, buries half of its face in its enormous breasts while displaying a curvaceous, deformed, and truncated body.

The eye is drawn to the globe-shaped stomach, around which two pelvises are mounted. The pregnant belly again recalls an eyeball (the navel and iris), which problematizes the erotic gaze of the maker and viewer alike. The doll returns the gaze twice: it stares back at him not only with the blank eye in its face, but through the iris of its optically coded navel.

An Epistemological Method 133

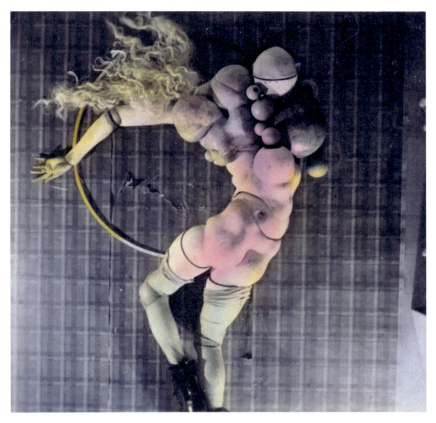

Fig. 43. Hans Bellmer, *Les Jeux de la Poupée* (*The Games of the Doll*), between 1938 and 1949. Gelatin silver print. Digital Image © CNAC/MNAM, Dist. RMN-Grand Palais / Art Resource, NY. © 2023 Artists Rights Society (ARS), New York / ADAGP, Paris.

In photograph 8 (Fig. 43), the doll, pinned to the floor, features a pair of legs in stockings and shoes, as well as one full arm stretched out on a table cloth.

Together these features form an arch, itself emphasized by the addition of a hoop. While the trunk is once again formed by two identical pelvises around a central stomach sphere, the upper body is now an extra pelvis and a multitude of different-sized balls. The curved shape of the doll's body resembles an erect penis, a few of the balls resembling a glans, the spray of hair an ejaculation. Nearby is an extended hand, giving the whole scene the choreography of masturbation. Thus, not only is the gaze destabilized by these multifarious

134 Uncanny Creatures

eyes, but gender is also scrambled: an androgynous body is endowed with both female (stockings, breasts, long curly locks) and male attributes (a penis with multiple glans).

Photograph 10 (Fig. 44) shows a truncated body made of two duplicate pelvises, assembled around an abdominal sphere, and arched over a duvet or pillow.

The doll, twisted sideways as if convulsed by spasms of orgasmic release, exhibits its erogenous body and offers its rosy buttocks to the viewer. All 3 photographs position the pregnant doll's belly in their center, and illustrate the kind of relationship doll thinking establishes between a doll-like artifact and the viewer. Construed as the receptacle of the viewer's penetrating and the maker's impregnating gazes, the sphere of the stomach is also a piercing

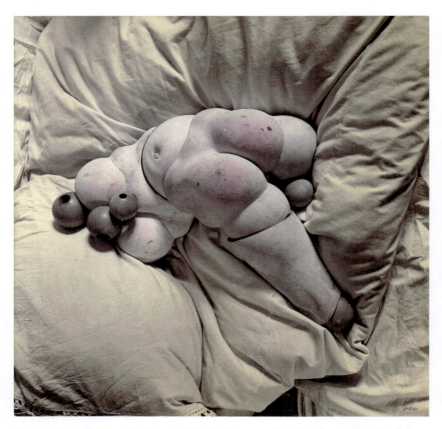

Fig. 44. Hans Bellmer, *La Poupée* (*The Doll*), 1949. Gelatin silver print. Digital Image © CNAC/MNAM, Dist. RMN-Grand Palais / Art Resource, NY. © 2023 Artists Rights Society (ARS), New York / ADAGP, Paris.

eye that looks back at the viewer. Looking back, the doll erases the distinction between object and subject, seer and seen.

The photographs of *The Games of the Doll* also engage with the idea of amalgam, a category Bellmer discusses in his introductory essay "Notes on the Subject of the Ball-Joint." His photographs show two types of amalgam: one between the doll and various objects, another between the doll's representation and different types of images. Even the photograph used as the album's front cover (Fig. 45) shows an example of the form: the two imbricated buttocks, themselves assembled around a ball joint, evoke an amalgam: a molar tooth and an Arquerite mineral.

Photograph 4 (Fig. 46), featuring various parts of a doll entangled with parts of a chair, is the first of three disturbing amalgams between a doll and its domestic reality.

Here the doll's head, abdominal sphere, thigh, and two pelvises, are broken apart and curled around the broken parts of a caned chair seat and leg. Bellmer assembles all these fragments on a tablecloth on the floor, adding to them a white hair bow, to introduce a childlike innocence to the sordid disarray. The bow accentuates the triangular layout of the composition, while the pink, red, orange, green and blue tints on the body parts give them the appearance of fruit. Like the corresponding parts of the doll, these oranges, apples, blueberries, plums, and cherries are ready for consumption. Within the image, chair and doll are entwined, so that the chair leg functions as an arm for the armless body, with a bent wooden hand then extending above the doll's head. Together this amalgam of limbs has the appearance of a sleeping woman. Photographs 5 and 6 show an amalgam formed by blending the doll with its environment. Both are shot in the woods – the first apparently during the day, the second at night. The first (Fig. 47) shows an armless and legless doll, a head, two reversible pelvises and a thigh, hanging from a tree, as if it had been lynched. Shot from below, the photograph looks as if the doll's trunk had morphed into the tree trunk, the branches apparently growing out of its head.

The second, nighttime image (Fig. 48) presents a four-legged doll, again in white socks and Mary Janes, placed next to a shrub. Entangled in the branches, the doll's legs take on the shape of the shrub, blending the two and linking the artificial with the natural. (Papier mâché, the doll's material, is derived from trees.)[28]

28. This literary reference to Ovid's *Metamorphoses VIII: 611-724*, and to the fable of Baucis and Philemon in particular, who were changed into an intertwining pair of trees upon their death, appears quite overtly in these photographs. Ovid, *Metamorphoses*, translated by Rolfe Humphries, (Bloomington: Indiana University Press, 1961), 200-204.

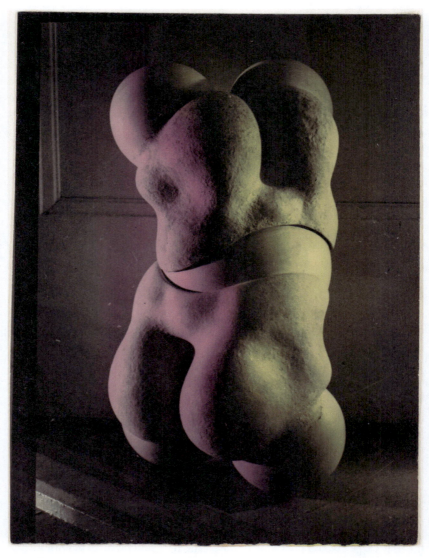

Fig. 45. Hans Bellmer, *La Poupée* (*The Doll*), c. 1936. Gelatin silver print. Image copyright © The Metropolitan Museum of Art. Image source: Art Resource, NY. © 2023 Artists Rights Society (ARS), New York / ADAGP, Paris.

An Epistemological Method 137

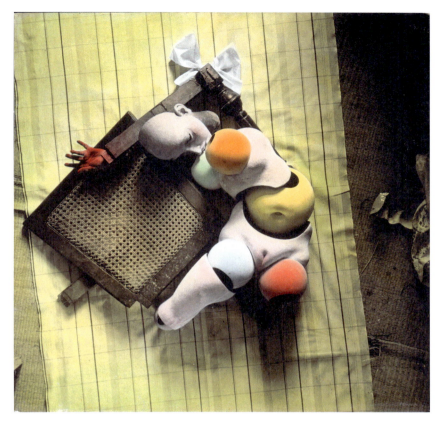

Fig. 46. Hans Bellmer, *La Poupée (The Doll)*, c. 1935–1936. Gelatin silver print. Digital Image © CNAC/MNAM, Dist. RMN-Grand Palais / Art Resource, NY. © 2023 Artists Rights Society (ARS), New York / ADAGP, Paris.

Photograph 9 (Fig. 49) is an indoor shot featuring an armless doll with an amputated leg, tied to a stairway and gazing blankly at the viewer.

The doll's body consists of a hand, placed between the balusters, a head with wig and bow, two pelvises, an abdominal sphere, and two legs, one truncated. The complete leg, the left one, is bound at the knee with twine in the form of a bow, while the other is cut off midway across the thigh. The doll's body is woven into the balusters, draped on the stairway, hiding its face, while looming large for the viewer. The blend of doll and environment reveals how doll thinking operates in these photographs: The viewer's categories are scrambled, as he tries to track a doll that seems to blend into fruits, a tree, or a chair.

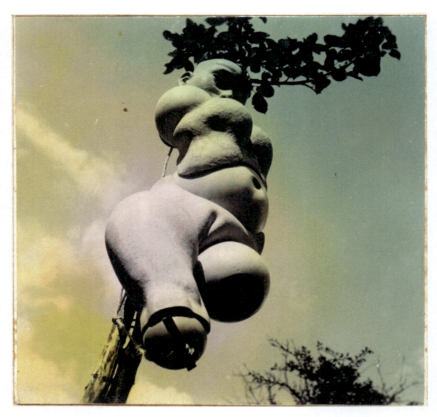

Fig. 47. Hans Bellmer, *Les Jeux de la Poupée* (*The Games of the Doll*), between 1938 and 1949. Gelatin silver print. Digital Image © CNAC/MNAM, Dist. RMN-Grand Palais / Art Resource, NY. © 2023 Artists Rights Society (ARS), New York / ADAGP, Paris.

The amalgamation of the familiar with the unfamiliar, the natural with the artificial, the ordinary with the peculiar, is the essential action of doll thinking for Bellmer.

Bellmer amalgamates images across media and genres. Characterized by dramatic lighting, mysterious ambience, erotic violence and cruelty, the photograph of the amputated doll tied to a stairway brings to mind images from German Expressionist cinema, as well as Renaissance religious iconography.

The amalgam of references and influences is particularly apparent in photograph 11 (Fig. 50), showing two pairs of legs, in white socks and black Mary Janes, attached vertically on either side of a tree in the woods.

An Epistemological Method 139

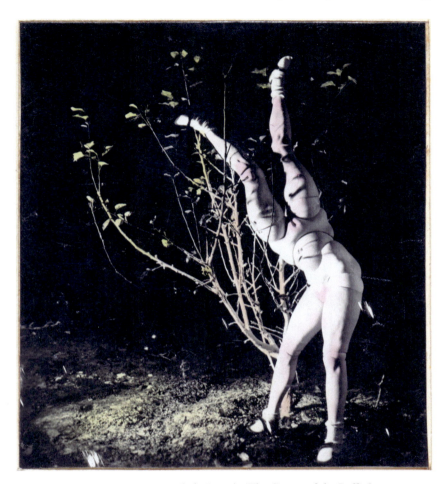

Fig. 48. Hans Bellmer, *Les Jeux de la Poupée* (*The Games of the Doll*), between 1938 and 1949. Gelatin silver print. Digital Image © CNAC/MNAM, Dist. RMN-Grand Palais / Art Resource, NY. © 2023 Artists Rights Society (ARS), New York / ADAGP, Paris.

We can see eyeballs hanging from either side of the tree trunk at ankle height, as well as a white pitcher, set in the background on the far right. This scene is one of Bellmer's most sadistic and violent images, a tableau of punishment or sacrifice, even religious martyrdom.

This brings us to a link between the 14 images of *The Games of the Doll*, representing violent and cruel games, and the 14 Stations of the Cross, depicting the suffering and agony of Christ. Photograph 11 seems to allude directly to Station XI,

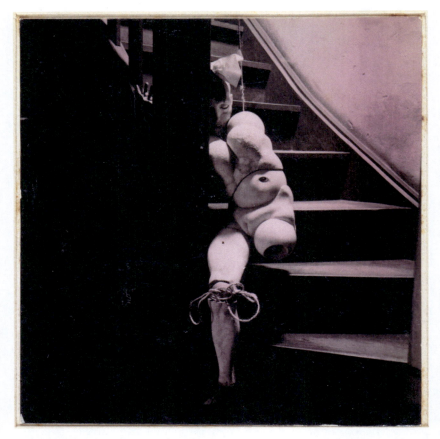

Fig. 49. Hans Bellmer, *Les Jeux de la Poupée* (*The Games of the Doll*), between 1938 and 1949. Gelatin silver print. Digital Image © CNAC/MNAM, Dist. RMN-Grand Palais / Art Resource, NY. © 2023 Artists Rights Society (ARS), New York / ADAGP, Paris.

in which Jesus Christ is nailed to the cross. Among the numerous religious depictions of the crucifixion, the Isenheim altarpiece (1506–1515) by Matthias Grünewald (Fig. 51) is known to have had a long-lasting effect on Bellmer.[29]

29. It is a biographical fact that Bellmer went with his tuberculin first wife Margarethe on a pilgrimage to Colmar in 1932 to admire the Isenheim altarpiece. Years later, commenting on the figure of Mary Magdalene in the central panel, the artist wrote to the art historian Patrick Waldberg: "Think of the Magdalene in tears, kneeling at the feet of the pale figure on the cross: in her grief, she wrings not only her hands but also her head, her hair, the rags

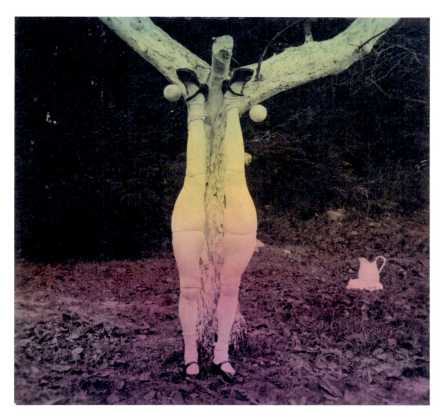

Fig. 50. Hans Bellmer, *Les Jeux de la Poupée* (*The Games of the Doll*), between 1938 and 1949. Gelatin silver print. Digital Image © CNAC/MNAM, Dist. RMN-Grand Palais / Art Resource, NY. © 2023 Artists Rights Society (ARS), New York / ADAGP, Paris.

Among the many striking similarities, Sue Taylor notes, "the arcing tree branches in the photograph echo the bowed arms of Grünewald's Christ."[30] The white pitcher stands in place of John the Baptist, who points at Christ's open wound in the crucifixion image. The pitcher's spout, which replaces John's pointing finger, directs the viewer's attention to the figure, an amalgam of fragmented parts, not a human or even divine being, but something pointedly

that cover her body and even her toes. When the reaction or gesture of a person does not find expression in the whole of their body, whether in a contemporary photograph or a masterpiece of art, I am no longer interested." Cited by Lichtenstein, *Behind Closed Doors*, 85.

30. Taylor, *The Anatomy of Anxiety*, 92–93.

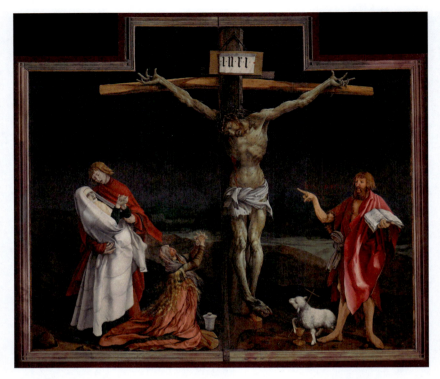

Fig. 51. Matthias Grünewald, *Isenheim Altarpiece*, 1506–1515. Oil on wood. © Musée Unterlinden Colmar, photo RMN-GP.

artificial, not a male body but a female one. The contour of these two pairs of elongated legs, in parallel in front of an isolated tree, sketch out the shape of a vulva: Christ's gaping wound in the Grünewald painting has become female genitalia in Bellmer's photograph.

Beyond the imagery, there are several other aesthetic similarities. The movable, folding structure of the altarpiece, offering various combinations and enabling the display of three different views (Nativity, Crucifixion, and the patron saints), recalls the anatomical possibilities of the ball-jointed doll and the constant rearrangement of its parts. In photograph 11, Bellmer amalgamates objects (his doll with a tree) and images (a profane doll photograph with a painting of crucifixion) and, in so doing, he triggers doll thinking. These amalgamations stand in the foreground of Bellmer's Surrealist agenda, in the essay and the doll photographs. Subtler is the underlying anagrammatic principle, and its influence on Bellmer's particular brand of doll thinking.

The Machine-Gunneress in a State of Grace:
Doll Thinking the Anagram

In 1936, Bellmer started work on his third doll, drawing inspiration from the paintings of other Paris-based artists, among them Pablo Picasso's *Woman Seated in a Red Armchair* (1934) and Joan Miró's *Woman* (1934). He made a few drawings and paintings of the new doll before settling on the shape of a sculpture he called *The Machine-Gunneress in a State of Grace* (*La Mitrailleuse en état de grâce*) (Fig. 52).[31]

The construction of a third doll, which metamorphoses into a mechanical doll-like sculpture, attests to the constant evolution of Bellmer's doll thinking and his tireless investigation of his doll's body. By combining an automatic firearm with a religious belief, the Surrealist title: *The Machine-Gunneress in a State of Grace* amalgamates violence and death, with pleasure and bliss – a fusion that calls to mind *la petite mort,* orgasm reached in the sexual act. The construction of this three-foot-high doll was similar to the first and second, a continuous evolution, each doll pregnant with the next, their maker endlessly potent. For the third, Bellmer used broom handles and metal rods, and built the body parts out of papier mâché. According to Peter Webb *The Machine-Gunneress in a State of Grace* "shows a many-limbed monster that seems to be a cross between a giant telescope and a praying mantis," again fusing the natural and man-made.[32] The sculpture consists of anthropomorphic and mechano-morphic elements: a conic head, with a suggestive cleft on the top and a mouth at the bottom, two small breasts, and two large spoon-shaped limbs; a small wooden sphere around which the whole machine is articulated; and broom handles with moveable joints (Fig. 53).

The look and plasticity recall the second, ball-jointed doll, while the articulated wooden limbs are reminiscent of the first. But the third doll has no interior – no cavities or orifices, no belly or womb. Above all, the originality of *The Machine-Gunneress in a State of Grace* lies in its explicit expression of hybridity, reinforced by a mix of wooden and papier mâché materials. Part machine, part human, part male, part female, this hybrid creation demonstrates doll thinking at every stage, actively erasing anthropological categories and gender divisions. For the record, Bellmer had already explored androgyny in *The Games of the Doll*.

31. The name of Bellmer's sculpture is a nod to the machine gun invented by Leonardo Da Vinci (1452–1519). Bellmer was repeatedly inspired by the mechanical inventions and war machines designed by the famous Florentine.

32. Webb, *Death, Desire, and The Doll*, 57.

144 Uncanny Creatures

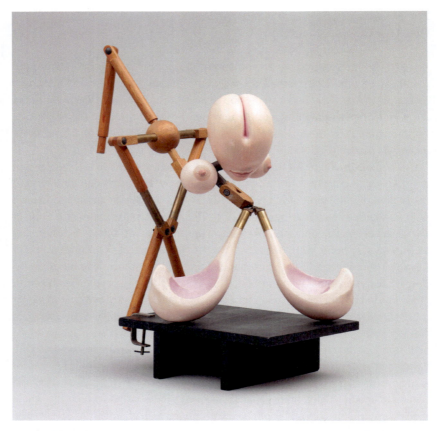

Fig. 52. Hans Bellmer, *La mitrailleuse en état de grâce (The Machine-Gunneress in a State of Grace)*, 1937. Digital Image © The Museum of Modern Art/Licensed by SCALA / Art Resource, NY. © 2023 Artists Rights Society (ARS), New York / ADAGP, Paris.

Photograph 11 (Fig. 54) features the four-legged doll, half-lying, half-sitting on a rumpled bed, one set of legs splayed, wearing open trousers with open fly and belt, while the other half extends unclothed.

This image recalls yet another hybrid doll, the Topsy-Turvy doll, a cloth figure that originated in American plantation nurseries in the nineteenth century, before being refashioned in German bisque porcelain and mass produced. The Topsy Turvy is a two-headed, two-bodied doll, with a black body and a white one, conjoined at the lower waist, where the hips and legs would ordinarily be.

An Epistemological Method 145

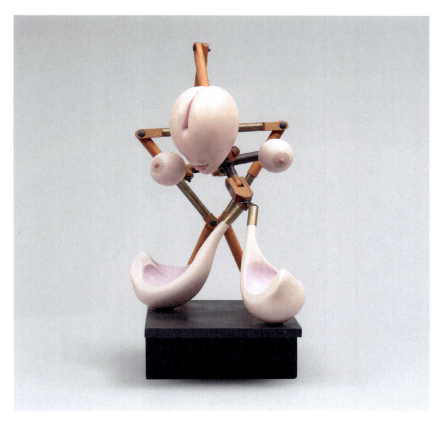

Fig. 53. Hans Bellmer, *La mitrailleuse en état de grâce (The Machine-Gunneress in a State of Grace)*, **1937. Digital Image © The Museum of Modern Art/Licensed by SCALA / Art Resource, NY. © 2023 Artists Rights Society (ARS), New York / ADAGP, Paris.**

The lining of the one's doll's dress is the outside of the other's, so that the skirt flips over to conceal one racialized body when the other is upright. With that inspiration, Bellmer replaced the head and torso with the missing limbs, and substituted gender-specific clothes for race. With the *The Machine-Gunneress in a State of Grace* the artist goes a step further in dismantling the polarity of gender and biological sex: the cleft on the top of the Gunneress' could be the meatus of a penis glans, or the outer lips of a vulva; the forelimbs have the shape of testicles, as well as breasts. The doll is an uncanny object of desire, a toy that both enacts and demands doll thinking.

146 Uncanny Creatures

Fig. 54. Hans Bellmer, *Les Jeux de la Poupée* (*The Games of the Doll*), between 1938 and 1949. Gelatin silver print. Digital Image © CNAC/MNAM, Dist. RMN-Grand Palais / Art Resource, NY. © 2023 Artists Rights Society (ARS), New York / ADAGP, Paris.

This third doll sculpture is also deeply permutable, with articulated parts that bend and move in 360 degrees. Although Bellmer left it behind upon immigrating to Paris in 1938, the three existing original photographs of *The Machine-Gunneress in a State of Grace* clearly demonstrate this flexibility. That detail sets *The Machine-Gunneress in a State of Grace* apart from the other two. Moreover, the three original photographs show that he did not stage his doll sculpture in tableaux vivants settings, nor did he publish the series with an accompanying text. By this point, Bellmer's doll thinking had shifted away

from photography, centering once again on the doll itself as the source and object of permutation.

The limitless permutability brings to mind the anagrammatic principle underlying the first two dolls, but with a major difference: unlike the ball-jointed doll, which requires the addition of duplicated limbs (pelvis, arm, or legs) to be transformed, the third doll sculpture is self-sufficient. Bellmer built his second doll because he was dissatisfied with the anatomical limitations of the first; one may assume he built *The Machine-Gunneress in a State of Grace* for similar reasons. With the ball-jointed doll, anagrammatic games were possible only through amalgamation, i.e. the addition of extra body parts and objects. So, Bellmer designed a doll-like sculpture whose fixed structure and moveable limbs could imitate the restrictive practice of composing anagrams – adapting to his newest phase of doll thinking.

In this regard, *The Machine-Gunneress in a State of Grace* is the perfect illustration of a pure anagram: the parts are comparable to the letters of a word, and can be rearranged at whim, infinitely, without any addition. Indeed, with the collaboration of his female partners – Bulgarian poet Nora Mitrani, whom he met in 1946, and seven years later German artist Unica Zürn, with whom he shared part of his life – he began composing anagrams. "Anagrams work better," he noted, "with two people, a man and a woman."[33] In a 1954 postscript to Zürn's *Oracle and Spectacle*, a collection of her anagrammatic poems and drawings, Bellmer gave a detailed account of the practice. Equating language with the human body, he reads written words and letters as body parts reordered: "the sentence may be compared to a body, which invites us to disarticulate it, in order that its true contents may be recomposed through an endless series of anagrams." Acknowledging the destruction inherent in the process, he points out, that "the anagram is born from a violent and paradoxical conflict. It presupposes a maximal tension of imaginative will and, at the same time, of the technical limitations of the means at hand – only the given letters may be used, none other."[34]

After recognizing that chance plays a great part in the discovery of an anagram, Bellmer adduces the following example: "Beil (ax) becomes Lieb (love)

33. The importance of collaboration in Bellmer's creative process must be emphasized here: the construction of both dolls is the result of a family collaboration (involving mostly wife, brother, and cousin), while the creation of anagrams is the product of the collaboration between lovers. See Webb, *Death, Desire, and The Doll*, 138.

34. Lichtenstein, *Behind Closed Doors*, 174–175.

or Leib (body) when the diligent hand of stone glides over it."[35] His choice of a word whose anagram is "Leib" (body) is anything but accidental: it proves for him the link between body and language, and conjures verbal images. Perhaps no anagrammatic reshuffling could capture this link as well as "Beil," whose rearrangement yields a connection between ax, body, and love. For Bellmer, only an anagram can reveal the unexplored potential contained in a single word: a chopping ax (Beil) guided by a loving desire (Lieb) to dismember a body (Leib). This triple meaning lives inside the *The Machine-Gunneress in a State of Grace*, whose catapult-like aspect is threatening, while the human-like limbs and sexual organs are arousing. The practice of reshuffling the limbs of the doll sculpture works just like the letters: each new manipulation of the body parts that produces new shapes, images, and meanings, is at the same time an act of violence, a scene of violence, even as the new and uncanny carnality summons desire.

Somehow, the singularity of the doll sculpture as well as its analogy with the anagram has been neglected in the scholarship on Bellmer. The artwork was lost, and only rebuilt under the artist's supervision in 1961, which speaks volumes for its importance in his eyes. Scholars generally read the ball-jointed doll and the games Bellmer plays with it as a metaphor for anagrammatic play, and then too often construe the articulated doll body as an anagrammatic one, influenced by the artist's later statement: "the sentence may be compared to a body, which invites us to disarticulate it." Most scholars overlook the sentence preceding that assertion: "Truly, the human being knows his language even less than he knows his body." Bellmer provides this stipulation for his practice of writing anagrams: "only the given letters may be used, none other." Both quotes disqualify the ball-jointed doll from any analogy with anagrammatic practice: the reshuffling of its limbs, which often requires the addition of duplicated body parts, makes the second doll unfit for a pure anagram.

Certainly, an anagrammatic principle underlies Bellmer's first and second doll projects: in *The Doll*, the principle was mainly achieved by doubling effects and the dis/assembling of the body parts. In *The Games of the Doll*, it relied on amalgamation and the duplication of body parts. Drawing from Marvin Altner's convincing analysis, which questions the validity of the anagram as a key to Bellmer's ball-jointed doll, I posit that Bellmer's interest in anagram only shows its full expression in *The Machine-Gunneress in a State of Grace*, and only here does the artist demonstrate the full force of his doll thinking.[36]

35. Lichtenstein, *Behind Closed Doors*, 175.

36. Marvin Altner, *Hans Bellmer: Die Spiele der Puppe. Zu den Puppendarstellungen in der Bildenden Kunst von 1914–1938* (Weimar: Verlag und Datenbank für Geisteswissenschaften, 2005), 123.

The Half Doll: Doll Thinking as an Expression of the Physical Unconscious

The Half Doll (*La demi-poupée*) (Fig. 55), from 1972, was the last doll sculpture Bellmer created before his death in 1975, the final attempt at doll thinking in a project that spanned almost four decades.

This doll is a four-foot high wooden and papier mâché construction, this time not made by the artist's hand, but outsourced to a carpenter, who built nine different versions. There are, to my knowledge, neither photographs of *The Half Doll*, nor any poetic introduction. Bellmer has settled upon the object itself.

The Half Doll looks simpler – a trunk with head and only one breast, one leg, and one arm. Reminiscent of the ball-jointed doll from *The Games of the Doll*, it is articulated with ball joints at the knee, hip, shoulder, elbow, and wrist; it also sports a very large checkered bow at the back of the head, one white sock and one Mary Jane shoe. The doll's head, with its small puckered mouth and cleft at the top, recalls *The Machine-Gunneress in a State of Grace*. *The Half Doll* looks like a malformed fetus, the product of doll wombs no longer fertile. The almost reductive simplicity also seems to suggest that Bellmer, near his end, has returned to the beginning. *The Half Doll* is the illustration of his theory of the "physical unconscious," which he discovered and elaborated through decades of doll making and doll thinking.

My reading of the doll is strongly at odds with Webb, who contends that "compared to its progenitor, it represents a travesty of the original inspiration which descends to the level of Kitsch."[37] Not only does Webb misconstrue Bellmer's last doll but, in doing so, he fails to recognize the connection to the 1957 essay "A Brief Anatomy of the Physical Unconscious or The Anatomy of the Image." By contrast, I wish to underscore the doll's title and structure, both of which conjure the image of an anatomical cut, a doll literally split in half, pointedly missing an arm, a leg, and a breast. This constitution as a *half-doll* is precisely what renders its amalgamation with nearby objects more visible. *The Half Doll*'s single body parts are, moreover, interchangeable, with the arm resembling the leg, the hand evoking the foot, and the ball-joint of the shoulder recalling a breast. The doll bears both feminine (the round form of the breast, the hourglass shape of the trunk) and masculine attributes (the phallic form of its leg intruding into/protruding from its lower abdomen). The cleft on top of the doll's head suggests both

37. Webb, *Death, Desire, and The Doll*, 182.

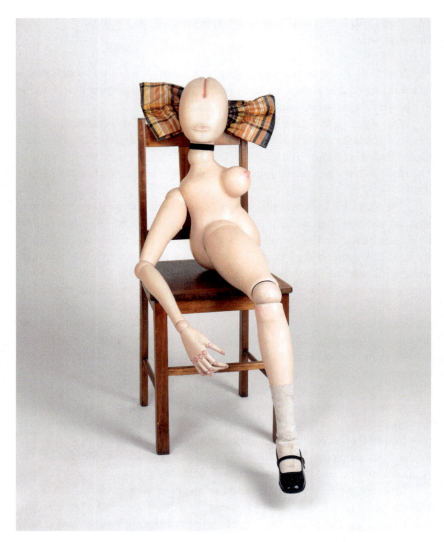

Fig. 55. Hans Bellmer, *La demi-poupée (The Half Doll)*, 1971. Wood, paint and assemblage, doll: 90 cm (height). Art Gallery of New South Wales, purchased 1996. © Estate of Hans Bellmer/ADAGP. Copyright Agency. Image © Art Gallery of New South Wales.

vulva and the meatus of a glans. Thus, I argue that *The Half Doll* is a three-dimensional illustration that the center of gravity/arousal can be shifted from one body part to another: arm to leg, elbow to knee, shoulder to breast, head to thigh, and so on.

That idea of displacement of erogenous zones, although sketched out in his 1938 "Notes on the Subject of the Ball Joint," is treated more fully 20 years later in an essay in French titled, "A Brief Anatomy of the Physical Unconscious or The Anatomy of the Image" ("Petite anatomie de l'inconscient physique ou L'anatomie de l'image") (1957). "The Anatomy of the Image" was Bellmer's most ambitious piece of writing to date. Not only does he reflect on his entire body of work, but he also gives a detailed and unprecedented account of his theory of the physical unconscious. While some read this essay as a statement that illuminates and coheres his entire body of work, I myself am reluctant to impose such a posteriori, teleological interpretations.

"A Brief Anatomy of the Physical Unconscious or The Anatomy of the Image" is a short, dense essay divided into three parts, "Images of the Self," "Anatomy of Love," and "The Outside World," and including drawings to illustrate various points. As with "Memories of the Doll Theme" and "Notes on the Subject of the Ball-joint," the essay is a mix of poetic writing, free association, and pseudo-scientific claims. Bellmer's main subject is the body's inextricable relationship to the unconscious and its images. Taking up the Freudian notion of displacement, discussed in such texts as *The Interpretation of Dreams,* and libidinal displacements in particular (see, for example, *Three Essays on the Theory of Sexuality*), Bellmer argues that the unconscious is located in the body, and the psyche is body as much as mind. According to him, an unconscious system, living in the body, transforms our physical sensations in order to circumvent pain, repression, or interdiction. Desire triggers these transformations by setting in motion movements of duplication and displacement.

In "Images of the Self" he offers a compelling case in point. He describes the young girl seated, leaning on a table and daydreaming. For him, the girl's languid pose demonstrates the duplication, displacement, and superimposition of body parts: her arm doubles for her leg, her armpit for her vagina, her hand for her foot, and her nose for her heel: "Hand and tooth," he writes, "armpit and vagina, heel and nose: in short, virtual and real arousal are intermingling by means of their superimposition."[38] He supports his novel theory of the body with graphic illustrations that make visible the concepts of duplication, displacement and superimposition of body parts visible and intelligible. The sketches show us the mechanism of the physical unconscious, of which *The Half Doll* is a later embodiment.

38. Hans Bellmer, "A Brief Anatomy of the Physical Unconscious or The Anatomy of the Image," in *The Doll* (London: Atlas Press, 2005), 112.

Epilogue

> Don't play with me, it just hurts me
> I'm bouncing off the walls
> No-no-no, I'm not your plastic doll
> —Lady Gaga, *Plastic Doll*, 2020

In Helmut Newton's black-and-white photograph "Store Dummies II" we see another encounter with the uncanny – a scene that feels strangely familiar at first, but evolves with our attention into something more mysterious and bizarre – an eerie crystallization of the photographer's doll thinking.

In 1976, Newton translated his ongoing fascination with store dummies into a series of fashion spreads for French *Vogue*. In his autobiography, he tells a bit of the origin story: "My preoccupation with store dummies, dolls, etc. began in 1968, when English *Vogue* published my first series of photos with these dummies. It showed a favorite model of mine, Willie Van Rooy, confronting a store dummy cast in her image, thus creating a kind of Doppelgänger."[1] "The use of these dummies," he later said, "allowed me to stage rather daring tableaux for French *Vogue*. Using live models would have been too risky."[2] And they were risqué indeed – photographs of store dummies, dressed in Yves Saint Laurent couture, engaged in sexual acts. "Store Dummies II" (Fig. 56), which appeared in the March 1976 issue, features two bare-chested brunettes – model Violeta Sanchez and her life-size replica, crafted by London-based mannequin designer Adel Rootstein – lying in bed and gazing at one another.[3]

1. Helmut Newton, *Autobiography* (London: Duckworth, 2003), 222.
2. Newton, *Autobiography*, 122.
3. José Alvarez, *Helmut & June. Portraits croisés*. (Paris: Bernard Grasset, 2020), 216.

Epilogue 153

Fig. 56. Helmut Newton, *Store Dummies II*, **1976. © 2022 HELMUT NEWTON FOUNDATION. All rights reserved.**

The two look like twins, their posture identical – each lying on her back, with one arm bent behind her – eyes locked, noses touching. The female model on the left, who's leaning in as though to kiss the other, turns out not to be a store dummy – despite the title – but a real woman, with the lines on her neck and under her armpit giving her away as human. The fact that Newton's favorite female models, the "Newton Girls," with their perfect measurements, *naturally* looked like plastic mannequins, is a further indication of his doll thinking – a refusal to differentiate between a female model and a dummy. In that regard, the German-born photographer fits right into the genealogy of doll thinkers and makers in this book. He shares their obsessions, as well as their impulse toward aesthetic experimentation. Like Nathanael, who confuses the

mechanical doll Olimpia with his fiancée, Newton is interested in blurring the line between the real woman and the artificial one. His photograph lays bare a real excitement in imagining and representing the confusion between fantasy and reality. Like Kokoschka before him, Newton commissioned a life-size replica of his female model, and the two certainly shared a fascination with verisimilitude. Their dolls' smooth surfaces bespeak an obsession with physical touch. Violeta Sanchez brings to mind a Pritzel doll, with her fuzzy hair, elongated and androgynous physique, languid attitude and aloof demeanor. Pritzel's influence is there, too, in the morbid sensuality and sterile eroticism of Newton's photograph. And the surrealist shadow of Bellmer's doll artifacts hovers over "Store Dummies II." Newton's playfulness, toying with the models and the viewer alike, recall Bellmer's staged doll photographs. By teasing the viewer, the photographer unsettles us, deflecting our projections and mocking our expectations.

Newton was taken to task in the 1990s by German feminist Alice Schwarzer, who called his images of women "not only sexist and racist, but also fascist."[4] Although trained by a female photographer of the Weimar era, he is by no means a feminist and "Store Dummies II" is not intended to pursue a feminist agenda, unlike the Moos' Alma doll pictures or Pritzel's portraits by Madame d'Ora. These emancipated women artists from the first half of the twentieth century promoted in their work the alternative image of New Woman, while scorning the fetishization of the female body in Western art. Newton's "Store Dummies II" does nothing to reproach the male gaze; it caters to it. And, yet, the image still undermines the heteronormative gaze. He positions the viewer as voyeur, intruding on a scene of intimacy, and entices us into the heterosexual fantasy he offers. We are paralyzed, helpless to choose between the model and the mannequin cast in her image. Newton uses the uncanny doubling to boobytrap the heterosexual fantasy of lesbian sex, and uncovers instead the queerness and uncanniness of hetero-normative desire. By presenting these fake twin sisters, he doll-thinks the viewer into an arousing experience of liminality and indeterminacy. The image ultimately leaves us questioning the normalcy and originality of our own heteronormative desires. When confronted with doll thinking, we discover ourselves to be first among the *Uncanny Creatures*. The uncanny is in the eye of the beholder.

4. See Alice Schwarzer, "Newton: Kunst oder Propaganda?," *Emma*, November/December 1993, 26–31, https://www.emma.de/artikel/newton-kunst-oder-propaganda-263514; Sylvia Bovenschen, "Alice in Newton-Land" *Der Spiegel*, July 25, 1994, 92–94, https://www.spiegel.de/spiegel/print/d-13683769.html.

We are titillated and unsettled by the lesbian-chic image of a woman desiring her mannequin doppelgänger. In the model's narcissistic self-love – she is lying in bed naked touching her mirror image, i.e. herself – we see a scene of erotic pleasure derived from self-contemplation, and triggered by a non-normative desire, a desire for an artificial, inorganic surrogate. "Store Dummies II" entices the viewer into an experience of liminality precisely because its aesthetic is liminal. The photograph lies at the intersection of two paradigms, modernity and postmodernity. While the image is without a doubt indebted to twentieth-century avant-garde movements, and to Surrealism in particular, its arrangement announces a paradigm shift, and a displacement of the uncanny.[5] It ultimately does much more than simply interrogate mimesis or destabilize the status of photography as an index of reality. It informs on the interchangeability and reproducibility of the human body and its substitution by its own image, which is a source of the uncanny. "Store Dummies II" is form- and content-wise a simulacrum, defined by cultural theorist Jean Baudrillard as something that replaces reality with its representation – that is, a copy with no original.[6] Recycling lesbian erotica and copying avant-garde aesthetics, Newton's photograph makes the swapping of representation for reality sexy. The Store Dummies series, while appearing to channel the surreal, verges on the "hyperreal": Newton makes it difficult (not yet impossible) to distinguish between reality and simulation at first glance. The photograph announces the era of the simulacrum, and cites the doll thinkers of modern German culture as harbingers of hyperreality.

5. Quintieri elucidates this paradigm shift and takes it as the point of departure for her analysis of contemporary doll artifacts. See Rosalinda Quintieri, *Dolls, Photography, and the Late Lacan* (New York: Routledge, 2021).

6. Jean Baudrillard, *Simulacra and Simulation*, Sheila Faria Glaser, trans. (Detroit: University of Michigan Press, 1994).

Bibliography

PRIMARY LITERATURE

Bellmer, Hans. *Petite anatomie de l'inconscient physique: ou l'anatomie de l'image.* Paris: Le Terrain vague, 1957.
Bellmer, Hans. "A Brief Anatomy of the Physical Unconscious or The Anatomy of the Image." In *The Doll.* London: Atlas Press, 2005.
Hoffmann E.T.A. *The Serapion Brethren II.* Translated by Alex Ewing. George Bell & Sons: London, 1892.
Hoffmann E.T.A. "The Sandman." In *The Best Tales of Hoffmann*, edited by E.F. Bleiler, 183–214. New York: Dover Publications, 1967.
Hoffmann E.T.A. "The Sandman." In *Tales of Hoffmann*, 85–127 New York: Penguin Books, 1982.
Kokoschka, Oskar. *A Sea Ringed with Visions.* New York: Horizon Press, 1962.
Kokoschka, Oskar. *My Life.* Translated by David Britt. New York: MacMillan Publishing, 1974.
Kokoschka, Oskar and Heinz Spielmann, eds. *Briefe I: 1905–1919.* Düsseldorf: Claasen Verlag, 1984.
Mork, Editha, and Wolfgang Till, eds. *Lotte Pritzel, Puppen des Lasters, des Grauens und der Extase.* Munich: Puppentheatermuseum Verlag, 1987.
Rilke, Rainer Maria. *Zu den Wachspuppen von Lotte Pritzel.* Leipzig: Verlag der weißen Bücher, 1914.

SECONDARY LITERATURE

Alvarez, José. *Helmut & June. Portraits croisés.* Paris: Bernard Grasset, 2020.
Barthes, Roland. *Camera Lucida: Reflections on Photography.* Translated by Richard Howard. New York: Hill & Wang, 1981.
Baudrillard, Jean. *Simulacra and Simulation.* Translated by Sheila Faria Glaser. Detroit: University of Michigan Press, 1994.
Bates, David. "Cartesian Robotics." *Representations* 124, no. 1 (Fall 2013): 43–68.

Bibliography

Benjamin, Walter. "The Work of Art in the Age of Its Technological Reproducibility." Translated by Harry Zohn. In *Illuminations: Essays and Reflections*, edited by Hannah Arendt, 217–251. New York: Schocken Books, 1968.

Berber, Anita, and Sebastian Droste. *Dances of Vice, Horror, and Ecstasy*. Translated by Merril Cole. Newcastle Upon Tyne: Side Real Press, 2012.

Bernstein, Robin. *Racial Innocence: Performing American Childhood from Slavery to Civil Rights*. New York: New York University Press, 2011.

Blum, Harold P. "Oskar Kokoschka and Alma Mahler: Art as Diary and as Therapy." In *The Psychoanalytic Study of the Child*, vol. 65, edited by Robert A. King, Samuel Abrams, A. Scott Dowling, and Paul M. Brinich, 293–309. New Haven: Yale University Press, 2011.

von Boehm, Gero, director. *Helmut Newton: The Bad and the Beautiful*. Kino Lorber, 2020. 1hr. 33 min.

Borek, Barbara, "Geschöpfe meiner selbst – die Puppen der Künstlerin Lotte Pritzel (1888–1952) zwischen Kunst und Gewerbe." Ph.D. diss. Technische Universität Berlin, 2003.

Borek, Barbara. "Die Pritzelpuppen der Puppenpritzel." In *Ab nach München: Künstlerinnen um 1900*, edited by Antonia Voit, 316–319. Munich: Münchner Stadtmuseum, 2014.

Brantly, Susan. "A Thermographic Reading of E.T.A. Hoffmann's *Der Sandmann*." *The German Quarterly* 55, no. 3 (1982): 324–335.

Breton, André. "Introduction." In *Max Ernst: Beyond Painting and Other Writings by the Artist and His Friends,* by Max Ernst, 177-183. New York: Wittenborn Schultz, 1948.

Brown, Bill. "Thing Theory." *Critical Inquiry* 28, no. 1 (2011): 1–16.

Brugger, Ingried. *Oskar Kokoschka und Alma Mahler, Die Puppe: Epilog einer Passion*. Frankfurt am Main: Städtische Galerie im Städel, 1992.

Bovenschen, Sylvia. "Alice in Newton-Land." Der Spiegel (July 25, 1994): 92–94. https://www.spiegel.de/spiegel/print/d-13683769.html.

Candlin, Fiona, and Raiford Guins, eds. *The Object Reader*. New York: Routledge, 2009.

Coester, R. "Lotte Pritzel–Munich." *Deutsche Kunst und Dekoration: illustrierte Monatshefte für moderne Malerei, Plastik, Architektur, Wohnungskunst und künstlerisches Frauen-Arbeiten* 45 (October, 1919): 347.

Cixous, Hélène. "Fiction and Its Phantoms: A Reading of Freud's *Das Unheimliche* ('The Uncanny')." *New Literary History* 7, no. 3 (Spring, 1976): 525–548.

Descartes, René. *Discourse on the Method and Meditations on First Philosophy*, edited by David Weissman, 4–48. New Haven: Yale University Press, 1996.

Didi-Huberman, Georges. "Viscosities and Survivals: Art History Put to the Test by Material." In *Ephemeral Bodies: Wax Sculpture and the Human Figure*, edited by Roberta Panzanelli, 154–169. Los Angeles: Getty Publications, 2008.

Drux, Rudolf. *Die Lebendige Puppe, Erzählungen aus der Romantik*. Frankfurt am Main: Fischer Taschenbuch Verlag, 1986.

Duden. "Ach." https://www.duden.de/rechtschreibung/ach.

Ebenstein, Joanna. *The Anatomical Venus*. London: Thames & Hudson, 2016.

Ellis, John M. "Clara, Nathanael and the Narrator: Interpreting Hoffmann's *Der Sandmann*." *The German Quarterly* 54, no. 1 (1981): 1–18.

Fletcher, John. "Freud, Hoffmann and the Death-Work." *Angelaki: Journal of Theoretical Humanities* 7, no. 2 (2002): 125–141.
Freud, Sigmund. "Fetishism." In *Miscellaneous Papers, 1888–1938*. Vol. 5, *Collected Papers*. Edited by James Strachey, 198–205. London: Hogarth Press, 1950.
Freud, Sigmund. "The Uncanny." In *The Standard Edition of the Complete Psychological Works of Sigmund Freud*, vol. 17 [1917–1919], *An Infantile Neurosis and Other Works*, edited by James Strachey, 217–256. London: Hogarth Press, 1952.
Freud, Sigmund. *The Interpretation of Dreams*. Translated by A. A. Brill. New York: Random House, 1978.
Freud, Sigmund. *Three Essays on the Theory of Sexuality. The 1905 Edition*. Edited and introduced by Philippe van Haute and Herman Westerink. London: Verso, 2016.
Glüber, Wolfgang. "Puppen für die Vitrine. Zu den Arbeiten der Puppenkünstlerin Lotte Pritzel." *Kunst in Hessen und am Mittelrhein* 36, no. 37 (1998): 139–150.
Goebbel, Eckart. "'Herzpause'. Rainer Maria Rilke über Puppen." In *Martyrdom in Literature: Visions of Death and Meaningful Suffering in Europe and the Middle East from Antiquity to Modernity*, vol. 17, edited by Friederike Pannewick, 283–297. Wiesbaden: Reichert Verlag, 2004.
Goethe, Johann Wolfgang von. *West-Eastern Divan*. Translated by Eric Ormsby. London: Gingko, 2019.
Gorsen, Peter. *Sexualästhetik: Grenzformen der Sinnlichkeit im 20. Jahrhundert*. Reinbeck: Rowohlt Taschenbuch Verlag, 1987.
Grosz, Elizabeth. "Naked." In *The Prosthetic Impulse: From a Posthuman Present to a Biocultural Future*, edited by Joanne Morra and Marquard Smith, 187–202. Cambridge: MIT Press, 2005.
Hewett-Thayer, Harvey. *Hoffmann: Author of the Tales*. Princeton: Princeton University Press, 1984.
Hilmes, Oliver. *Malevolent Muse: The Life of Alma Mahler*. Translated by Donald Arthur. Boston: Northeastern University Press, 2015.
Hirschfeld, Georg. "Neue Puppen von Lotte Pritzel." *Deutsche Kunst und Dekoration: illustrierte Monatshefte für moderne Malerei, Plastik, Architektur, Wohnungskunst und künstlerisches Frauen-Arbeiten* 31 (October 1912): 259.
Hoffman, Edith. *Kokoschka: Life and Work*. London: Faber and Faber, 1947.
Jentsch, Ernst. "On the Psychology of the Uncanny" [first published 1905]. Translated by Roy Sellars. *Angelaki: Journal of Theoretical Humanities* 2, no. 1 (1995): 7–16.
Kayser, Ulrich, dir. *Die Pritzelpuppe*. Berlin, Germany: Universum-Film AG, 1923.
Keegan, Susan. *The Eye of God: A Life of Oskar Kokoschka*. London: Bloomsbury, 1999.
Kleist, Heinrich von. "On the Marionette Theatre." In *On Dolls*, edited by Kenneth Gross, 1–10. Kendal: Notting Hill Editions Ltd, 2018.
Kim, Eunjung. "Why Do Dolls Die? The Power of Passivity and the Embodied Interplay Between Disability and Sex Dolls." *Review of Education, Pedagogy, and Cultural Studies*, 34, nos 3–4 (July 2012): 94–106.
Krauss, Rosalind. "Corpus Delicti." *October* 33 (Summer, 1985): 31–72.
Kretzschmar, Dirk. "Geschlecht/Sexualität/Liebe." In *E.T.A. Hoffmann Handbuch: Leben-Werk-Wirkung*, edited by Christine Lubkoll and Harald Neumeyer, 261–266. Stuttgart: Verlag J.B. Metzler, 2015.

Krobb, Florian and Elaine Martin, eds. *Weimar Colonialism, Discourses and Legacies of Post-Imperialism in Germany after 1918*. Bielefeld: Aisthesis Verlag, 2014.

La Mettrie de, Julien Offroy. *Machine Man and Other Writings*, edited by Ann Thompson. New York: Cambridge University Press, 1996.

Lammer, Christine. *Die Puppe, Eine Anatomie des Blicks*. Vienna: Verlag Turia und Kant, 1999.

Langbehn, Volker. *German Colonialism, Visual Culture, and Modern Memory*. New York: Routledge, 2010.

Lelièvre, Stéphane. "Présence d'E.T.A. Hoffmann sur les scènes lyriques françaises." In *Le surnaturel sur la scène lyrique: du merveilleux baroque au fantastique romantique*, edited by Agnès Terrier and Alexandre Dratwicki, 53–70. Lyon: Symétrie, 2012.

Lessing, Gotthold Ephraim. *Laokoön oder Über die Grenzen der Malerei und Poesie*. Berlin: Christian Friedrich, 1766.

Lichtenstein, Therese. *Behind Closed Doors: The Art of Hans Bellmer*. Berkeley and Los Angeles: University of California Press, 2001.

Lieb, Claudia. "Krank geschrieben: Wie Ärzte und Poeten Hoffmanns Bild vom pathologischen Künstler prägten." In *E.T.A. Hoffmann Portal der Staatsbibliothek zu Berlin*. Berlin: De Gruyter, 2017. https://etahoffmann.staatsbibliothek-berlin.de/erforschen/rezeption/rezeption-laender/deutschland/.

Lieb, Claudia. "Der Sandmann." In *E.T.A. Hoffmann: Leben-Werk-Wirkung*, edited by Detlef Kremer, 169–185. Berlin: De Gruyter, 2010.

Liebrand, Claudia."Automaten/Künstliche Menschen." In *E.T.A. Hoffmann Handbuch: Leben-Werk-Wirkung*, edited by Christine Lubkoll and Harald Neumeyer, 242–246. Stuttgart: Verlag J.B. Metzler, 2015.

Marks, Laura U. *Touch: Sensuous Theory and Multisensory Media*. Minneapolis: University of Minnesota Press, 2002.

Marvin, Altner. Hans Bellmer: Die Spiele der Puppe. Zu den Puppendarstellungen in der Bildenden Kunst von 1914–1938. Weimar: Verlag und Datenbank für Geisteswissenschaften, 2005.

Meldrum-Brown, Hilda. *E.T.A Hoffmann and the Serapiontic Principle*. Rochester: Camden House, 2006.

Meyer, Dorle. *Doppelbegabung im Expressionismus: Zur Beziehung von Kunst und Literatur bei Oskar Kokoschka und Ludwig Meidner*. Göttingen: Universitätsverlag, 2013.

Michel, Wilhelm. "Puppen von Lotte Pritzel." *Deutsche Kunst und Dekoration: illustrierte Monatshefte für moderne Malerei, Plastik, Architektur, Wohnungskunst und künstlerisches Frauen-Arbeiten* 27 (October, 1910): 329–338.

Michel, Wilhelm. "Neue Wachspuppen von Lotte Pritzel." *Deutsche Kunst und Dekoration: illustrierte Monatshefte für moderne Malerei, Plastik, Architektur, Wohnungskunst und künstlerisches Frauen-Arbeiten* 33 (October 1913): 312–315.

Newman, Gail. "Narrating the Asymbolic in E.T.A. Hoffmann's *Der Sandmann*." *Seminar* 33, no. 2 (1997): 119–133.

Newton, Helmut. *Autobiography*. London: Duckworth, 2003.

Ohlsen, Nils. "Forels Hände: Bemerkungen zu den Händen im Werk Oskar Kokoschkas." In *Kokoschka: Werke der Stiftung Oskar Kokoschka*, 21–32. Heidelberg: Wachter Verlag, 2001.

Ovid. *Metamorphoses*. Translated by Rolfe Humphries. Bloomington: Indiana University Press, 1961.
Panagl, Oswald. "Hoffmanns Erzählungen im Repertoire der Wiener Staatsoper." In the program bill for *Jacques Offenbach: Les Contes d'Hoffmann*, 96–100. Vienna: Wiener Staatsoper, 2014.
Papapetros, Spyros. "Movements of the Soul: Traversing Animism, Fetishism, and the Uncanny." *Discourse* 34, nos 2–3 (Spring/Fall 2012): 185–208.
Praz, Mario. "La poupée de Kokoschka." In *Le pacte avec le serpent, tome III Serpent*. Paris: Christian Bourgeois, 1991.
Quintieri, Rosalinda. *Dolls, Photography, and the Late Lacan: Doubles Beyond the Uncanny*. New York: Routledge, 2021.
Reilly, Kara. *Automata and Mimesis on the Stage of Theatre History*. New York: Palgrave Macmillan, 2011.
Reinhold, Bernadette, and Eva Kernbauer, eds. *Zwischenräume zwischentöne*. Berlin: De Gruyter, 2018.
Rilke, Rainer Maria. "Dolls: On the Wax Dolls of Lotte Pritzel." In *On Dolls*, edited by Kenneth Gross, 51–62. Kendal: Notting Hill Editions, 2018.
Riskin, Jessica. "The Defecating Duck or The Ambiguous Origins of Artificial Life." *Critical Inquiry* 29, no. 4 (2003): 559–633.
Roe, Francesca Roe. "The Satanic Sex: Lotte Pritzel and the Puppet as Gendered Body," *Academia*. https://www.academia.edu/19587485/The_Satanic_Sex_Lotte_Pritzel_and_the_Puppet_as_a_Gendered_Body.
Roos, Bonnie. "Oskar Kokoschka's Sex Toy: The Women and the Doll Who Conceived the Artist." *Modernism/Modernity* 12, no. 2 (2005): 291–309.
Royle, Nicholas. *The Uncanny*. New York: Routledge, 2003.
Ruelfs, Esther. "D'Ora's Photographs of Women in the Illustrated Magazines of the 1920's." In *Madame d'Ora*, edited by Monika Faber, 87–96. New York: Prestel Publishing, 2020.
Schmitz-Emans, Monika. "Eine schöne Kunstfigur: Androiden, Puppen und Maschinen als Allegorien des literarischen Werkes." *Arcadia* 30, no. 1 (1995): 1–30.
Schober, Thomas. *Das Theater der Maler: Studien zur Theatermoderne anhand dramatischer Werke von Kokoschka, Kandinsky, Barlach, Beckmann, Schwitters und Schlemmer*. Stuttgart: M&P Verlag für Wissenschaft und Forschung, 1994.
Schreiber, Justina. "Hermine Moos, Painter: On the Occasion of Discovering a Hitherto Unknown Photograph of Kokoschka's Alma Doll." In *Oskar Kokoschka: Ein Künstlerleben in Lichtbildern*, edited by Bernadette Reinhold and Patrick Werkner, 91–95. Vienna: Ambra Verlag, 2013.
Schwarzer, Alice. "Newton: Kunst oder Propaganda?" *Emma* (November/December 1993): 26–31. https://www.emma.de/artikel/newton-kunst-oder-propaganda-263514.
Scott, Walter. "On the Supernatural in Fictitious Composition, and in Particularly in the Works of E.T.A. Hoffmann." *Foreign Quarterly Review* 1 (1827): 60–98.
Sebastian. "Neue Puppen von Lotte Pritzel." *Deutsche Kunst und Dekoration: illustrierte Monatshefte für moderne Malerei, Plastik, Architektur, Wohnungskunst und künstlerisches Frauen-Arbeiten* 38 (September 1916): 422–425.
Silverman, Kaja. *The Acoustic Mirror: The Female Voice in Psychoanalysis and Cinema*. Bloomington: Indiana University Press, 1988.

Simms, Eva-Maria. "Uncanny Dolls: Images of Death in Rilke and Freud." *New Literary History* 27, no. 4 (1996): 663–677.

Smith, Marquard. "Touching: Oskar Kokoschka's Alma Mahler." In *The Erotic Doll: A Modern Fetish*, 109–135. New Haven: Yale University Press, 2013.

Solomon-Godeau, Abigail, trans. "Reconsidering Erotic Photography: Notes for a Project of Historical Salvage." In *Photography at the Dock: Essays on Photographic History, Institutions and Practices*, 220–238. Minneapolis: University of Minnesota Press, 1994.

Street, Lisa J. "Oskar Kokoschka's Doll: Symbol of Culture." Ph.D. diss. Emory University, 1993.

Sykora, Katharina. *Unheimliche Paarungen: Androidenfaszination und Geschlecht in der Fotografie*. Cologne: Verlag der Buchhandlung Walther König, 1999

Tatar, Maria. Lustmord: Sexual Murder in Weimar Germany. Princeton: Princeton University Press, 1997.

Taylor, Sue. *Hans Bellmer: The Anatomy of Anxiety*. Cambridge: The MIT Press, 2002.

Timpano, Nathan J. *Constructing the Viennese Modern Body: Art, Hysteria, and the Puppet*. New York: Routledge, 2017.

Treusch-Dieter, Gerburg. "Das Rätsel der Puppe." In *Die Puppe, Eine Anatomie des Blicks*, edited by Christine Lammer, 9–10. Vienna: Verlag Turia und Kant, 1999.

Voskuhl, Adelheid. *Androids in the Enlightenment: Mechanics, Artisans, and Cultures of the Self*. Chicago: University of Chicago Press, 2013.

W.F. "Vitrinen-Puppen von Lotte Pritzel." *Deutsche Kunst und Dekoration: illustrierte Monatshefte für moderne Malerei, Plastik, Architektur, Wohnungskunst und künstlerisches Frauen-Arbeiten* 50 (April 1922): 112–115.

Webb, Peter. *Death, Desire, and The Doll: The Life and Art of Hans Bellmer*. London: Solar Books, 2006.

Whitford, Frank. *Oskar Kokoschka: A Life*. New York: Atheneum, 1986.

Wolfskehl, Hanna, to Albert and Kitty Verwey, March 20, 1907. In *Karl Wolfskehl (1869–1969): Leben und Werk in Dokumenten*. Darmstadt: Hessische Landes-und Hochschulbibliothek Darmstadt, 1969.

Index

abdomens. *see* stomachs
Académie des Sciences (1738), 6–7
alchemy, 32–34, 71
Alma doll (Moos), 12, 36–65, 154; Bellmer and, 105; demise of, 61–63; Kokoschka's art of, 57–60; Kokoschka's reaction to, 54–57, 61; Mahler and, 42, 50–51, 61; making of, 39–45, 47–49, 60–61; materiality, 42–45, 47–55; photography of, 41f, 48–54, 50f, 51f, 53f; as a thing, 56–60; touch and, 38, 42–44, 47–48; uncanniness of, 56. *see also* anatomy (doll); Kokoschka, Oskar; Mahler, Alma; Moos, Hermine
"Alte und Neue Puppen" ("Old and New Dolls"), 99
Altner, Marvin, 148
amalgamation, 10, 125–129, 135–138, 147. *see also* Bellmer, Hans
anagrams, 12, 106, 108, 122, 128, 142; violence in, 147–148. *see also* Bellmer, Hans
The Anatomical Venus (Ebenstein), 85
anatomy (doll): breasts, 57–58, 59f, 83, 84f, 112–150; buttocks, 126f, 129, 130f, 133f–134f, 135, 136f; feet, 28, 43, 107, 149–151; hands, 42–44; pelvises, 128–129, 132–137; skin, 44–45, 47–48. *see also* Alma doll (Moos); arms; Bellmer, Hans (works); eyes; joints; legs; phallic symbolism; stomachs; vulval symbolism
anatomy (human), 108–110, 128, 151

androgyny, 13; of Bellmer's dolls, 133–134, 143–145, 149–150; of Pritzel's dolls, 12, 66, 72–80, 83–84, 89, 92, 154. *see also* gendered roles; queer theory
androids. *see* automatons
Anita Berber as Pritzel Doll (Madame d'Ora), 99, 101
anthropomorphism, 12–13, 131, 143
Aristotelian thought, 8, 78
arms: of Alma doll, 40, 41f, 43, 50f, 51f, 52, 53f, 55, 58; in Bellmer's works, 107–151; in Newton's works, 1, 2f, 3–4, 153f; of Pritzel's dolls, 72, 73f–76f, 77, 86, 87f, 96f, 97, 99, 100f–102f. *see also* anatomy (doll)
arousal. *see* desire
Artist with Doll (Kokoschka), 12, 38–39, 59–60, 59f
aura, 86, 88–89. *see also* Benjamin, Walter
The Automata (Die Automate) (Hoffmann), 7, 18
automatons, 4, 6–9. *see also The Sandman* (Hoffmann)
avant-garde movement: Pritzel and, 12, 70–71, 97–104

Bahlsen, Hermann, 66
ballet. *see* dancing
ball-jointed doll, 10, 12, 104, 106, 125–142, 147. *see also* anatomy (doll); Bellmer, Hans (works)
Barthes, Roland, 3

163

Baudrillard, Jean, 155
Bayerischer Rundfunk, 40
Beardsley, Aubrey, 77
Behind Closed Doors: The Art of Hans Bellmer (Lichtenstein), 106
Bellmer, Fritz, 108
Bellmer, Hans, 9–12, 105–151; Alma doll and, 105; amalgamation, 10, 125–129, 135–138, 147; anagrams, 12, 106, 108, 122, 128, 142, 147–148; eroticism and, 106–110, 128–129, 131–132; fragmentation, 117, 122; Hoffmann and, 14; Kokoschka and, 105–106; poetry and, 127–128; Pritzel and, 67, 104–105, 117n16, 125; reversibility of the body, theory of, 128–129; Surrealism and, 107, 126–127, 142; *Variations on the Assemblage of an Articulated Minor*, 122, 125; violence and, 106–107, 109–110. *see also* doll thinking, of Bellmer
Bellmer, Hans (works), 52, 105–151, 154; androgyny of, 133–134, 143–145, 149–150; ball-jointed doll, 10, 12, 104, 106, 125–142, 147; "A Brief Anatomy of the Physical Unconscious or The Anatomy of the Image" ("Petite anatomie de l'inconscient physique ou L'anatomie de l'image"), 106, 149, 151; *The Doll (Die Puppe)* (Bellmer), 106, 111f–112f, 114f–116f, 118f–121f, 123f–126f; *The Games of the Doll (Les jeux de la poupée)*, 106, 125–146, 130f–134f, 136f–142f, 146f; "The Genesis of the Doll" ("Die Entstehung der Puppe"), 108; *The Half Doll (La demi-poupée)*, 106, 149–151, 150f; "Images of the Self," 151; *The Machine-Gunneress in a State of Grace (La Mitrailleuse en état de grâce)*, 106, 143–149, 144f–145f; materiality of, 107–109, 143, 149; "Memories of the Doll Theme" ("Erinnerungen zum Thema Puppe"), 108–110, 127–128, 151; "Notes on the Subject of the Ball Joint" ("Notes au sujet de la jointure à boule"), 10, 127–128, 135, 151; photography of, 110–150; uncanniness in, 109, 113, 122; vulval symbolism in, 108, 110, 122, 142, 145, 150. *see also* anatomy (doll)
Benjamin, Walter: "The Work of Art in the Age of Its Technological Reproducibility," 86, 88
Berber, Anita, 12, 66, 69, 97, 101f; poem, 99, 103–104; "Vitrine Doll," 99, 102f
Bernstein, Robin: *Racial Innocence*, 10; scriptive thing, 54
Black dolls, 72–73, 95, 144–145
body. *see* anatomy
The Book of Dolls (Das Puppenbuch), 95
Borek, Barbara, 67
Boucher, François, 72
breasts: in Bellmer's works, 112–150; in Kokoschka's works, 57f–59f; in Pritzel's works, 83, 84f. *see also* anatomy (doll)
Breton, André, 122n17
"A Brief Anatomy of the Physical Unconscious or The Anatomy of the Image" ("Petite anatomie de l'inconscient physique ou L'anatomie de l'image") (Bellmer), 106, 149, 151
Brown, Bill, 56
The Burning Bush (Der brennende Dornbusch) (Kokoschka), 45
buttocks, 126f, 129, 130f, 133f–134f, 135, 136f. *see also* anatomy (doll)

Cagliostro, Alessandro, 33
Cahiers d'Art, 126n19–127n20
Cahun, Claude, 127n19
cameras, 116–117. *see also* photography
castration, 4, 17, 25, 63n71. *see also* phallic symbolism
Chanel, 1
Chess-playing Turk (Kempelen), 18
Christ, imagery of, 139–142
cinema, 70–72, 138
Cixous, Hélène, 26
Clair, Jean, 116
clockmaker theory, 8
Coester, R., 67
colonialism, 95. *see also* racialized dolls; Weimar Republic
Les contes d'Hoffmann (Tales of Hoffmann) (Offenbach), 16–17, 37–38, 105–106

Coppelia or The Girl with Enamel Eyes (Coppélia ou la fille aux yeux d'émail) (Saint-Léon and Delibes), 16–17
cultural appropriation, 95

dancing: Pritzel's dolls and, 70–72, 92–104; *The Sandman* and, 16–17n7, 29–31. *see also* Berber, Anita; Impekoven, Niddy
da Vinci, Leonardo, 41n14, 60n62, 143n31
Delibes, Léo: *Coppelia or The Girl with Enamel Eyes (Coppélia ou la fille aux yeux d'émail)*, 16–17
La demi-poupée (The Half Doll) (Bellmer), 106, 149, 150f, 151
demonic forces, 80
Descartes, René: *Treatise on Man*, 8
desire, 3, 5–6, 9; doll thinking and, 9, 24–25. *see also* Bellmer, Hans; eroticism; Kokoschka, Oskar
Deutsche Kunst und Dekoration, 12; Pritzel in, 67; Pritzel's work in, 65–66, 71–85, 88, 94, 104. *see also* "Dolls for the Vitrine" (Pritzel)
dialectics, 26
disorientation, 127. *see also* amalgamation
Dix, Otto, 63, 99n59
doll (term). *see* Puppe (term)
The Doll (Bellmer), 106–126, 129, 148. *see also* Bellmer, Hans (works)
doll making: Bellmer and, 107–108; Hoffman's interest in, 17–18; in *The Sandman*, 32–36. *see also* Alma doll (Moos); Moos, Hermine; Pritzel, Lotte
doll paintings (Kokoschka), 57–60
Doll Parts (Hole), 105
Dolls, Photography, and the Late Lacan (Quintieri), 51
"Dolls for the Vitrine" (Pritzel), 12, 65–104; eroticism of, 72–83, 85, 103–104; 1910, 71–78, 73f–75f; 1912/1913, 76f, 78, 79f, 80, 81f; 1914, 82–83, 84f, 85; 1916–1922, 92–104; 1924, 86, 87f, 88; uncanniness of, 65–66. *see also* Pritzel, Lotte (dolls)
"Dolls. On the Wax Dolls of Lotte Pritzel" ("Puppen. Zu den Wachspuppen von Lotte Pritzel") (Rilke), 67, 88–92

doll thinking, 6, 11–12, 155; about Pritzel's dolls, 78, 80, 83, 89–92, 99, 103–104; definition, 5; desire and, 9, 24–25; fear and, 24–25; Kokoschka and, 38–39, 41–45, 47–48, 52, 55–64; materiality and, 23; Moos and, 51–52; of Newton, 1–5, 2f, 153–154; photography and, 70; queer theory and, 14; in *The Sandman*, 18–36; wax and, 85–88
doll thinking, of Bellmer: first phase, 105–122; second phase, 125–142; third phase, 143–148; fourth phase, 149–151
doppelgängers, 113, 152–155
doubling, 110–113, 122, 125, 148, 151, 154. *see also* Bellmer, Hans (works)
Duchamp, Marcel, 127n19
dummies, 1–6, 10, 152–155. *see also* Newton, Helmut
duplication. *see* doubling

Ebenstein, Joanna: *The Anatomical Venus*, 85
Eckstein, Thomas, 108
egotism, 27–28
Eluard, Paul, 122n17, 127; *The Games of The Doll (Les jeux de la poupée)*, 127–142
English *Vogue*, 5n, 152
Enlightenment, 6, 9
"Die Entstehung der Puppe" ("The Genesis of the Doll") (Bellmer), 108
"Erinnerungen zum Thema Puppe" ("Memories of the Doll Theme") (Bellmer), 108–110, 127–128, 151
eroticism, 3–5, 154; Bellmer and, 106–110, 128–129, 131–132; of "Dolls for the Vitrine" (Pritzel), 72–83, 85, 103–104; Kokoschka and, 43, 55, 62–66; lesbian, 154–155. *see also* sadism
etymology, 110
Expressionism, 6, 12, 37n2, 63, 66, 88; German cinema, 138. *see also* Berber, Anita; Impekoven, Niddy

eyes: of Alma doll, 50f–51f, 53f, 58f, 59; of automatons, 7; in Bellmer's works, 107–108, 117, 122, 132–135; Kokoschka on, 43, 47; of Newton's dummies, 1, 2f, 3–5, 153f; Pritzel's, 66, 69; in *The Sandman*, 15, 19–20, 22–24, 28, 33–34. *see also* anatomy (doll)

fantasies. *see* eroticism
Fantasy Pieces in Callot's Manner (Fantasiestücke in Callots Manier) (Hoffmann), 15
fashion: magazines, 1, 5–6
fear, 131; doll thinking and, 24–25; uncanniness and, 4–5, 9, 29–30
feel. *see* touch
feet: Alma doll, 43; Bellmer's dolls, 107, 149–151; in *The Sandman*, 28. *see also* anatomy (doll)
female artists. *see* women artists
feminist critique, 13, 54, 83, 154–155. *see also* gender theory
The Fetish, Confessions of Artists (Der Fetisch, Künstlerbekenntnisse) (Kokoschka), 41–42
fetishism, 154–155; Freud on, 4, 25–26; Kokoschka and, 10, 12, 42–43, 56, 60; male, 1, 4, 13, 54; in *The Sandman*, 25–27. *see also* Alma doll (Moos)
"Fetishism" (Freud), 4, 25
films, 70–72, 138
firearms, 143
First Doll (Bellmer). *see The Doll* (Bellmer)
fragmentation, 117, 122. *see also* amalgamation
Fragonard, Jean-Honoré, 72
French Romanticism, 16
French Surrealism, 122, 125
French *Vogue*, 1–3, 152
Freud, Sigmund, 5–6, 9; "Fetishism," 4, 25; on fetishism, 25–26; *The Interpretation of Dreams*, 83, 151; *Three Essays on the Theory of Sexuality*, 27, 151; uncanniness and, 17, 25, 37, 90; "The Uncanny" ("Das Unheimliche"), 4, 16–17, 26. *see also* psychoanalysis
Freudian discourse, 13, 22, 92, 151
Friedmann, Ernst, 66, 94

Gall, France: *Poupée de cire, poupée de son*, 65
games, 128, 130–131. *see also* playfulness
The Games of the Doll (Les jeux de la poupée) (Bellmer and Eluard), 106, 125–146, 130f–134f, 136f–142f, 146f, 149; playfulness in, 129
gendered language, 33. *see also* neuter case; pronouns
gendered roles, 11; in *The Sandman*, 25–27, 30–32. *see also* androgyny; heteronormativity; Moos, Hermine
gender theory, 13, 145. *see also* queer theory
"The Genesis of the Doll" ("Die Entstehung der Puppe") (Bellmer), 108
The Girl and the Robot (Röyksopp), 14
Girl with Doll/Fränzi (Heckel), 49
Goebel, Eckart, 90–91
Goethe, Johann Wolfgang von, 15–16; "The Holy Longing" ("Selige Sehnsucht"), 91
Goya, Francisco: *The Nude Maja (La Maja Desnuda)*, 52
Gröpius, Walter, 39
Grosz, Elizabeth, 83
Grosz, Georg, 63
Grünewald, Matthias: Isenheim altarpiece, 140–141, 142f
guns, 143

The Half Doll (La demi-poupée) (Bellmer), 106, 149, 150f, 151
hands: of Alma doll, 42–44; Pritzel's, 86. *see also* anatomy (doll)
Hans Bellmer: The Anatomy of Anxiety (Taylor), 106–107
Heckel, Erich: *Girl with Doll/Fränzi*, 49
Hennings, Emmy, 77
Hess, Carry: *Niddy Impekoven as Lotte Pritzel Doll*, 99, 100f
Hess, Nini: *Niddy Impekoven as Lotte Pritzel Doll*, 99, 100f
heteronormativity, 3, 11, 26–27, 154. *see also* gendered roles; queer theory
Hewett-Thayer, Harvey, 17–18
Hilmes, Oliver, 63
Hirschfeld, Georg, 80
Hoddis, Jakob van, 77
Hoffman, Edith, 55, 60, 62

Hoffmann, E.T.A., 5, 11, 14–36; *The Automata (Die Automate)*, 7, 18; Bellmer and, 14; *Fantasy Pieces in Callot's Manner (Fantasiestücke in Callots Manier)*, 15; interest in doll making, 17–18; Kokoschka and, 14, 36, 37n2; ladder metaphor, 21–24; *Night pieces (Nachtstücke)*, 14; Pritzel and, 14; reception and legacy, 15–16; *The Sandman* (see *The Sandman* (Hoffmann)); *The Serapion Brethren (Die Serapionsbrüder)*, 21–24

Hole: *Doll Parts*, 105

"The Holy Longing" ("Selige Sehnsucht") (Goethe), 91

homunculi, 32–33, 71

human–machine boundary, 9, 31

hyperreality, 155

"Images of the Self" (Bellmer), 151

Impekoven, Niddy, 12, 66, 97, 99, 100f

impregnation, 107, 117, 126, 134. *see also* pregnancy

incest, 28–29

industrialization, 6, 8–9

intellectual uncertainty (Jentsch), 6, 17, 92

The Interpretation of Dreams (Freud), 83, 151

Isenheim altarpiece (Grünewald), 140–141, 142f

Jacquet-Droz, Henri Louis, 7; *Musician*, 18

Jacquet-Droz, Pierre, 7–8; *Musician*, 18

Jentsch, Ernst, 5, 9, 31n69; intellectual uncertainty, 6, 17, 92; "On the Psychology of the Uncanny" ("Zur Psychologie des Unheimlichen"), 4, 17; on uncanniness, 37

Jesus, imagery of, 139–142

Les jeux de la poupée (The Games of the Doll) (Bellmer and Eluard), 106, 125–146, 130f–134f, 136f–142f, 146f, 149

joints: ball, 108–109, 117, 122, 125–129, 135, 142–143, 147–149; in *The Sandman*, 28. *see also* anatomy (doll)

Kähnert, Maria Elisabeth, 71

Kallmus, Dora. *see* Madame d'Ora

Kaufmann, Johann Friedrich, 7

Kaufmann, Johann Gottfried, 7; *Trumpeter*, 18

Kayser, Ulrich, 71

Keegan, Susan, 55, 60, 62

Kempelen, Wolfgang von, 7; *Chess-playing Turk*, 18

Kinzing, Peter, 7

Kleist, Heinrich von: "On the Marionette Theatre," 97

Knaus, Friedrich von, 7

Koch, Alexander, 66

Kokoschka, Oskar, 9, 11, 37–64, 69, 154; Alma doll reaction, 54–57, 61; Bellmer and, 105–106; doll thinking of, 38–39, 41–45, 47–48, 52, 55–64; eroticism, 43, 55, 62–66; on eyes, 43, 47; fetishism, 10, 12, 42–43, 56, 60; Hoffmann and, 14, 36, 37n2; letters, 40–45, 47–49, 54–56, 61–63, 105–106; relationship with Mahler, 39–40, 63–64; Moos' defiance of, 48–50, 54; Pritzel and, 39–40, 65, 105. *see also* Mahler, Alma

Kokoschka, Oskar (works): Alma doll art, 57–60; *Artist with Doll*, 12, 38–39, 59f, 60; art of Alma Mahler, 44–45, 46f, 47, 51; *The Burning Bush (Der brennende Dornbusch)*, 45; *The Fetish, Confessions of Artists (Der Fetisch, Künstlerbekenntnisse)*, 41–42; *My Life*, 60–62; *Painter with Doll*, 12, 38–39, 59f, 60; *A Sea Ringed with Visions*, 60, 63; *Standing Female Nude*, 45–48, 46f; *Study for Woman in Blue*, 57f; *Woman in Blue*, 12, 39, 57–59, 58f. *see also* Alma doll (Moos)

Kraftwerk: *Das Model*, 1

Krull, Germaine, 86

Kruse, Käthe, 95n56

Kunst und Dekoration. see Deutsche Kunst und Dekoration

ladder metaphor (Hoffmann), 21–24

Lady Gaga: *Plastic Doll*, 152

legs: of Alma doll and paintings, 45–46, 48–49, 50f, 51f, 55; of Bellmer's dolls, 107–150; of Pritzel's dolls, 69, 73f–76f, 77, 96f, 97, 99, 100f–102f. *see also* anatomy (doll)

Index

Leonardo da Vinci, 41n14, 60n62, 143n31. *see also* Bellmer, Hans; Kokoschka, Oskar; Michelangelo; Renaissance art
lesbianism, 154–155. *see also* queer theory
letters: Kokoschka's, 40–45, 47–49, 54–56, 61–63, 105–106
Lichtenstein, Therese, 105–106; *Behind Closed Doors: The Art of Hans Bellmer,* 106
Lieb, Claudia, 18

The Machine-Gunneress in a State of Grace (La Mitrailleuse en état de grâce) (Bellmer), 106, 143, 144f–145f, 146–149
Madame d'Ora, 68, 69f, 70, 154; *Anita Berber as Pritzel Doll,* 99, 101f
"Maelzel's Chess Player" (Poe), 7
Magdalene, Mary, 45, 140n29. *see also* religious iconography
Mahler, Alma, 11–12, 38, 69; Alma doll and, 42, 50–51, 61; relationship with Kokoschka, 39–40, 63–64; paintings of, 44–45, 46f, 47, 51. *see also* Alma doll; Kokoschka, Oskar
Mahler, Gustav, 38
La Maja Desnuda (The Nude Maja) (Goya), 52
male aggression. *see* violence
male fetishism, 1, 4, 13, 54. *see also* fetishism
male gaze. *see* voyeurism
Man a Machine (Mettrie), 8
Manet, Edouard, 60n59; *Olympia,* 49, 52, 58n58
mannequins. *see* dummies
Maria Theresa, Empress of Austria, 7
Marie-Antoinette, Queen of France, 7
Marks, Laura, 47
Marx, Karl: materialist theory, 11
Mary Janes, 130, 135, 138, 149–150
masturbation, 133–134
materiality, 8–10, 24; of Alma doll, 42–45, 47–55; of Bellmer's dolls, 107–109, 143, 149; doll thinking and, 23; papier mâché, 126, 135, 143, 149; of Pritzel's dolls, 85–88
Mechanical Turk, 7

"Memories of the Doll Theme" ("Erinnerungen zum Thema Puppe") (Bellmer), 108–110, 127–128, 151
Metamorphoses (Ovid), 9, 135n28
Mettrie, Julien Offroy de la: *Man a Machine,* 8
Michel, Wilhelm, 71, 77–78, 82–83, 85
Michelangelo, 41n14, 60n62. *see also* Kokoschka, Oskar; Leonardo da Vinci; Renaissance art
Minotaure, 122, 125–126. *see also* Bellmer, Hans; Surrealism
Miró, Joan: *Woman,* 143
La Mitrailleuse en état de grâce (The Machine-Gunneress in a State of Grace) (Bellmer), 106, 143, 144f–145f, 146–149
Mitrani, Nora, 147
Das Model (Kraftwerk), 1
Moos, Henriette, 40, 48–49
Moos, Hermine, 11–12, 38; as Alma doll maker, 39–45, 41f, 47–49, 60–61; defiance of Kokoschka, 48–50, 54; doll thinking of, 51–52; Kokoschka's letters to, 41–45, 47–48, 54–56, 61; other art of, 40; photography, 48–54, 50f, 51f, 53f. *see also* Alma doll (Moos)
movies, 70–72, 138
museums, 7n9–n12, 125
Musician (Jacquet-Droz), 18
My Life (Kokoschka), 60–62

Nachtstücke (Night Pieces) (Hoffmann), 14
Naguschewski, Ursula, 105, 108, 122n17
narcissism, 27–28, 155
neuter case, 13. *see also* gendered language
Newton, Helmut: autobiography, 3, 6n; "Store Dummies II," 152, 153f, 154–155; "Upstairs at Maxim's," 1–5, 2f, 10
New Woman, 68–69, 154. *see also* Madame d'Ora; Pritzel, Lotte; Weimar Republic
Niddy Impekoven as Lotte Pritzel Doll (Hess), 99–100
Night pieces (Nachtstücke) (Hoffmann), 14

"Notes on the Subject of the Ball Joint" ("Notes au sujet de la jointure à boule") (Bellmer), 10, 127–128, 135, 151
The Nude Maja (La Maja Desnuda) (Goya), 52

objects. *see* thing theory; toys
Offenbach, Jacques: *Tales of Hoffmann (Les contes d'Hoffmann)*, 16–17, 37–38, 105–106
"Old and New Dolls" ("Alte und Neue Puppen"), 99
Olympia (Manet), 49, 52, 58n58
"On the Marionette Theatre" (Kleist), 97
"On the Psychology of the Uncanny" ("Zur Psychologie des Unheimlichen") (Jentsch), 4, 17
Oracle and Spectacle (Zürn), 147
Ovid: *Metamorphoses*, 9, 135n28

Pagel, Gerhard, 40, 44, 65. *see also* Kokoschka, Oskar; Moos, Hermine; Pritzel, Lotte
Painter with Doll (Kokoschka), 12, 38–39, 59f, 60
papier mâché, 126, 135, 143, 149. *see also* Bellmer, Hans (works); materiality
peepshow. *see* voyeurism
pelvises, 128–129, 132–137. *see also* anatomy (doll)
"Petite anatomie de l'inconscient physique ou L'anatomie de l'image" ("A Brief Anatomy of the Physical Unconscious or The Anatomy of the Image") (Bellmer), 106, 149, 151
"la petite mort," 143
phallic symbolism, 4, 25–26, 83, 116, 133–134, 145, 149–150. *see also* castration; vulval symbolism
photography, 10; of Alma doll, 41f, 48–54, 50f, 51f, 53f; of Bellmer's work, 110–150; doll thinking and, 70; etymology of, 110n10; by Madame d'Ora, 68, 69f, 70, 99, 101f; Pritzel's own, 69–71; Surrealist, 3, 12–13, 52, 110
physical unconscious, 106–107, 149, 151. *see also* Bellmer, Hans
Picasso, Pablo: *Woman Seated in a Red Armchair*, 143

Pinner, Erna, 95
Plastic Doll (Lady Gaga), 152
playfulness, 5, 127, 129, 154. *see also* games; toys
Poe, Edgar Allan: "Maelzel's Chess Player," 7
poetry, 78; about Pritzel's dolls, 94–95, 99, 103–104; Bellmer and, 127–128
positivism, 6
posthumanism, 12
La poupée (The Doll) (Bellmer). *see The Doll* (Bellmer)
Poupée de cire, poupée de son (Gall), 65
power of uncanniness, 11–12. *see also* uncanniness
pregnancy, 107, 116–117, 126, 132, 134. *see also* impregnation
Pritzel, Lotte, 9–11, 40n10, 65–104, 154; avant-garde movement and, 12, 70–71, 97–104; Bellmer and, 67, 104–105, 117n16, 125; biography, 65–68, 77; in *Deutsche Kunst und Dekoration*, 67; eyes, 66, 69; hands, 86; Hoffmann and, 14; Kokoschka and, 39–40, 65, 105; photography and film of, 69–71, 69f; relationship with her dolls, 68–71, 77–78, 86; Rilke and, 67, 88–89. *see also* Berber, Anita; Impekoven, Niddy; Madame d'Ora; Rilke, Rainer Maria
Pritzel, Lotte (dolls), 93f, 96f, 98f, 102f; about photographs of, 69–71; androgyny of, 12, 66, 72–80, 83–84, 89, 92, 154; dancing and, 70–72, 92–104; in *Deutsche Kunst und Dekoration*, 65–66, 71–85, 88, 94, 104; doll thinking about, 78, 80, 83, 89–92, 99, 103–104; materiality of, 85–88; poetry about, 94–95, 99, 103–104; touch and, 86; uncanniness of, 65–66, 80, 83, 89–92, 97, 99; vulval symbolism in, 80, 81f, 83. *see also* anatomy (doll); "Dolls for the Vitrine" (Pritzel)
The Pritzel-Doll (Die Pritzelpuppe), 70–72
Pritzel's Doll ("Die Pritzelpuppe") (Berber), 99
pronouns, 13, 128. *see also* gendered language
psychoanalysis, 106–107. *see also* Freud, Sigmund; Freudian discourse

psychology. *see* Jentsch, Ernst
Puppe (Rammstein), 37
Puppe (term), 13, 33, 92, 110
Die Puppe (The Doll) (Bellmer). *see The Doll* (Bellmer)
Das Puppenbuch (The Book of Dolls), 95
"Puppen für die Vitrine." *see* "Dolls for the Vitrine" (Pritzel)
"Puppen. Zu den Wachspuppen von Lotte Pritzel" ("Dolls. On the Wax Dolls of Lotte Pritzel") (Rilke), 67, 88–92
puppets, 51, 80
pure anagrams, 147–148
Pygmalion, 9–10, 63

queer theory, 6, 11, 24–27, 154–155; doll thinking and, 14. *see also* androgyny; gender theory; heteronormativity
Quintieri, Rosalinda, 155n5; *Dolls, Photography, and the Late Lacan*, 51

Racial Innocence (Bernstein), 10
racialized dolls, 72–73, 95, 144–145
Rammstein, 37
Reinhardt, Max, 105
religious iconography, 88, 138–142
Renaissance art, 41n14, 45, 60, 125, 127, 138
reversibility of the body, theory of, 128–129. *see also* Bellmer, Hans
Rilke, Rainer Maria, 12, 40, 66; "Dolls. On the Wax Dolls of Lotte Pritzel" ("Puppen. Zu den Wachspuppen von Lotte Pritzel"), 67, 88–92; Pritzel and, 67, 88–89
Riskin, Jessica, 8
Rococo period, 72, 77
Roentgen, David, 7–8
Roland Barthes, 3
Romanticism, 6, 22, 28; French, 16
Roos, Bonnie, 48, 55
Rootstein, Adel, 152–153
Rooy, Willie Van, 152
Röyksopp: *The Girl and the Robot*, 14
Royle, Nicholas, 26

sadism, 109, 129–130, 139, 141. *see also* eroticism; violence
Saint-Léon, Arthur: *Coppelia or The Girl with Enamel Eyes (Coppélia ou la fille aux yeux d'émail)*, 16–17
Sanchez, Violeta, 152–154

Sandman (creature), 15
The Sandman (Der Sandmann) (Hoffmann), 9–11, 14, 37, 105–106, 153–154; anatomy in (*see* anatomy (doll)); dancing in, 16–17n17, 29–31; doll making in, 32–36; doll thinking in, 18–36; fetishism in, 25–27; gendered roles in, 25–27, 30–32; incest and, 28–29; narration of, 34–36; queerness in, 24–27; satire in, 30–31, 34; story and reception, 15–16. *see also* Hoffmann, E.T.A.
satire: in *The Sandman*, 30–31, 34
Schickele, René, 89
Schiele, Egon, 66–67
Schreiber, Justina, 40, 48
Schwarzer, Alice, 154
Scott, Walter, 15
scriptive thing (definition), 54. *see also* Bernstein, Robin
A Sea Ringed with Visions (Kokoschka), 60, 63
Second Doll (Bellmer). *see The Games of the Doll* (Bellmer)
"Selige Sehnsucht" ("The Holy Longing") (Goethe), 91
The Serapion Brethren (Die Serapionsbrüder) (Hoffmann), 21–24
sex roles. *see* androgyny; gendered roles
sexualization. *see* eroticism
sexual violence, 63, 72. *see also* violence
shoes. *see* feet; Mary Janes
Simms, Eva-Maria, 90–91
simulacrum, 155
skin: of Alma doll, 44–45, 47–48. *see also* anatomy (doll)
Smith, Marquard, 48, 56
Standing Female Nude (Kokoschka), 45, 46f, 47–48
Stations of the Cross, 139–142
stomachs, 108–140. *see also* anatomy (doll); impregnation; pregnancy
"Store Dummies II" (Newton), 152, 153f, 154–155
Study for Woman in Blue (Kokoschka), 57f
Surrealism, 3, 6, 62, 67; Bellmer and, 107, 126–127, 142; French, 122, 125; photography, 3, 12–13, 52, 110; writing, 108

Symbolism (movement), 6, 12, 67. *see also* Rilke, Rainer Maria

Tales of Hoffmann (Les contes d'Hoffmann) (Offenbach), 16–17, 37–38, 105–106
Taylor, Sue, 141; *Hans Bellmer: The Anatomy of Anxiety*, 106–107
thing theory, 56–60
Third Doll (Bellmer). *see The Machine-Gunneress in a State of Grace* (Bellmer)
Three Essays on the Theory of Sexuality (Freud), 27, 151
Timpano, Nathan, 37
Titian: *Venus of Urbino*, 49
Topsy-Turvy doll, 144–145
touch: Kokoschka and Alma Doll, 38, 42–44, 47–48; Pritzel's dolls and, 86
toys, 51, 80, 89–91, 95n56, 127, 145. *see also* Kruse, Käthe; Pritzel, Lotte; Rilke, Rainer Maria
Treatise on Man (Descartes), 8
Treaty of Versailles, 95
Trumpeter (Kaufmann), 18

UFA film company, 70–72
uncanniness: of Alma doll, 56; in Bellmer's works, 109, 113, 122; fear and, 4–5, 9, 29–30; Freud and, 17, 25, 37, 90; Jentsch on, 37; of Newton's works, 152, 154–155; power of, 11–12; of Pritzel's dolls, 65–66, 80, 83, 89–92, 97, 99. *see also* fear; Freud, Sigmund; Jentsch, Ernst
uncanny: definitions, 3–5
"The Uncanny" "Das Unheimliche" (Freud), 4, 16–17, 26
"Upstairs at Maxim's" (Newton), 1–5, 2f, 10
Urtext, 9. *see also The Sandman* (Hoffmann)

vaginal symbolism. *see* vulval symbolism
Variations on the Assemblage of an Articulated Minor (Variations sur le montage d'une mineure articulée) (Bellmer), 122, 125
Vaucanson, Jacques de, 6–8
Venus of Urbino (Titian), 49

Vinci, Leonardo da, 41n14, 60n62, 143n31
violence, 106–107, 129–130, 139–141; in anagrams, 147–148; male on female, 3, 109–110; sexual, 63, 72. *see also The Games of the Doll (Les jeux de la poupée)* (Bellmer and Eluard); sadism
"Vitrine Dolls." *see* "Dolls for the Vitrine" (Pritzel)
Vogue: English, 5n, 152; French, 1–3, 152
Voskuhl, Adelheid, 8
voyeurism, 1, 54, 77, 110, 116–117, 129–131, 154
vulval symbolism: in Bellmer's works, 108, 110, 122, 142, 145, 150; in Pritzel's works, 80, 81f, 83. *see also* phallic symbolism

Waldberg, Patrick, 140n29
Watteau, Antoine, 72
wax, 4, 85–88. *see also* materiality; Pritzel, Lotte (dolls)
Webb, Peter, 143, 149
Weimar Republic, 10–11, 68–69, 95, 99
Die weißen Blätter, 88–89
Weltanschauung, 29
Wiegleb, Johann Christian, 17
Woman (Miró), 143
Woman in Blue (Kokoschka), 12, 39, 57, 58f, 59
Woman Seated in a Red Armchair (Picasso), 143
wombs. *see* impregnation; pregnancy; stomachs
women artists, 68. *see also* Berber, Anita; feminist critique; Impekoven, Niddy; Madame d'Ora; Moos, Hermine; Pritzel, Lotte
"The Work of Art in the Age of Its Technological Reproducibility" (Benjamin), 86, 88

Yva (Else Ernestine Neuländer-Simon), 10, 154. *see also* Newton, Helmut

Zürn, Unica: *Oracle and Spectacle,* 147
"Zur Psychologie des Unheimlichen" ("On the Psychology of the Uncanny") (Jentsch), 4, 17